IMAGES
of America

HUDSON RIVER
BRIDGES

IMAGES
of America

HUDSON RIVER
BRIDGES

Kathryn W. Burke

ARCADIA
PUBLISHING

Published by Arcadia Publishing
Charleston, South Carolina

Library of Congress Catalog Card Number: 2006938684

For all general information contact Arcadia Publishing at:
Telephone 843-853-2070
Fax 843-853-0044
E-mail sales@arcadiapublishing.com
For customer service and orders:
Toll-Free 1-888-313-2665

Visit us on the Internet at www.arcadiapublishing.com

To my husband, Walter, for his encouragement, support, and the idea to create this book; to my daughters, Maureen and Kate; and in memory of my father, William Wilson (1927–1987).

CONTENTS

ACKNOWLEDGMENTS

The following people deserve many thanks for their assistance in making this book possible: from the New York State Bridge Authority, chairman James P. Sproat for contributing the foreword for this book; John Bellucci, director of public relations and planning; Olive Rose, Bellucci's assistant; and the many individuals too numerous to mention who contributed photographs and information (any photographs not otherwise indicated come from the archives of the New York State Bridge Authority); from the Port Authority of New York and New Jersey, Tony Ciavolella, public relations officer, who sent me the photographs of the George Washington bridge for use in this book; Nyack Library Local History Room, in particular Carol Weiss, for her continued assistance, and Denning McTague, local library historian, for the Tappan Zee bridge photographs; Catskill Chamber of Commerce, Linda Overbaugh, executive director, for sending additional photographs of the Rip Van Winkle Bridge and the village of Catskill; Walkway.org members Fred Schaeffer and Judy Moran for sharing their photographs and information on the Poughkeepsie Railroad Bridge along with information from *Bridging the Hudson*, by Carleton Mabee; Barbara Clay for her expert legal advice; Joseph Elias from NRS Computers in Rockland; and my nephew Jake Woodruff, for all his technical assistance. For support from my family, Walter, Maureen, and Kate, and my sisters Mary Ibsen and Meg Woodruff, who helped to keep me plugging along; and Erin Vosgien, my editor from Arcadia Publishing, always ready to answer questions and give assistance and support.

FOREWORD

Engineering marvels, historic landmarks, wildlife refuges—the bridges of the Hudson River are all these and more.

From humble beginnings as a way to finance a bridge during the Great Depression, the New York State Bridge Authority is proud of our heritage and our contributions to the people and history of the Hudson Valley.

This collection of images and history presents the hard work and dedication of 80 years of people, families, communities, and the bridges that tie them together. The boom of the automobile in the 1920s led to a massive expansion of roads and the network that ties them together throughout the Hudson Valley, yet getting from one bank of the Hudson to the other still required a ferryboat anywhere between New York City and Albany.

It was the bridges, beginning with the Bear Mountain bridge, that allowed the wealthy and the vacationer to access the Palisades, Catskills, and Adirondacks. But maybe more importantly, the bridges allowed the laborer, the baker, the tradesman to bring their skills and goods to new markets in an easy and efficient manner.

Today the bridges of the Hudson River connect Boston to Los Angeles, and the New York State Bridge Authority serves a vital role in operating the five Mid-Hudson bridges. We are pleased that we have been able to keep up with technological advances to keep traffic moving smoothly while also preserving the historic character and history of these magnificent structures.

Providing safe roosting areas for peregrine falcons has its own rewards, and innovative lighting that adds an element of art and design allows the bridges to be an integral part of the stewardship of the Hudson River.

As we celebrate the Hudson-Champlain quadricentennial in 2009, preserving our history and the stories behind the pictures lends perspective to the true impact of the Hudson River bridges for future generations.

James P. Sproat, Chairman
New York State Bridge Authority
November 2006

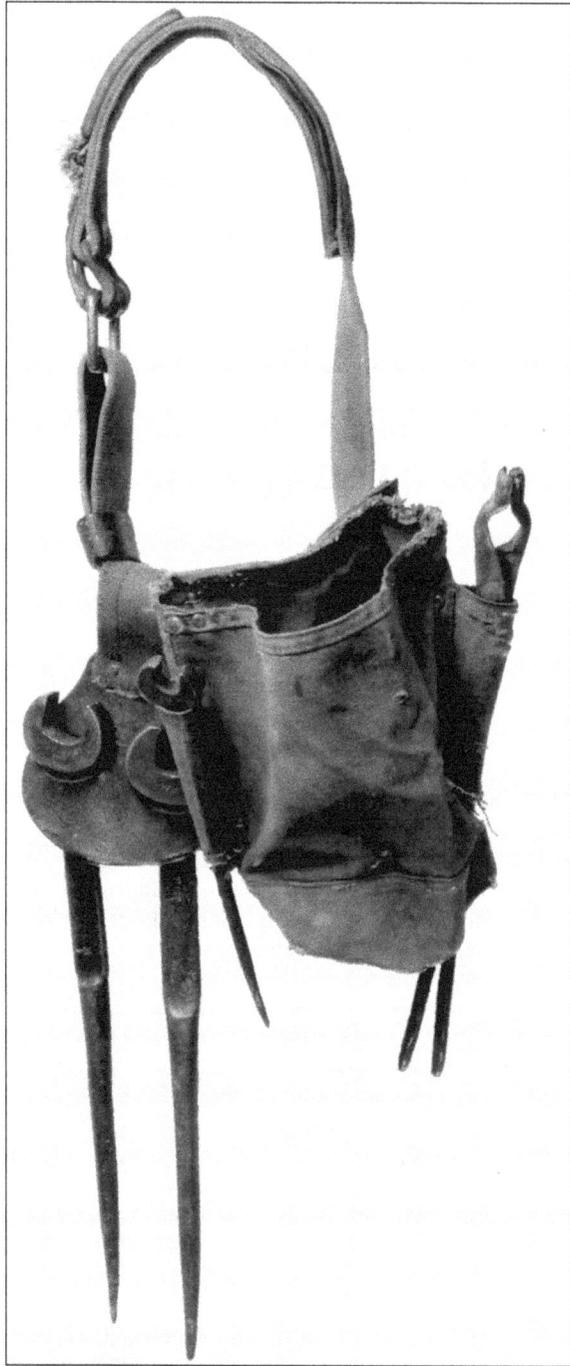

This bolt bag was worn by early ironworkers, who over the years have labored to build bridges essentially by hand. The bag was worn over the shoulder, keeping the tools close at hand as the men worked at precarious heights. The pointed end of the spud wrenches hanging from the left side pocket was used to line up the holes in the steel trusses of the bridge prior to riveting. The wrench was also used to tighten the rivets. The rivet tong in the pocket on the far right was used for handling hot rivets.

INTRODUCTION

For most of us, crossing a bridge means getting to our destination. We never think about the bridge or the means for its construction. At the very least we might notice a beautiful view as we impatiently wait in traffic. This book is designed to encourage people to stop and take a look at the marvelous bridges over the mighty Hudson River. Take note of what was necessary to build these bridges, the expense in money and individuals. Through well-preserved old photographs, we will examine the function and beauty of these architectural marvels.

The bridges are organized chronologically as they were built. There are similarities to the development process, the construction process, and connections of people involved in the creation of more than one bridge. Politics and economics of each particular time determined everything about the bridges. In many cases, lessons learned building a bridge were helpful as the later bridges were attempted. The period of time from the late 1800s to the late 1900s was a time when people took pride in their work, and the resulting bridges are evidence to that testament.

The first bridge on the Hudson River was the Poughkeepsie Railroad Bridge, also known simply as the Poughkeepsie bridge. It stands high across the Hudson River between Poughkeepsie and Highland. Trains ran without hesitation from track to bridge to track across the river. The Poughkeepsie Railroad Bridge shortened considerably the route that would have been needed to go north around the river. It simplified freight crossing the river, eliminating the need to be loaded onto ferryboats. Trains ran uninterrupted on the Poughkeepsie Railroad Bridge from 1888 until the fire in 1974. Current efforts by the Walkway Over the Hudson group hope to preserve the bridge for pedestrians and cyclists' use.

The Bear Mountain Hudson River Bridge, or just the Bear Mountain bridge as it is more commonly known, stands regally at the entrance to the Highlands of the Hudson River valley. Its construction became a study in cable design for the John A. Roebling Company, well known for its contributions to many important area bridges. The Bear Mountain bridge was built as the automobile became an integral part of the country's development.

The Franklin D. Roosevelt Mid-Hudson Bridge, or the Mid-Hudson bridge as it is more commonly known, was said to be one of the most beautiful bridges of its time, built during the Depression. It was used as a model for the Golden Gate Bridge. It was for vehicle traffic what the Poughkeepsie bridge was for railroads. Prior to the building of the Newburgh-Beacon bridge, the Mid-Hudson was a major connection between New England and the West.

The George Washington Memorial Bridge, or just the George Washington bridge as it is now called, continued to grow with age as the commuting population expanded. The forethought of the bridge's designer enabled the George Washington bridge to be built stronger than was

necessary at the time to allow future construction that would almost double its capacity by adding the lower level. The George Washington bridge is as famous as other New York City landmarks, such as the Empire State Building and the Statue of Liberty. Maintained by the Port Authority of New York and New Jersey, the George Washington bridge is one of the many great responsibilities of the port authority.

The New York State Bridge Authority, one of the state's many authorities, has successfully cared for and developed the bridges of the middle Hudson River area. Thoughtful planning and careful maintenance continue to enable the bridge authority to serve the Hudson Valley.

The Rip Van Winkle Bridge, the most northern of the New York State Bridge Authority's bridges, spans the river in a beautiful rural setting. Pockets of population and magnificent vistas are adjacent to that area of the Hudson River. Travelers gained greater access to the Catskill Mountains in the west and the Berkshire Mountains in Massachusetts. The local village of Catskill and the city of Hudson are also more readily connected by the existence of the bridge.

The George Clinton Kingston-Rhinecliff Bridge, or the Kingston-Rhinecliff bridge as it is more commonly called, opened the entire Kingston-Rhinecliff area, giving companies a greater job pool and people more options for living and working. Its structural simplicity connects the sides of the river as if travelers were driving down a local road.

The Governor Malcolm Wilson Tappan Zee Bridge, or the Tappan Zee bridge as it is better known, crosses the Hudson River at its widest point. The bridge is three miles of beautiful views, often all the way to Manhattan on a clear day. The New York State Thruway has the mammoth responsibility for maintaining the Tappan Zee bridge. Lessons learned from the development of other Hudson River crossings could prove beneficial to answering the concern for more capacity crossing at the point of the Tappan Zee bridge.

The twin spans of the Hamilton Fish Newburgh-Beacon Bridge, or the Newburgh-Beacon bridge as they are called, sit together high above the Hudson River connecting not just the communities of Beacon and Newburgh but the entire Northeast with the rest of the country. The design of the spans makes them as much a part of the view as the surrounding landscape.

Each bridge tells its story through the photographs assembled here. The history of each bridge contains much more than timbers, concrete, and steel. Each bridge represents courageous times, difficult times, and tranquil times in the history of the Hudson River valley. The Hudson River bridges stand with a foot on each shore enabling us to cross seamlessly from one area to another, expanding our opportunities and experiences. Greater developments in the region have been made possible by enlarging the labor pools for businesses, job opportunities for individuals, housing options, and recreation available to residents. It is imperative as we continue to grow and develop as a greater community that we are reminded where we came from and what it took us to get where we are. Preserving the past and making the story available to encourage thoughtful development are important by-products of my book.

One

POUGHKEEPSIE RAILROAD BRIDGE

The end of the Civil War saw a boom in railroad construction in the United States. Proposals for railroad bridges across the Hudson River were made for a variety of locations between Albany and New York City. Interest in connecting coal and steel from Pennsylvania with manufacturing centers in New England prevailed with the signing of a charter with the newly incorporated Poughkeepsie Bridge Company to build a railroad bridge between Poughkeepsie and Highland. The original cornerstone was laid on December 17, 1873, with great ceremony. The invitation seen here celebrated the event. Unfortunately with the panic of 1873, a major economic depression, and the death of Pennsylvania Railroad president J. Edgar Thomson, funds were no longer available to construct the bridge.

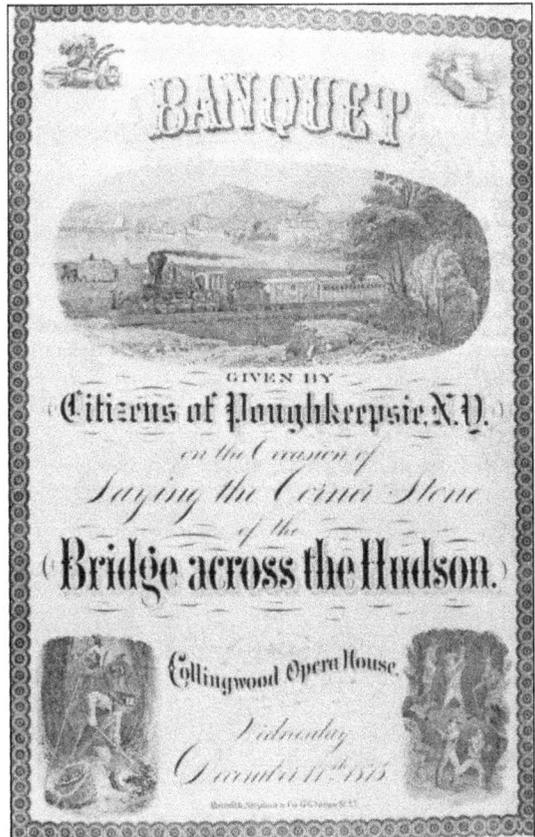

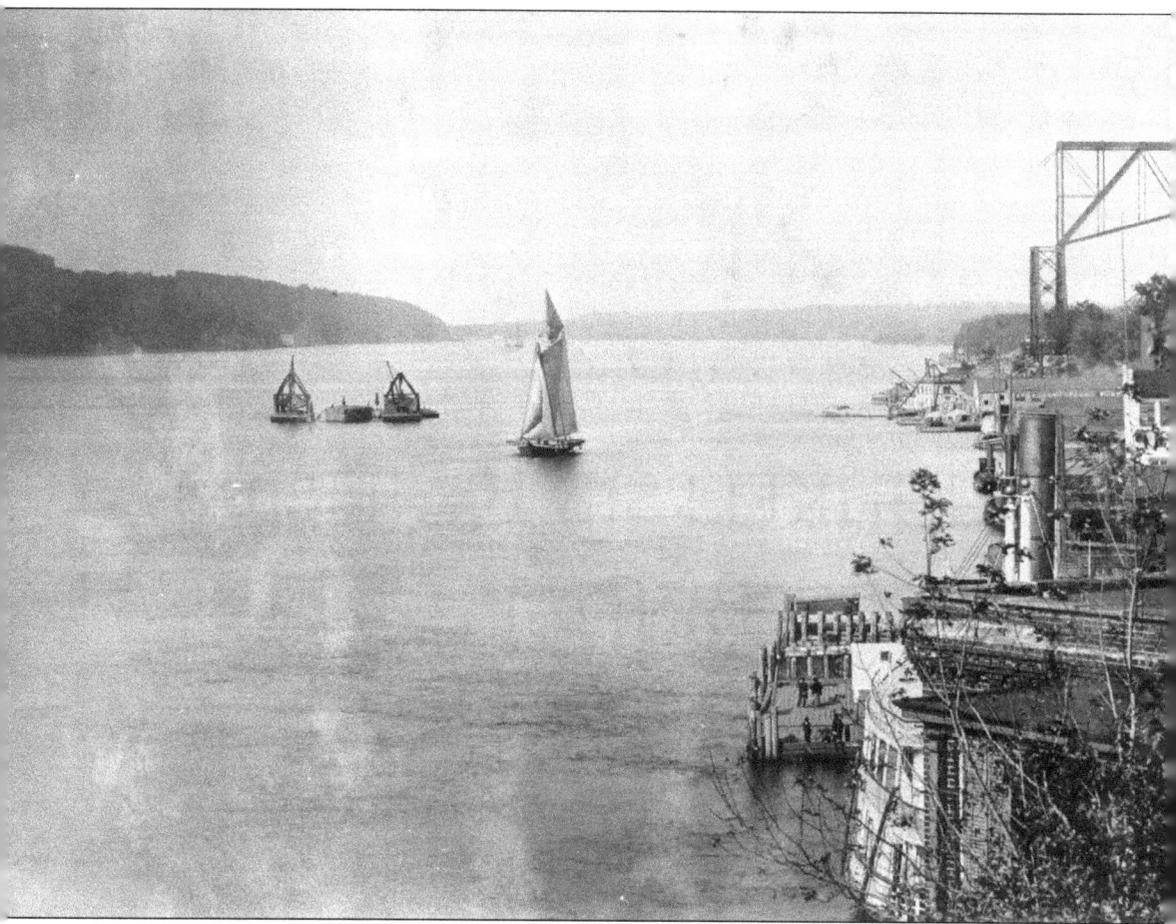

After many long years and several attempts to obtain funds, the Poughkeepsie Bridge Company hired the Union Bridge Company to commence construction of the railroad bridge in 1886. In this view, looking northwest from south of the bridge on the eastern shoreline, erection is just beginning on the first pier on the eastern shore in Poughkeepsie. The bridge was to rest on concrete piers made within forms of heavy hemlock lumber. After much difficulty, these cribs were sunk into the river, settling on the hard rock gravel near the firm rock bottom. Derricks dropped buckets of concrete into the water-filled crib pockets where it hardened adding weight to further settle the pier into the river bottom. The hemlock timber forms remained permanently underwater filled with a concrete core that would become the foundations for the piers.

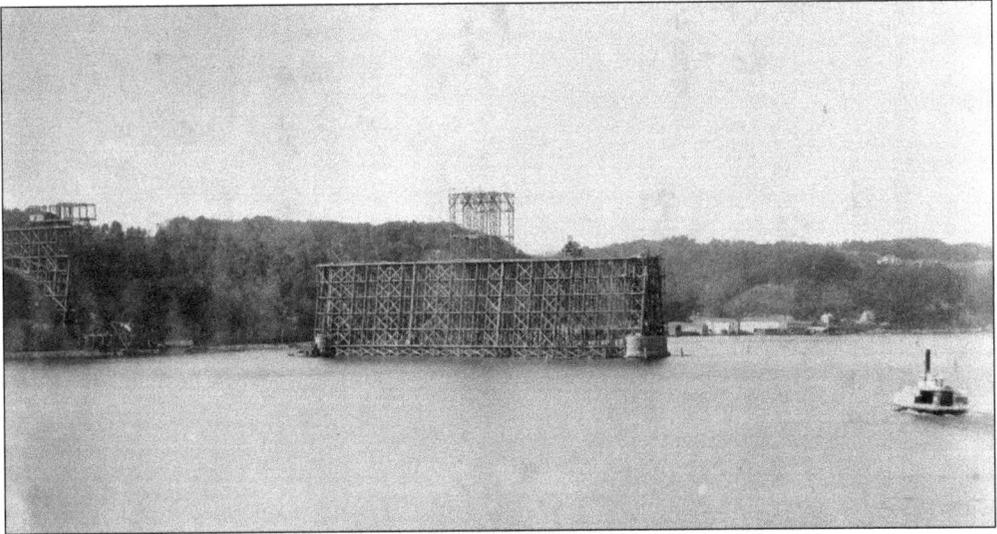

It was decided that the bridge would be built in sections of three cantilever spans connected by two fixed spans each 525 feet long. These fixed spans required staging to build them upon. The stagings, as seen in the photograph above, were 220 feet above the water and rested on piles driven through 60 feet of water and 60 feet of mud to reach a point of sufficient depth and support. The Poughkeepsie Highland Ferry can be seen in the photograph to the right of the bridge structure.

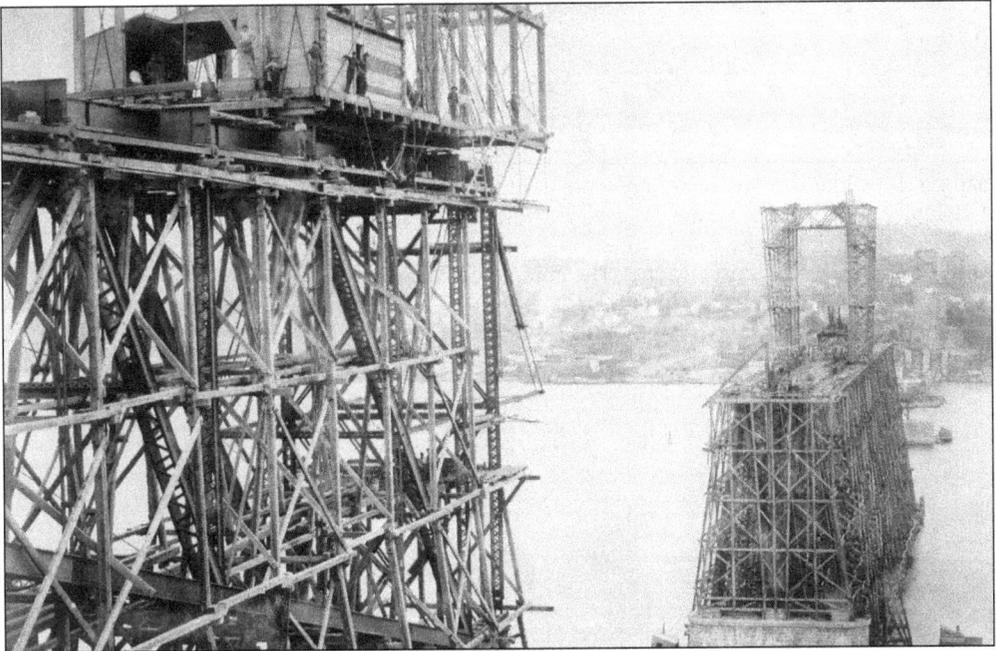

In this view, looking east across the river through the bridge structure into the city of Poughkeepsie, the traveling scaffold used to erect the cantilever spans can be seen on top of the left-side structure. The two traveling scaffolds moved out daily from the place of beginning over the piers on each side of the fixed span until they met in the center with the completed cantilever span. Workmen hoisted up the pieces of steel from a barge in the river using suspended planks to walk on as they hammered the pieces in place.

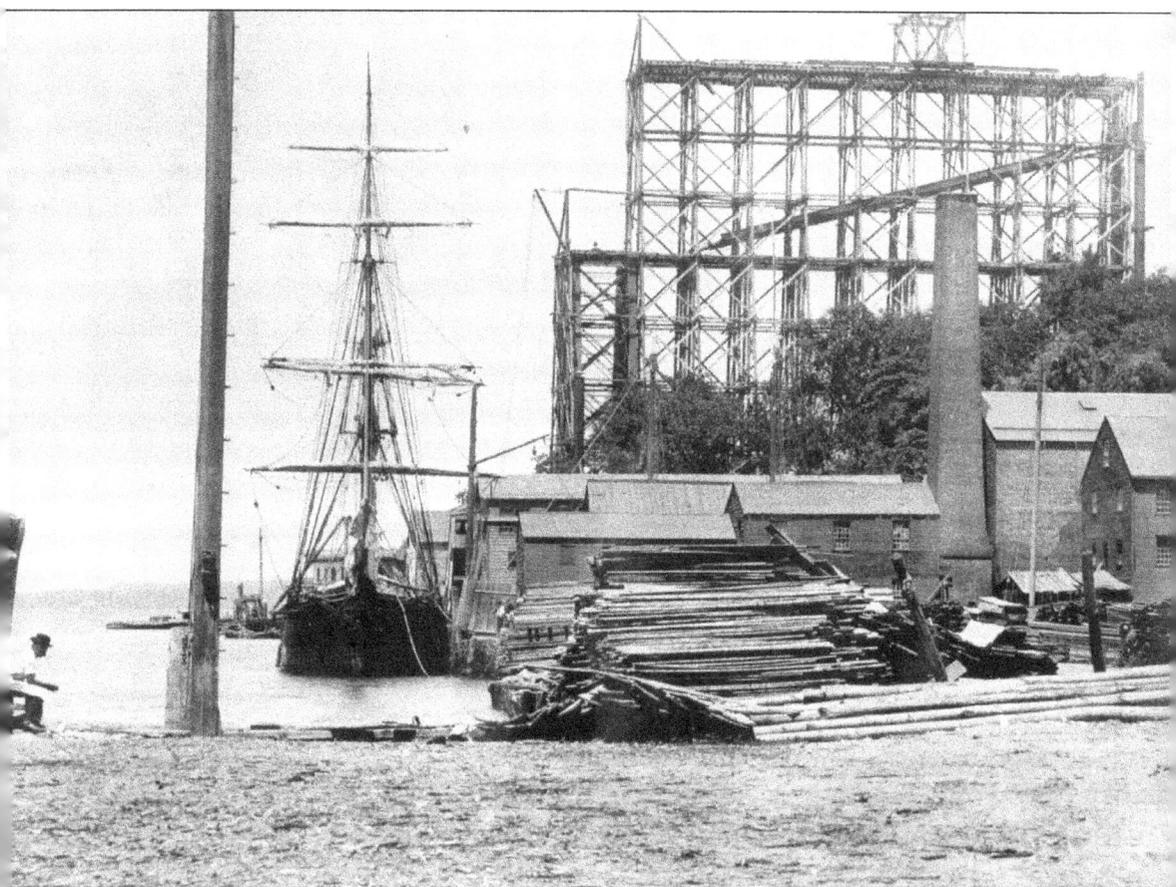

Sailing ships like the one seen here were used to bring supplies up the river to the bridge site. The lumber piled on the shore was used for framing the stagings and the scaffolding seen in the bridge section behind the row of trees. Steel trusses were transported from Pittsburgh by way of rail lines that would eventually cross the completed bridge.

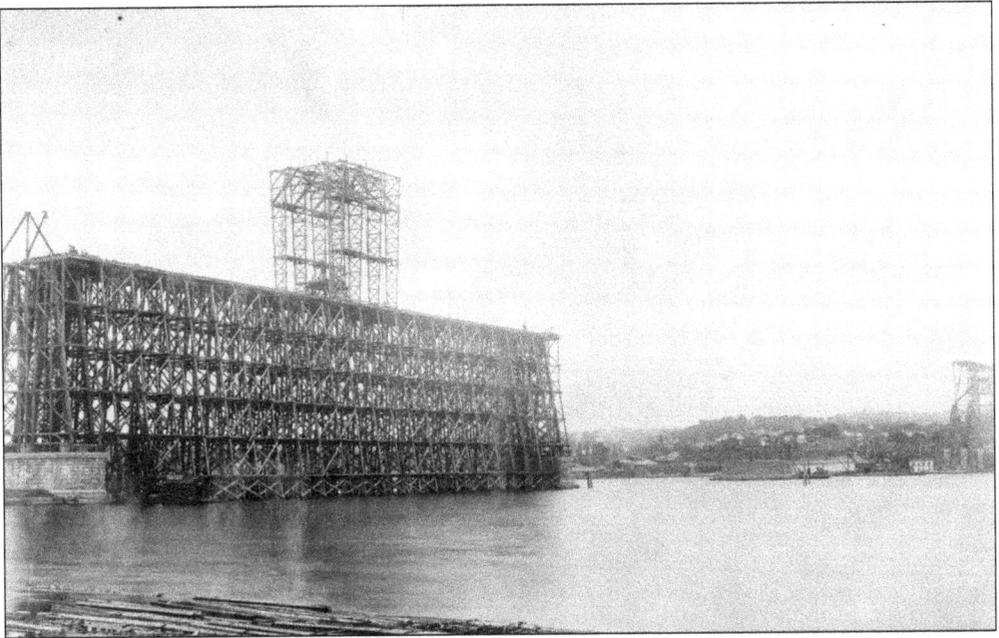

The use of cantilever spans was a time-saver as well as a savings of three very costly stagings used to construct fixed bridge spans. Putting up one staging and constructing the steel structure of a fixed span, as pictured here, can take three to four months. Constructing the cantilever span between the fixed span using the traveling scaffold takes only three to four weeks.

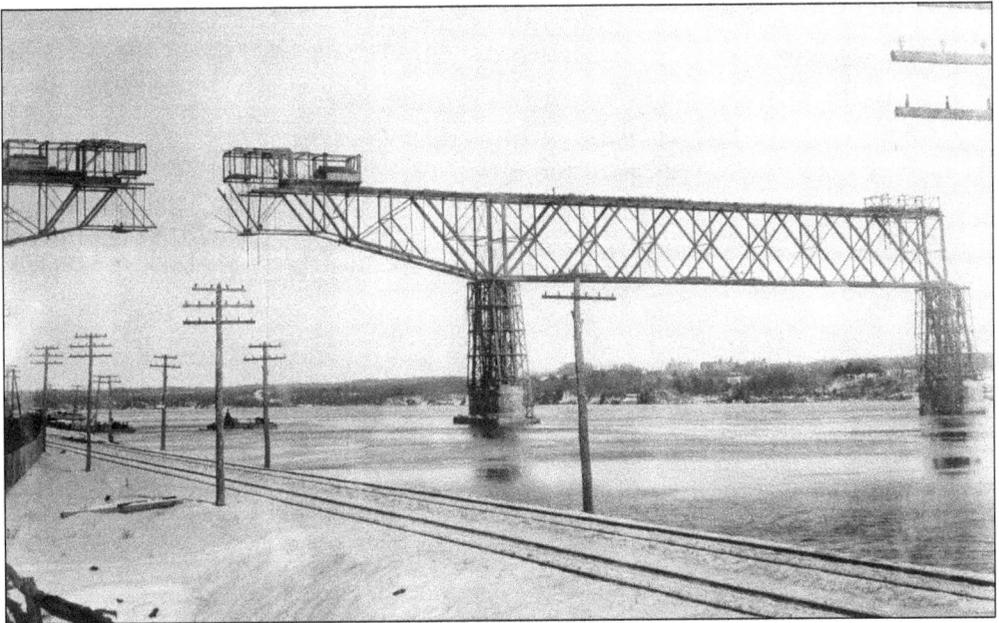

The cantilever span here is being constructed over the railroad tracks on the west shore of the Hudson River. Since the construction was completed by the traveling scaffold, no interruption to the rail service was necessary. The cantilever span sections of the bridge were 548 feet long. Ice on the river enabled workers to use the solid surface to transport materials and walk from section to section more easily.

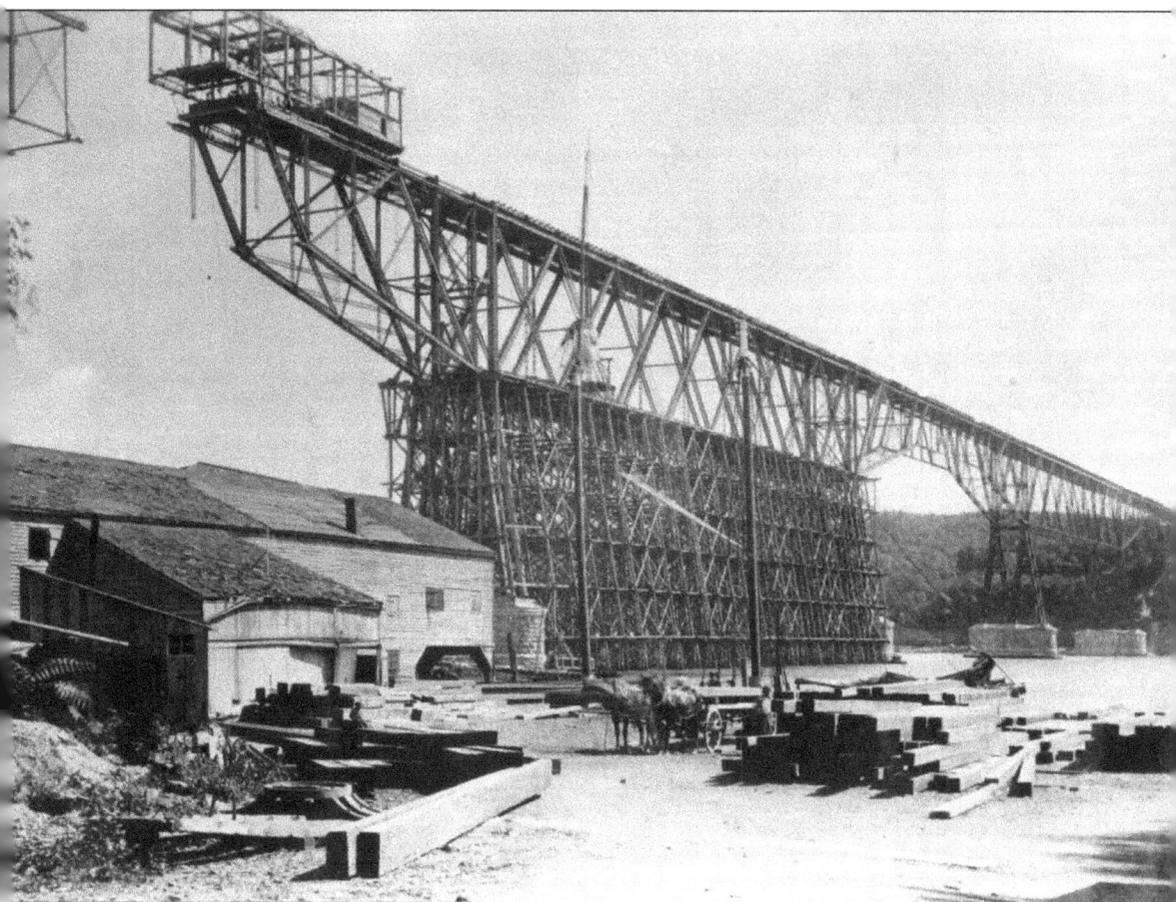

The nearly completed railroad bridge is seen here in August 1888, from a point north of the bridge on the east shore. Horses and a cart standing next to the pile of lumber were used at that time to transport heavy materials. Italian immigrant laborers, according to *Poughkeepsie News-Telegraph*, the newspaper at the time, were not taking jobs away from Americans, as was sometimes claimed. They often did the hard and mean work that no one else could or would do. These laborers received $1 to $1.25 per day.

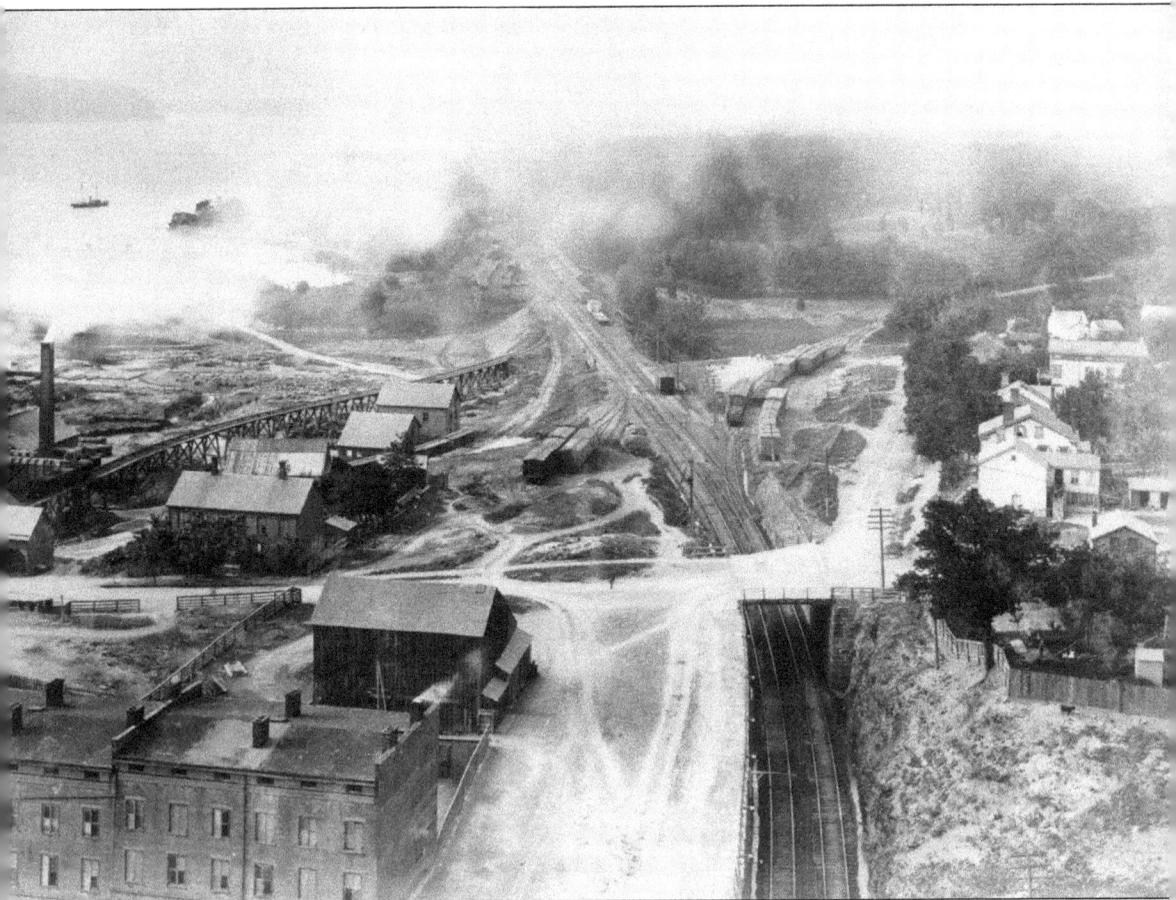

The New York Central tracks to Albany are seen here in the center of the photograph. Taken during the painting of the bridge in the summer of 1889 looking north from the east approach trestle, this photograph shows mist above the river and over the city of Poughkeepsie.

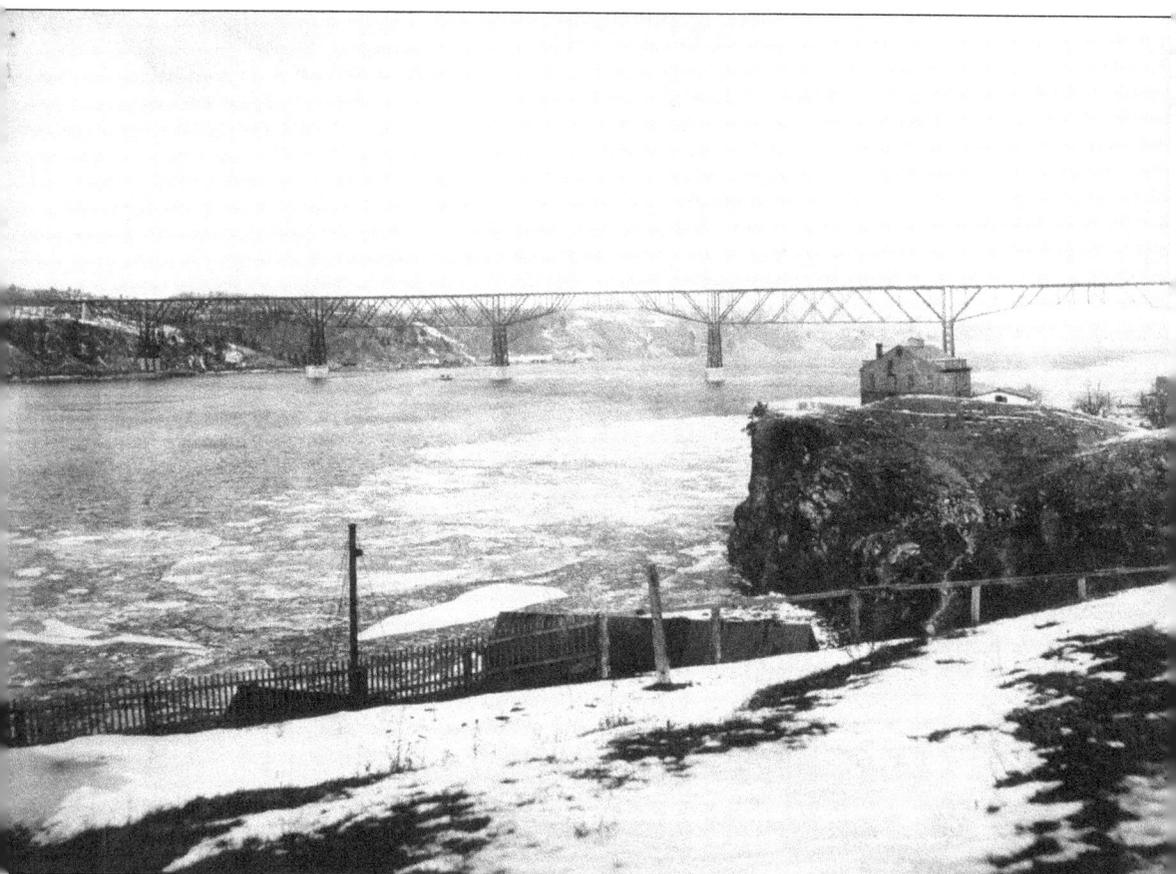

Snow covers the ground in the winter of 1889 after the bridge was opened for traffic. The Poughkeepsie bridge charter specifically required the bridge be open for use by January 1, 1889. A test run was made on December 29, 1888. No shaking was noted as the train rumbled along high over the surface of the river. Official ceremonies were held on December 31, and the bridge was open for use on January 1, 1889.

Looking through the trusses under the bridge deck toward the shoreline, the complicated bridge construction is evident. The hand-driven rivets connecting the many pieces of steel are a testament to the engineering marvel that is the Poughkeepsie Railroad Bridge.

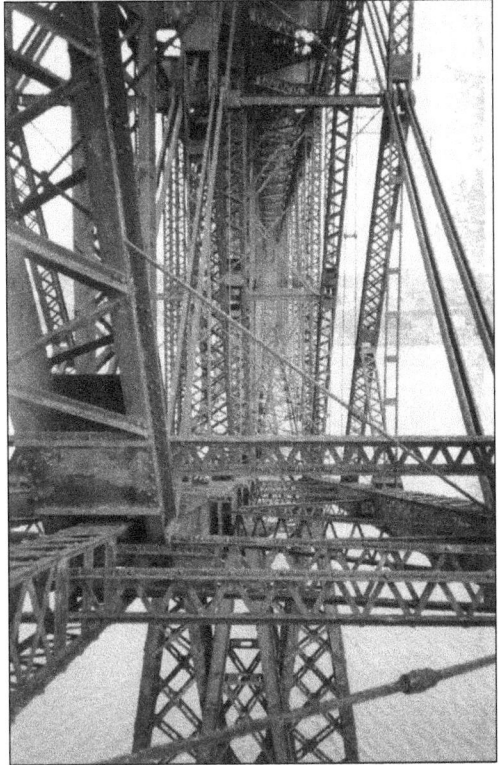

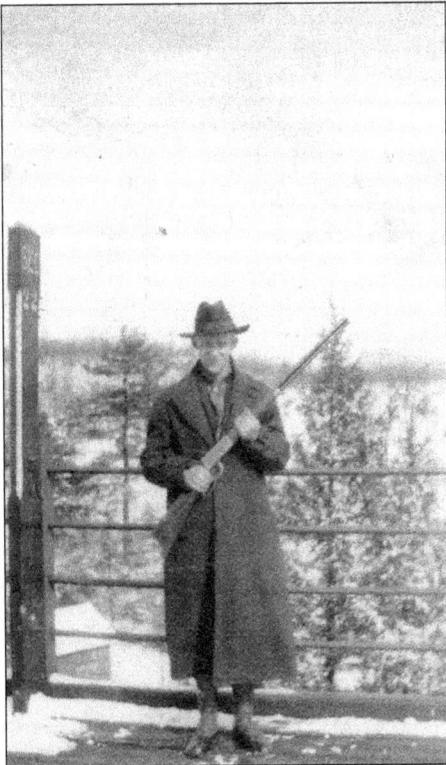

Harry Hornbeck from Ohioville, near New Paltz, volunteered at age 16 to guard the Poughkeepsie bridge during World War I. During both world wars, the Hudson River bridges were heavily guarded from enemy attack or sabotage. Toward the end of World War II, additional members of the New York State Police were assigned to help guard the bridges. Hornbeck enlisted in the army at age 17. During World War II, his wife, Alice Hornbeck, volunteered as a plane spotter. She was also responsible for reporting anyone not participating in the blackouts. (Courtesy Fawn Tantillo.)

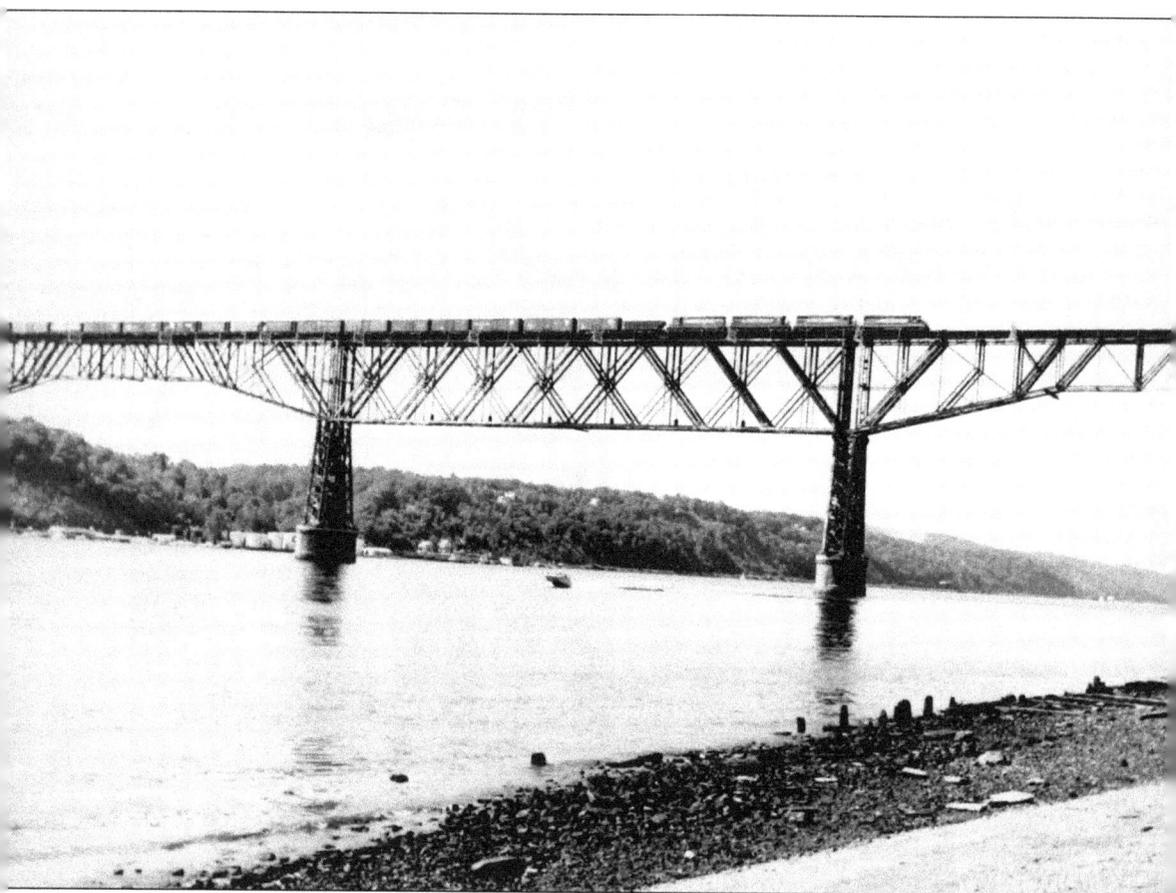

After over 85 years connecting rail service throughout the Northeast, the Poughkeepsie Railroad Bridge ceased to function. The last train, pictured here, rolled across the tracks above the river on May 8, 1974. It was an eastbound Penn Central Railroad train from Maybrook en route to New Haven, Connecticut. The bridge is viewed here from what is now Waryas Park on the Poughkeepsie shore. (Photograph by Heyward Cohen.)

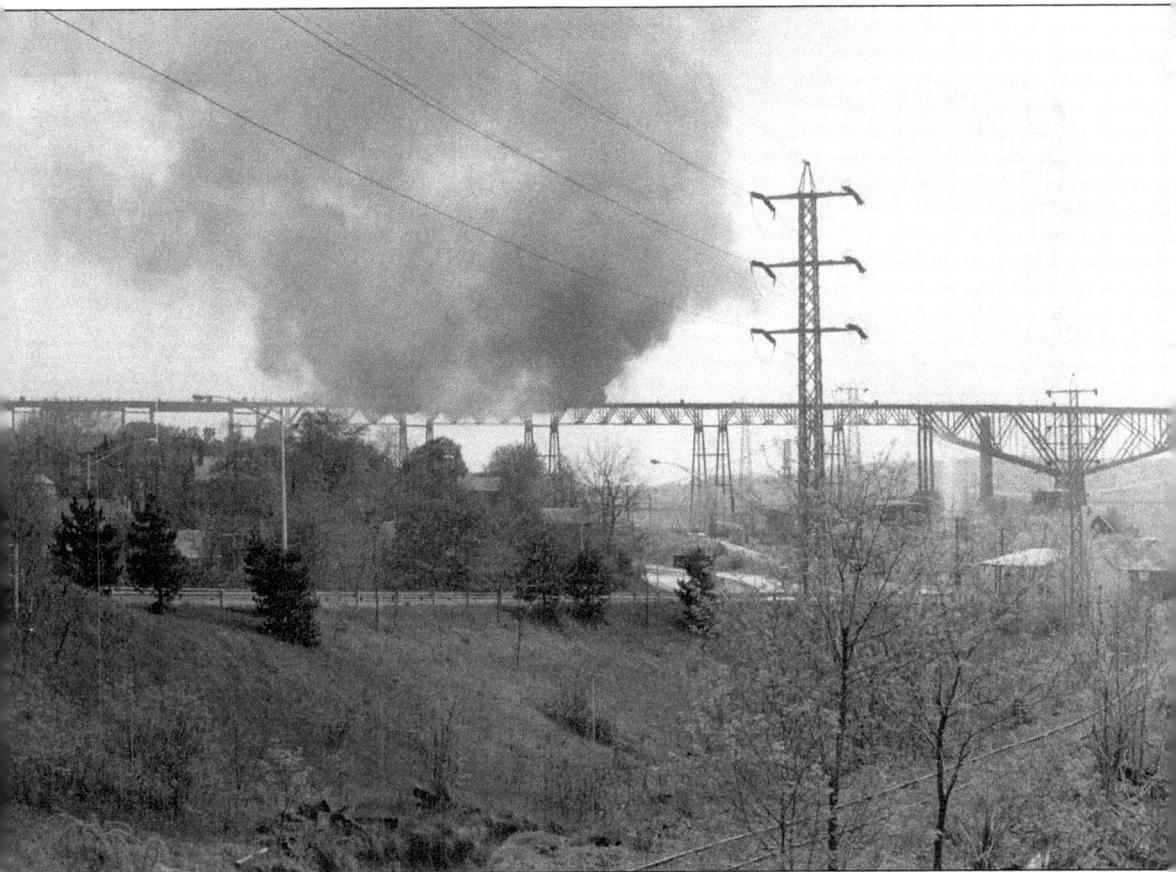

At about 2:45 p.m. on May 8, 1974, hours after the last train crossed the bridge, smoke from the flames can be seen in this photograph taken from the Marist College campus. Maintenance cutbacks by the bankrupt Penn Central Railroad had eliminated the trackwalker who might have been able to check the tracks for sparks in time to put out the fire before it devastated the bridge. (Photograph by Heyward Cohen.)

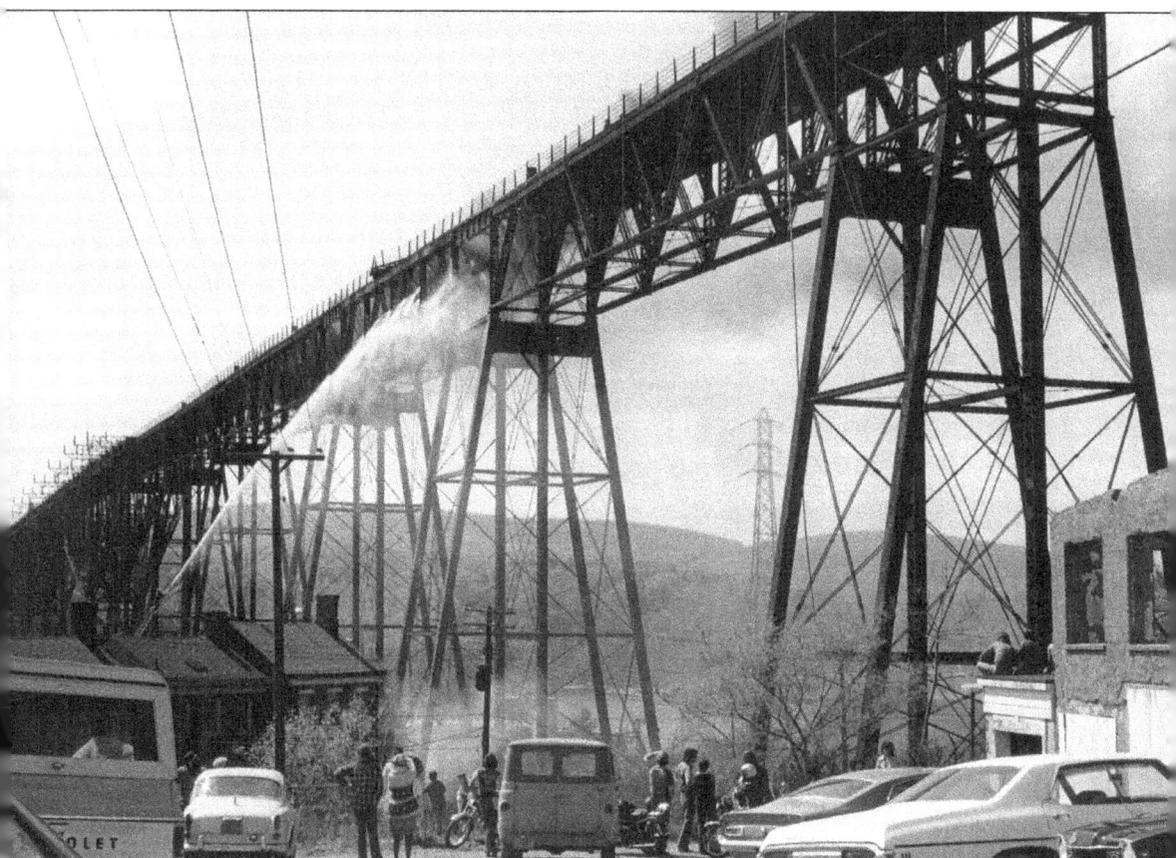

Firefighters lacked the equipment to reach the bridge deck. Heavily creosoted timbers and warm, dry weather conditions fanned the flames. Intense heat damaged and warped the steel track supports. Pieces fell from the bridge as the timbers burned. (Photograph by Heyward Cohen.)

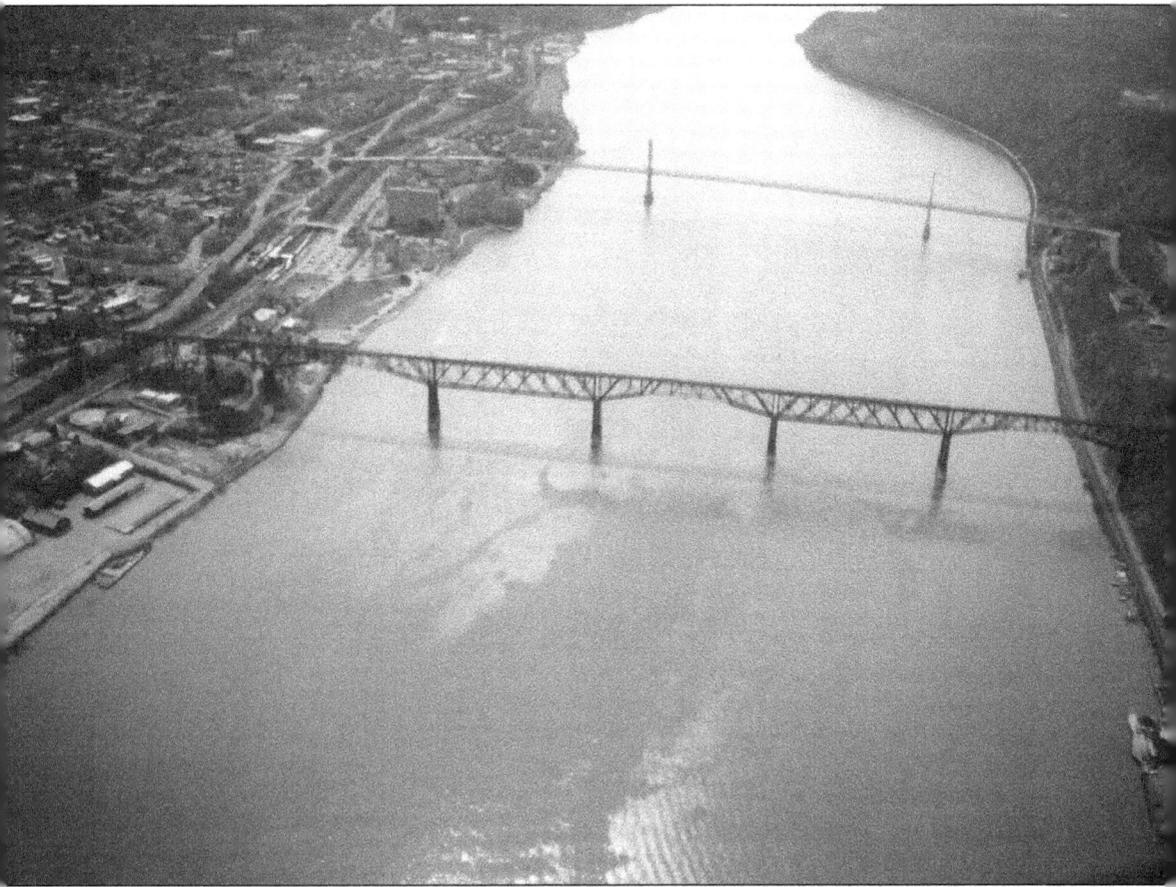

In this aerial view looking southward down the Hudson River, the Poughkeepsie Railroad Bridge is seen in front of the Mid-Hudson bridge. The city of Poughkeepsie is on the left, or east, shore. The town of Highland is on the west shore. The Poughkeepsie Railroad Bridge never lived up to its claim to increase the population of Poughkeepsie to over 50,000 people.

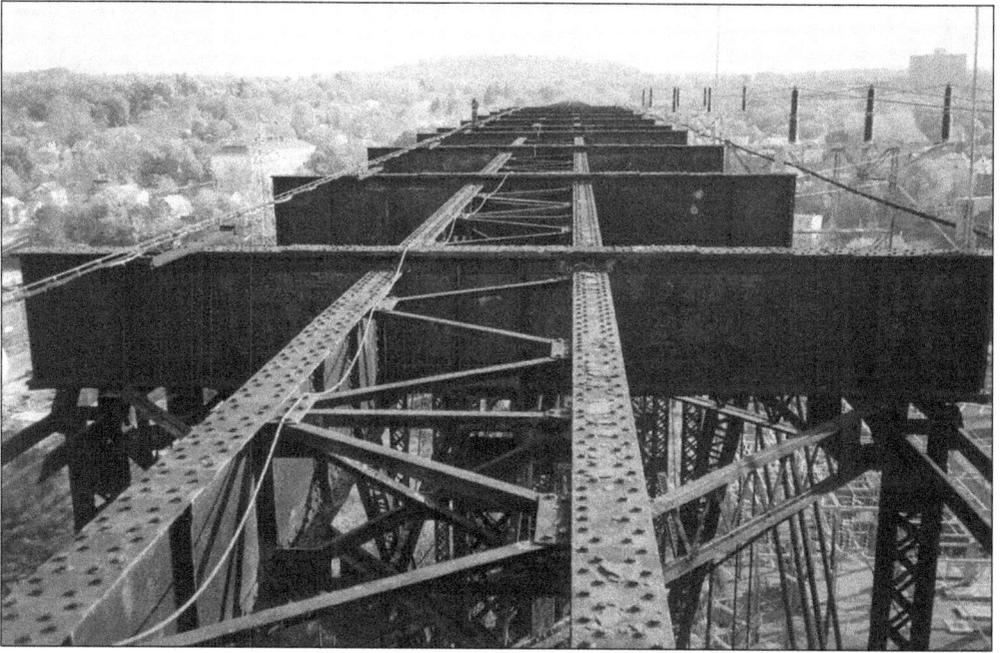

With the damaged debris removed, the steel infrastructure remains sound after almost 120 years. Currently owned by the nonprofit organization Walkway Over the Hudson, the hope is to turn the old railroad bridge into a pedestrian and bicycle trail connecting once again the old train routes in the area.

The rails and original structures can be seen here on the part of the bridge not damaged by the 1974 fire. Unobstructed views up and down the magnificent Hudson River are possible from this location over 200 feet above the water surface. Walkway Over the Hudson has constructed access for tours from the Highland side of the bridge to enlist the community support for maintaining this historic marvel.

Two

BEAR MOUNTAIN BRIDGE

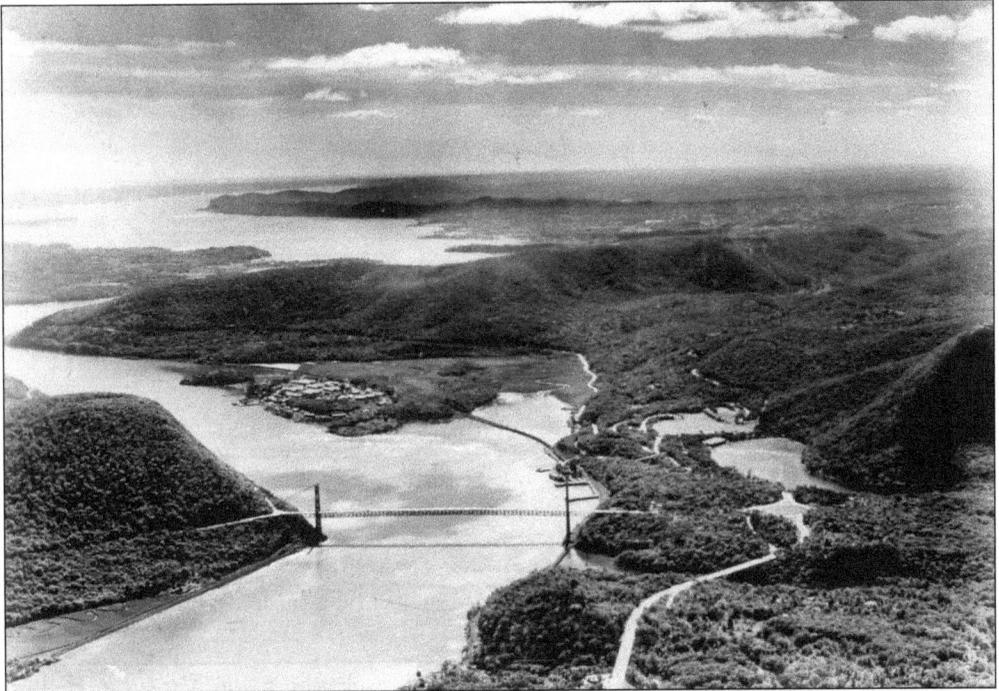

In this aerial view, looking south with the Hudson River curving its way to the Atlantic Ocean, Anthony's Nose is on the east, or left, side of the bridge with Bear Mountain on the west. The Bear Mountain bridge was built to make the newly opened Bear Mountain State Park more accessible to motorists. Prior to the bridge, getting to the park meant waiting hours at ferry landings to cross the river. With small hotels filling quickly to capacity with the crowds, people slept in their cars overnight.

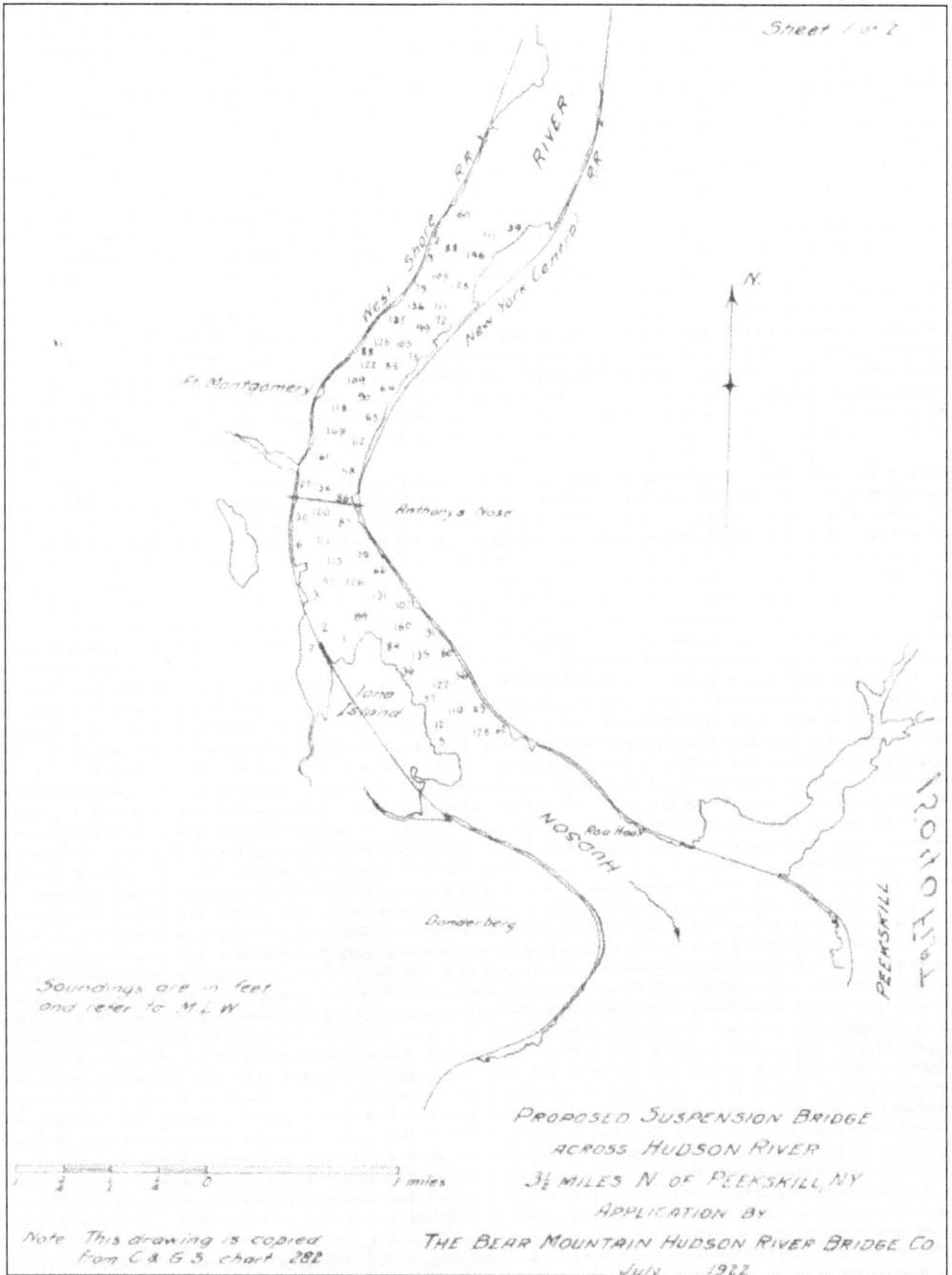

The diagram above, dated July 1922, is of the proposed suspension bridge across the Hudson River three and a half miles north of Peekskill. The proposed bridge would cross the river from Anthony's Nose on the east side of the river to just south of Fort Montgomery on the west. The channel at the narrow entrance to the Highlands had a depth of 130 feet, meeting the War Department's requirement for navigable depth.

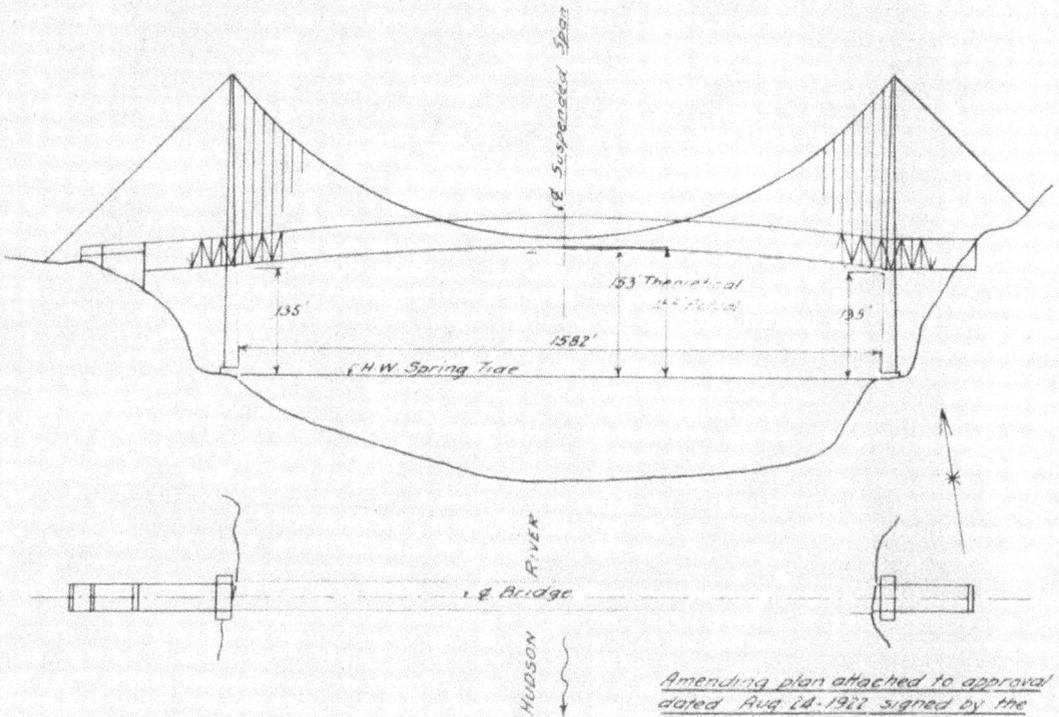

PROPOSED SUSPENSION BRIDGE
ACROSS HUDSON RIVER.
3½ MILES N. OF PEEKSKILL N.Y.
APPLICATION BY
THE BEAR MOUNTAIN HUDSON RIVER BRIDGE Co
Jan. 1923

Horizontal Scale

Vertical Scale

The amending plan that was attached to the approval, dated August 24, 1922, and signed by the assistant secretary of war, shows the design from the side of the proposed suspension bridge facing north up the river. The height of the bridge is based on the high-water mark for the spring tides. Both diagrams were presented as part of the application for construction by the newly formed Bear Mountain Hudson River Bridge Company.

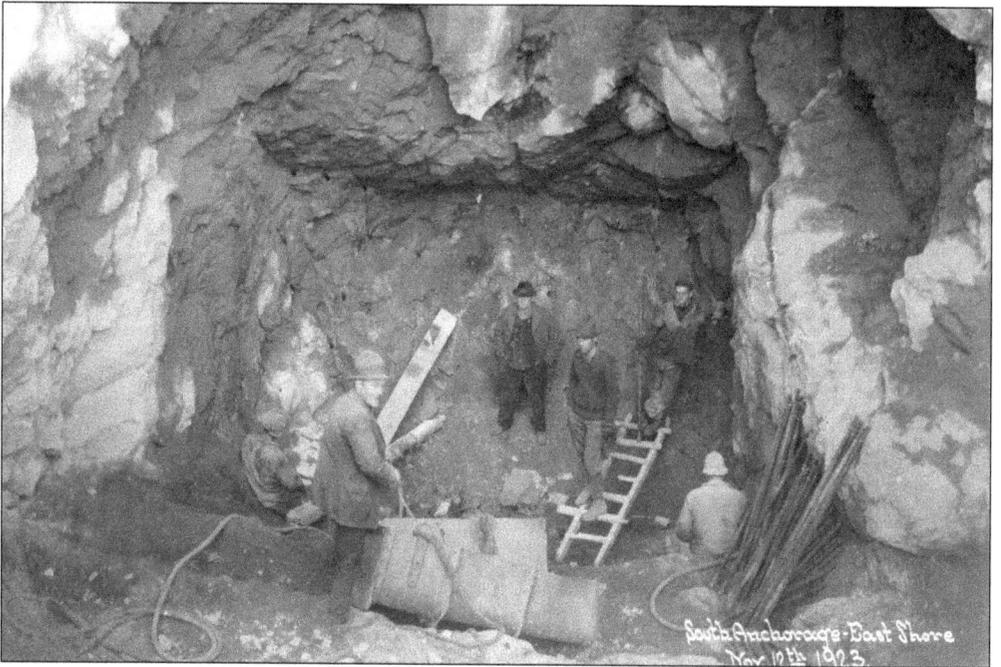

Construction began on the Bear Mountain bridge following the signing of the construction contract on March 24, 1923, with the digging of the anchorage holes in the rock sides of both shorelines. The rock formation provided a natural foundation for the piers and the necessary anchorage for the cables. Anchor pits were dug by hand at a rate of about eight feet per week depending on the rock. The depth of the anchor pit on the east shore was about 90 feet. The photograph above is the east shore of the river. The depth of the anchor pit on the west shore was about 110 feet. The photograph below is the west shore.

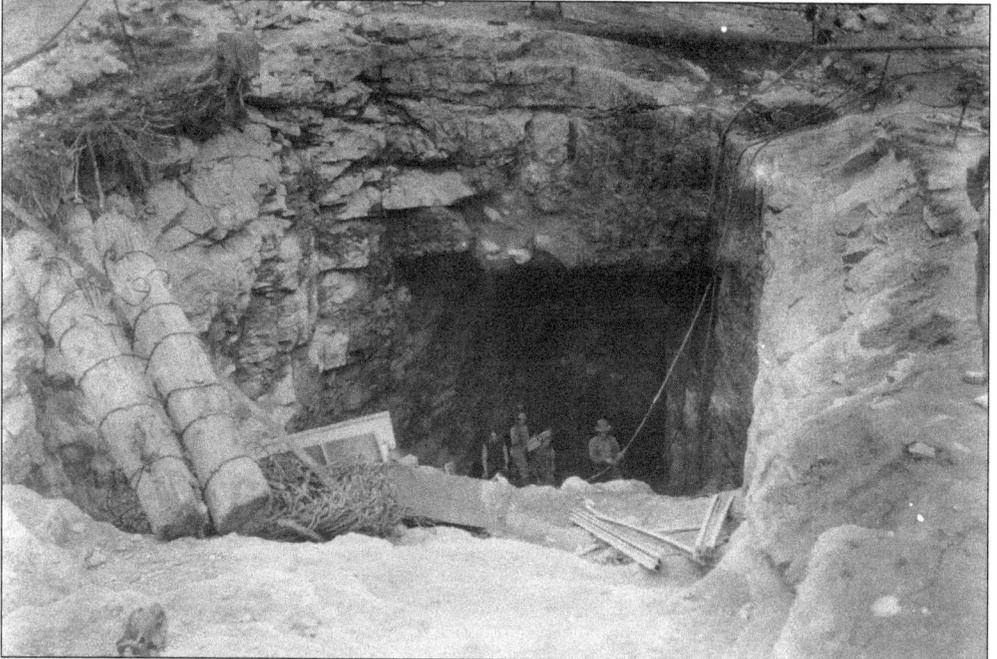

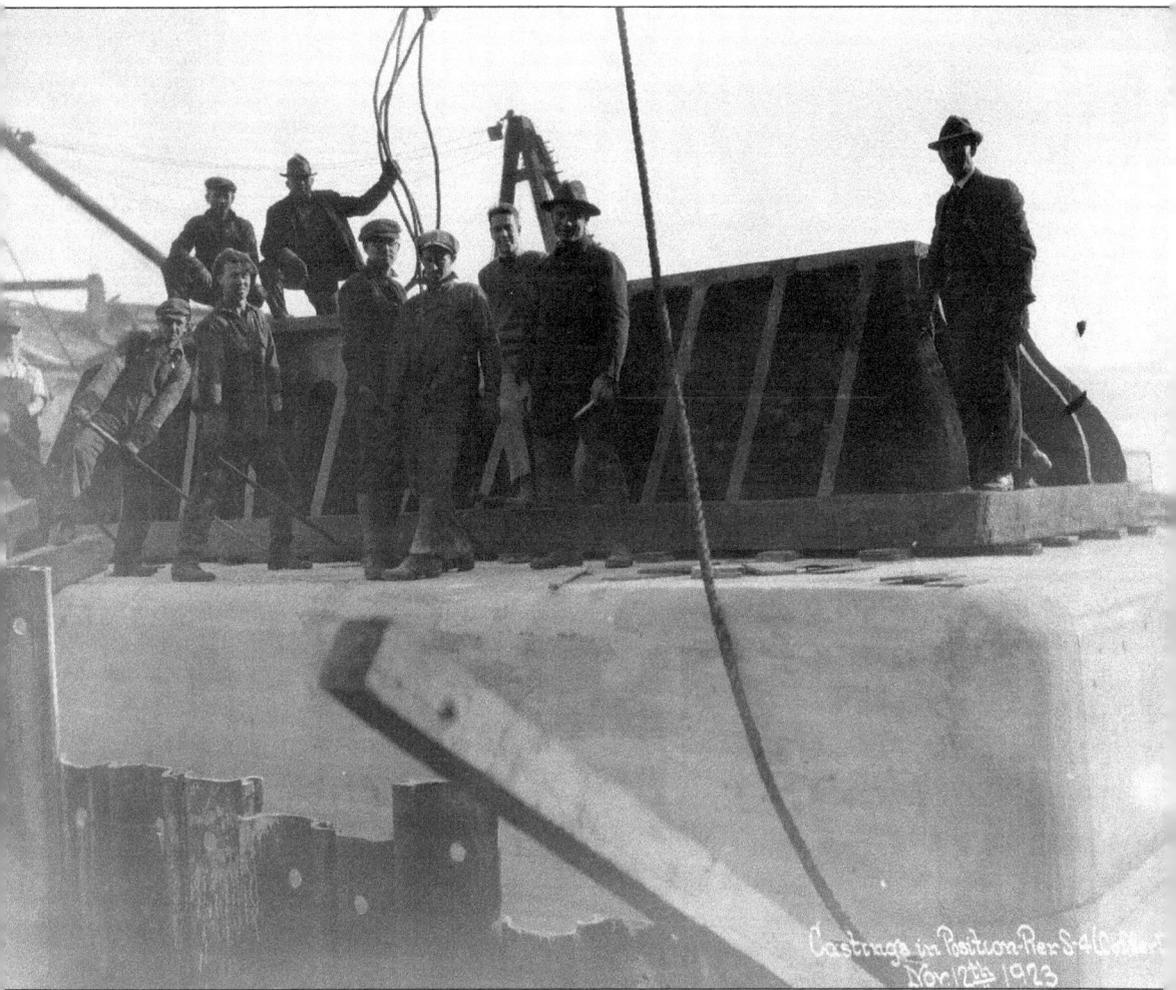

Castings in Position Pier S-4 Cofter
Nov 12th 1923

Workers in this photograph have just put the steel cast base in position on the concrete pier. The cast steel base measured 10 feet by 35 feet by 5 feet high. Each steel base rests on a concrete pier 20 feet by 40 feet founded on the rock near water level. The towers were erected on pairs of these bases, one tower on each side of the river.

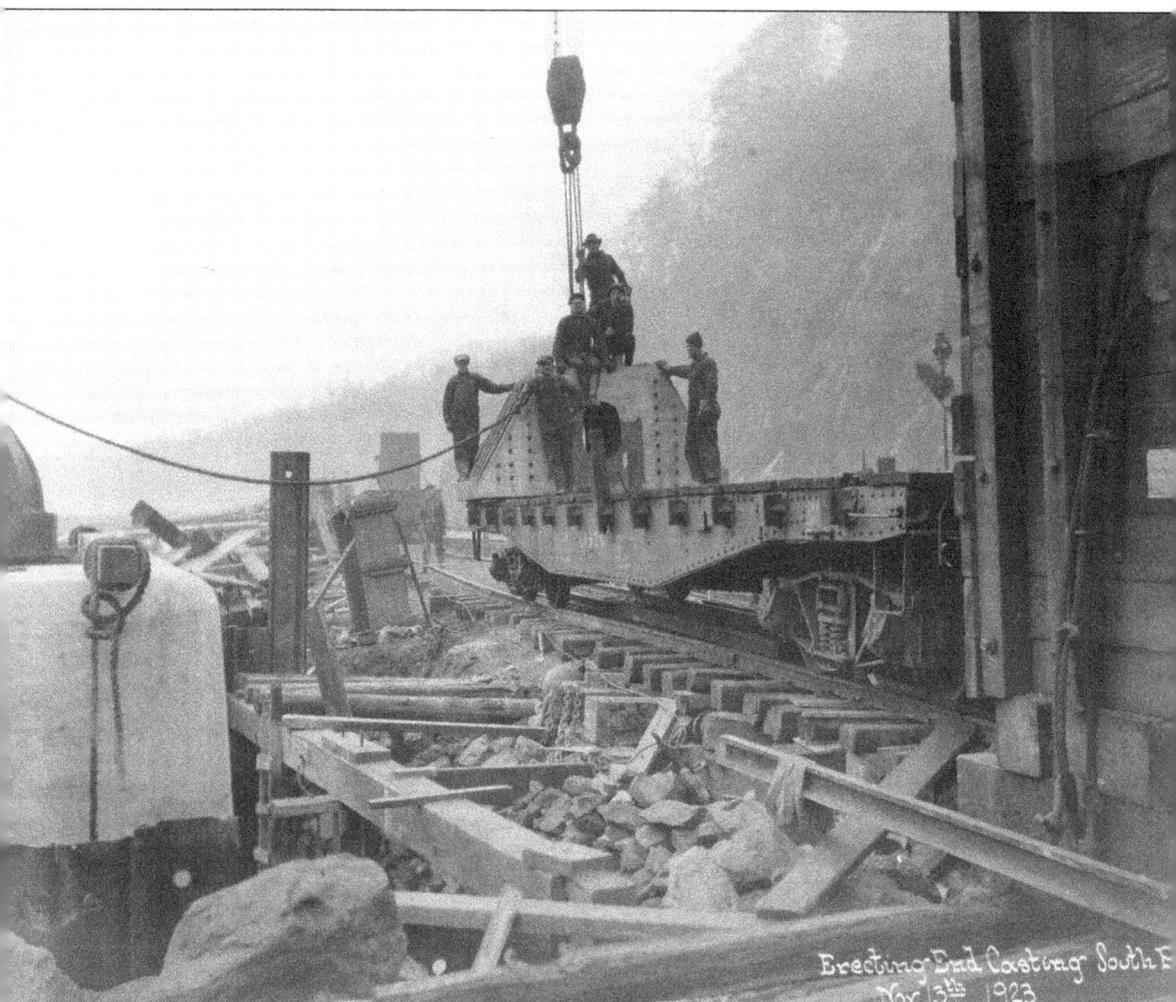

Erecting End Casting South E
Nov 13th 1923

Workers on the west shore of the river are using a makeshift railcar to transport matching cast steel bases, or footings, for the south pier on the opposite side of the river. The footings distribute the load evenly on the concrete piers.

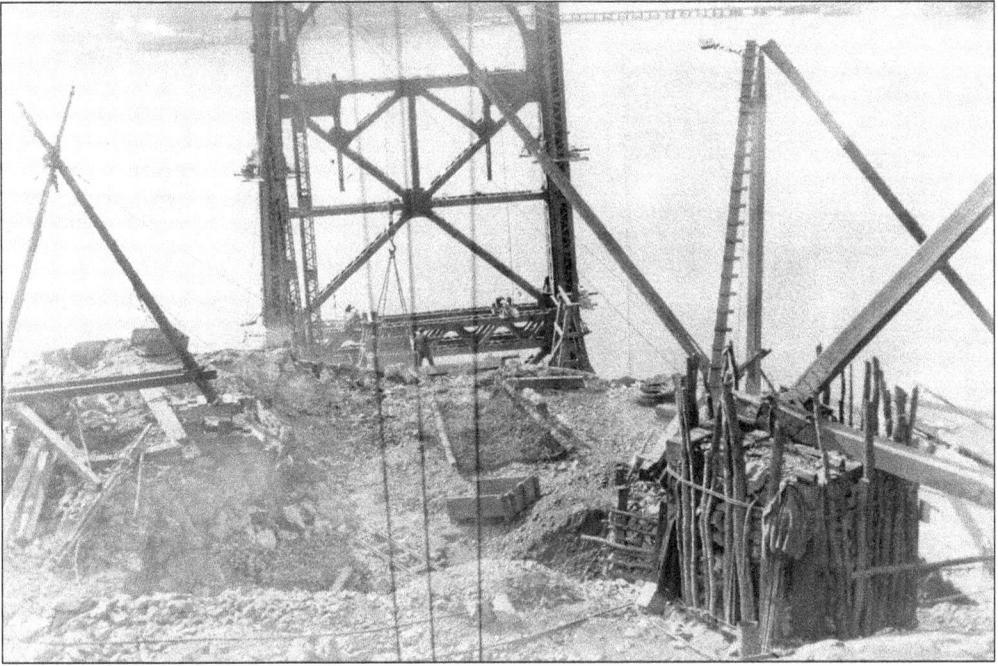

Erection of the east tower began on October 22, 1923. The arched section of the tower, as seen in the photograph above, will rise above the roadbed giving the look of a tunnel to soften the image created by the steel. Large cranes or creeper derricks were used to hoist pieces of the bridge into place. Men are seen climbing ladders built into the pieces of the bridge as the tower rises up from the river. Barges were used to carry materials to the construction site. The creeper derrick moved up the tower as the structure increased in height. Both towers would be completed by the middle of April 1924.

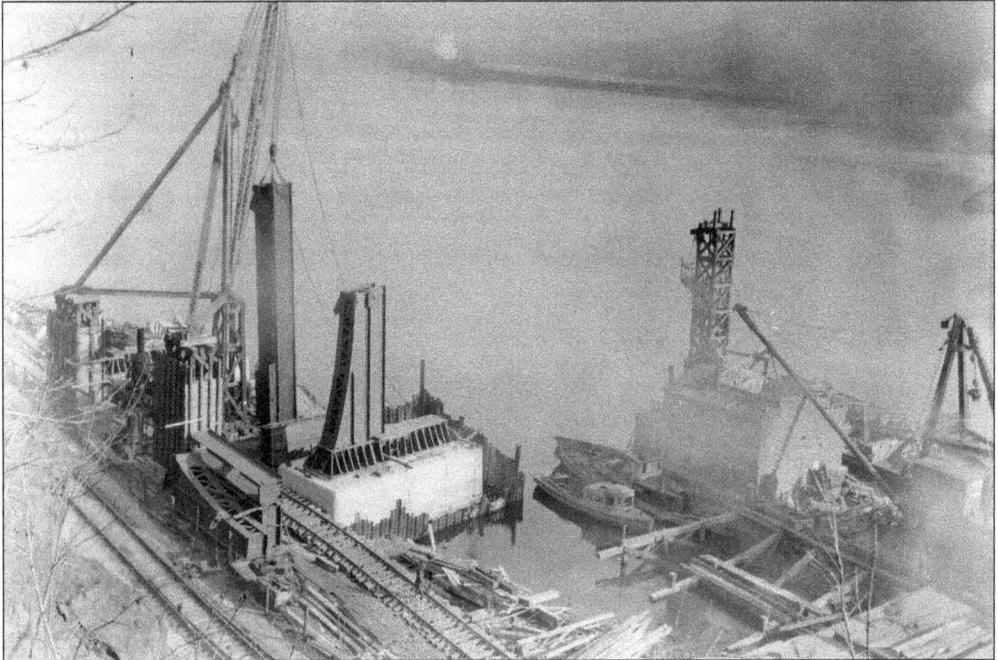

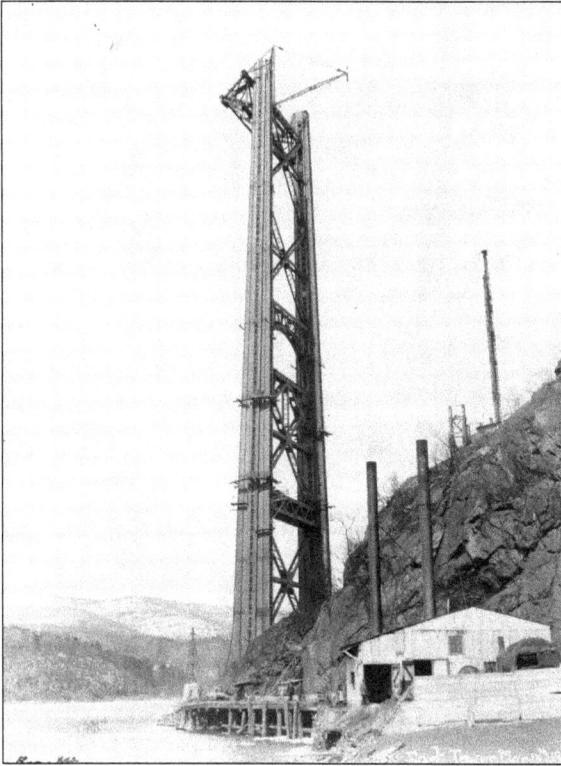

The completed towers rose 351 feet above the river. Steel towers were used rather than masonry due to time constraints on the construction. A bill introduced in the state legislature in February 1922 authorized the creation of the corporation to build a bridge across the Hudson River. Under the terms of the special act, the Bear Mountain Hudson River Bridge Company would have only three years to build the bridge and the highway approaches. The steel structure could be completed in less time than concrete. Many people were opposed to the proposed structure, complaining that the steel structure would be out of place in the beauty of the Highlands. The *New York Times* editorial on July 20, 1923, accused the Harriman family and the other investors of caring more about keeping costs down and building cheaply than preserving the beauty of the area.

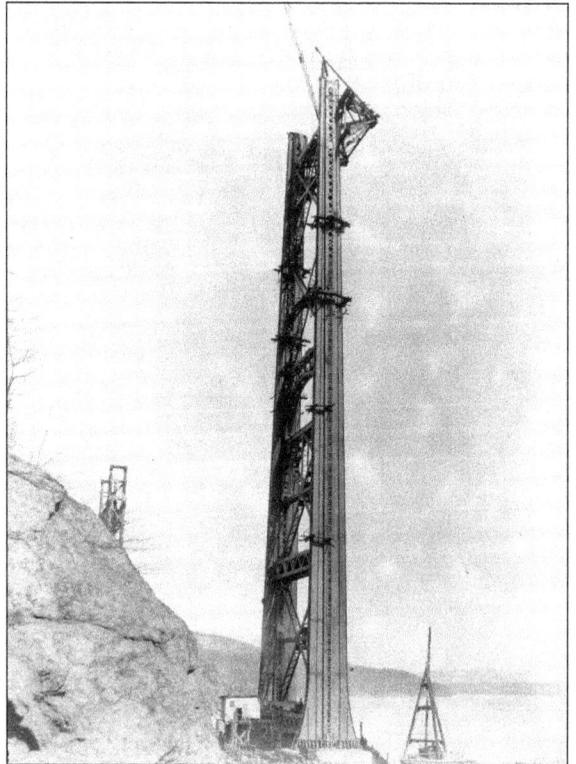

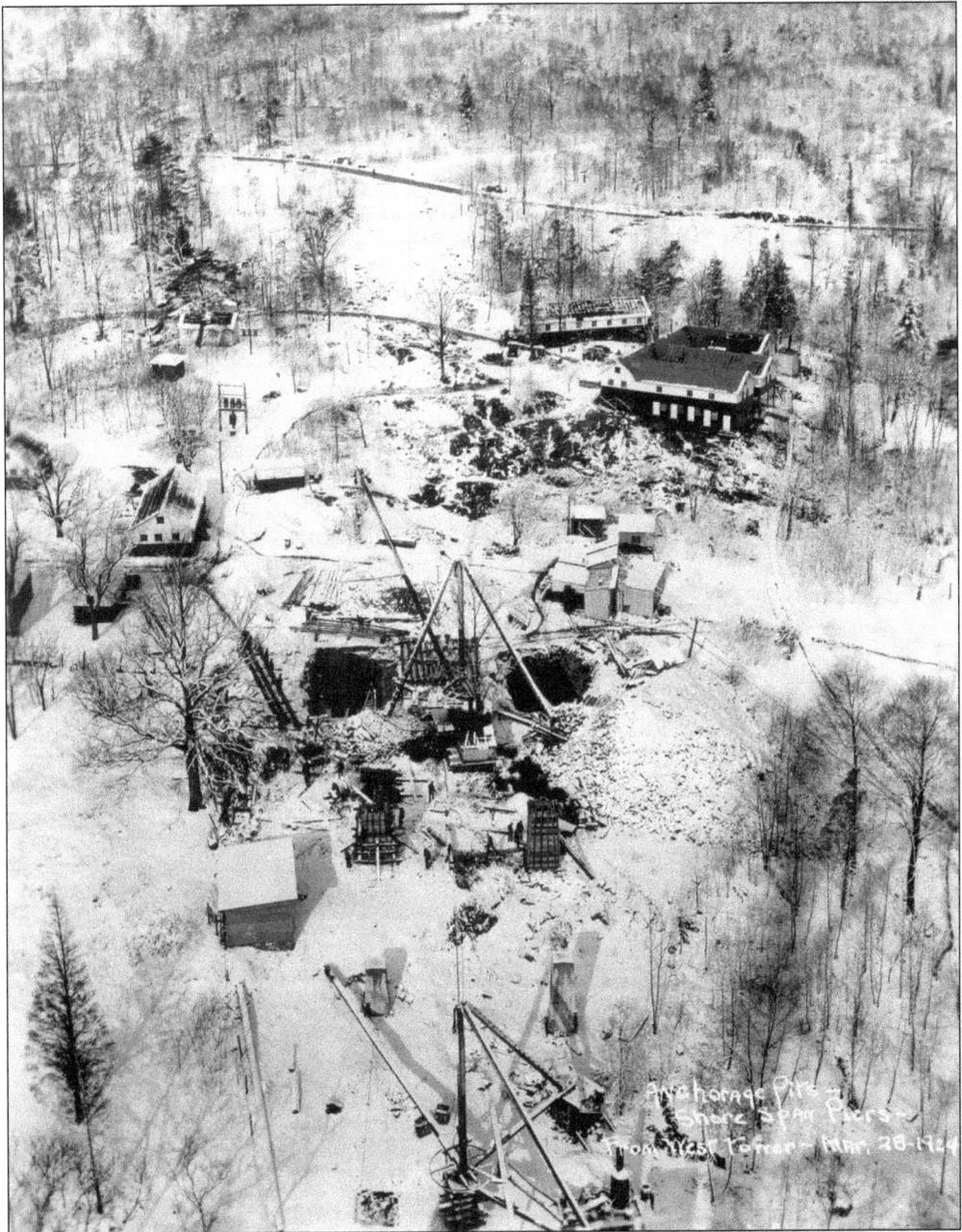

The west shore anchorage pits are seen in the center of the photograph as taken from the top of the completed west tower. Snow covers the ground, but the work continued. Three sets of concrete piers can be seen in pairs from the bottom of the photograph to the anchorage pits. The larger building to the right and to the rear of the anchorage pits is the workmen's bunkhouse with the foremen's quarters close by. The field office is the building at the left of center.

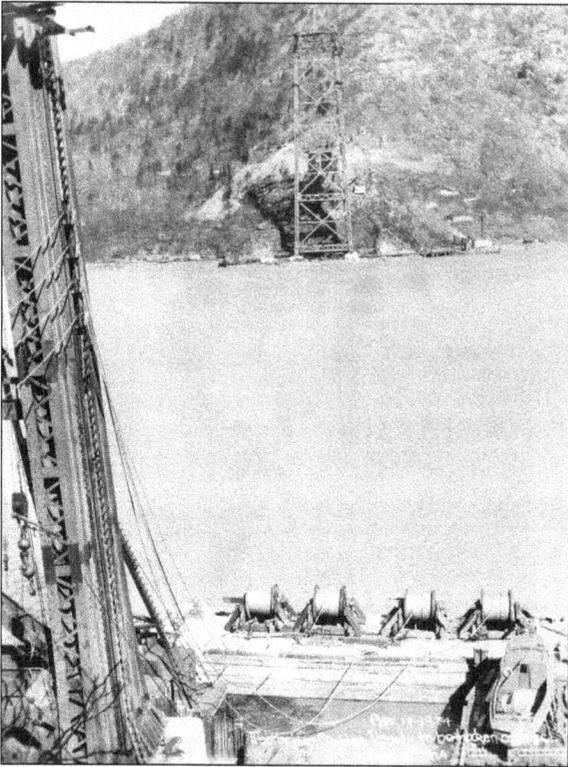

With the towers completed, the barge is lined up to pull the footbridge ropes from the west shore to the east shore. Ropes will be strung from the tower on the west shore to the tower on the east shore. Tugboats on either end of the barge slowly move the barge across the river as the rolls of ropes unwind. These ropes will form the connection between the two towers and will support the workmen's platform.

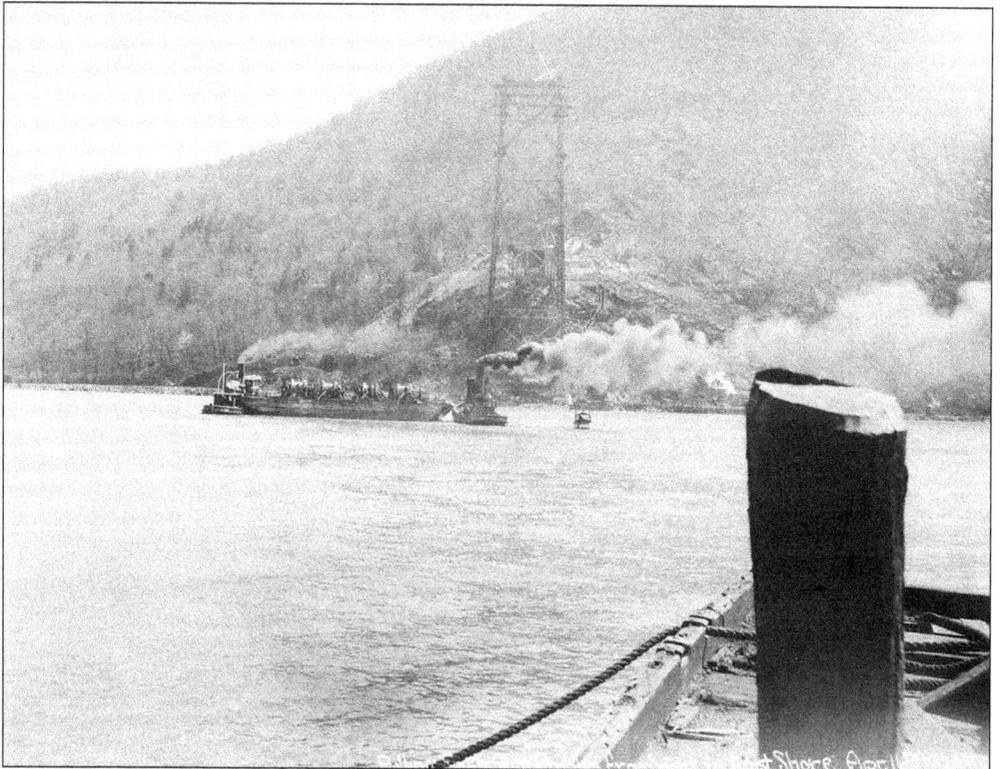

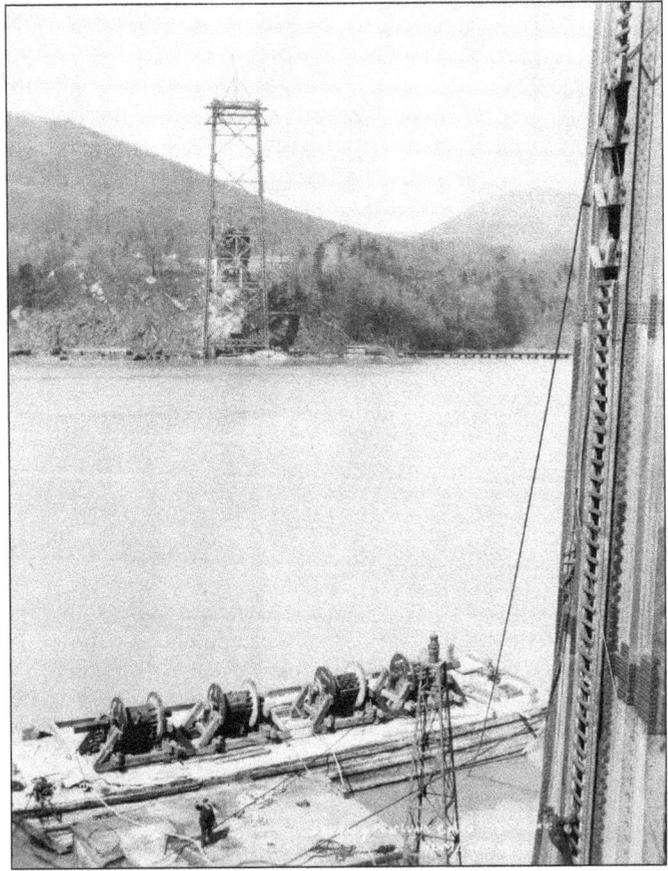

Landing the footbridge ropes on the east shoreline, the barge waits while the ropes are connected to the tower. The man on the platform directs the installation. The ropes swung into final position on May 2, 1924. The photograph below shows the ropes erected in proper deflection awaiting the construction of the timber platform. The ropes are two-and-one-quarter-inch galvanized suspender ropes, which will be cut later into multiple lengths and used as suspenders. The specific length of the ropes is necessary to avoid any difficulties later as the final cables are spun.

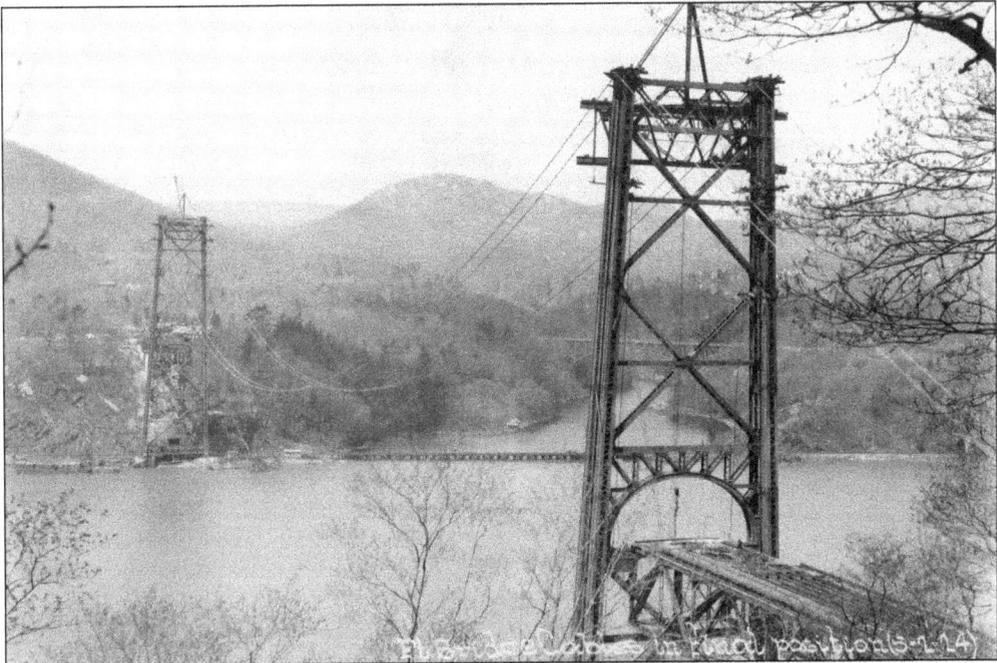

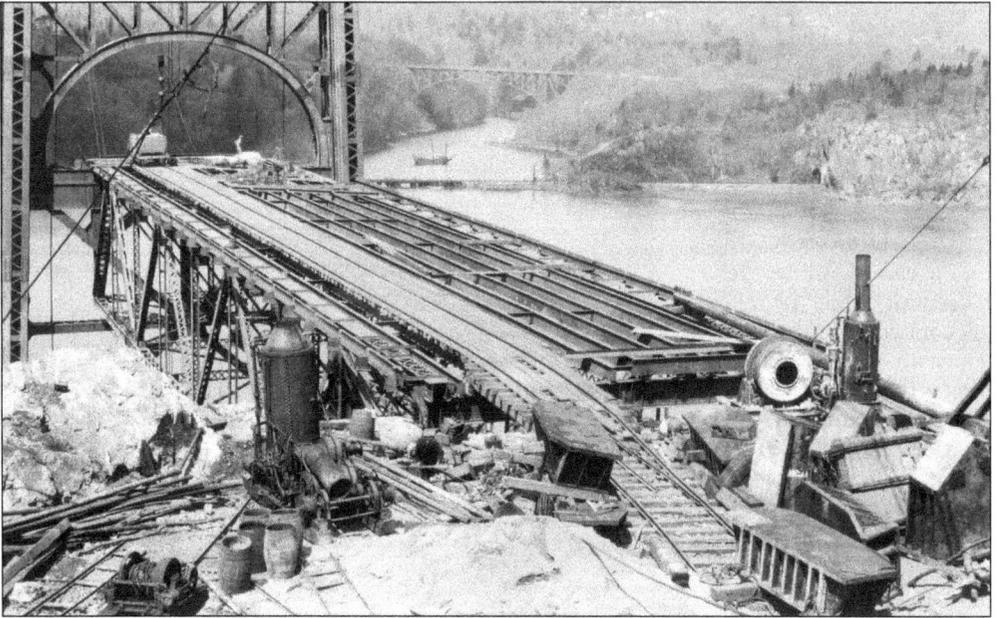

Construction continues on the eastern approach of the bridge. More makeshift rail lines are used to move building materials. Below the construction of the bridge other rail lines on both shores of the river must continue to service passenger and freight rail lines. The New York Central runs through a tunnel under the east side of the bridge, and the freight lines run along the west shore.

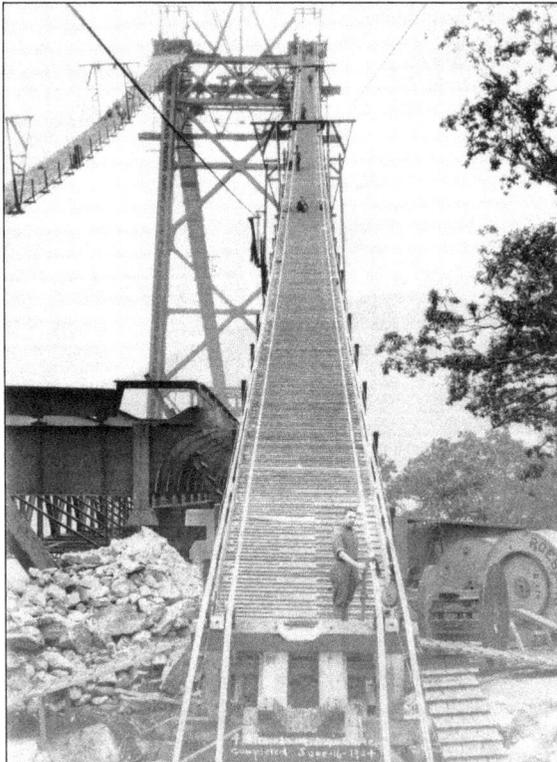

Workers utilize the walkway created by the footbridge ropes to continue the bridge construction. The walks are framed in sections and hoisted to the top of the towers. From that point they are slid down the ropes into position. The work requires great skill and daring on the part of the workers. Roebling cable spools can be seen alongside the partially completed bridge.

Rolls of Roebling cable, each containing approximately 85,000 feet of continuous length, were lined up as the west anchorage motor shed in the north pier begins weaving the main cables in the photograph above. Each main cable was constructed from 7,452 individual galvanized wires. The total length of single wire in the two cables is 7,377 miles. Four stands are spun at one time. The workers in the photograph at right are squeezing and binding the cable in place near the east tower.

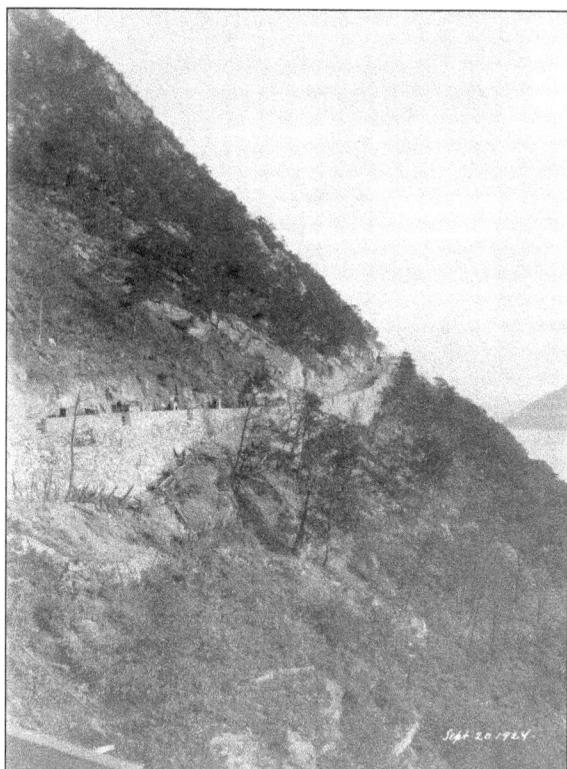

As the bridge nears completion so does the work on the east highway approach that follows around the south face of Anthony's Nose through rugged terrain high above the river. The highway was accessible only from the east end and was built directly above the New York Central Railroad. All construction was restricted so as to maintain the uninterrupted operation of the railroad. Extensive blasting and fill was necessary while building the roadway into the side of the granite slopes as it winds down to the eastern approach to the bridge.

The highway built for the Bear Mountain Hudson River Bridge Company was operated as a toll road. The toll house, pictured here, was located in the town of Cortlandt. Tolls were collected for road use whether or not the bridge was crossed. It was a dangerous road to travel, and the tolls purposely limited use of the road since the bridge company would have been liable for any accidents.

While the approach road is being cut through the mountainside, workers continue to construct the superstructure of the bridge. Steel girders forming the bottom section of the main structure are lifted from barges in the river to continue the work on the main span.

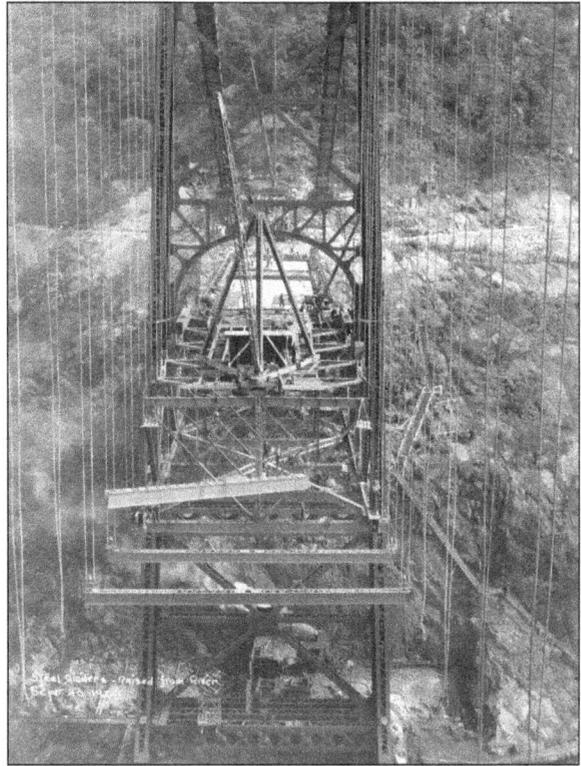

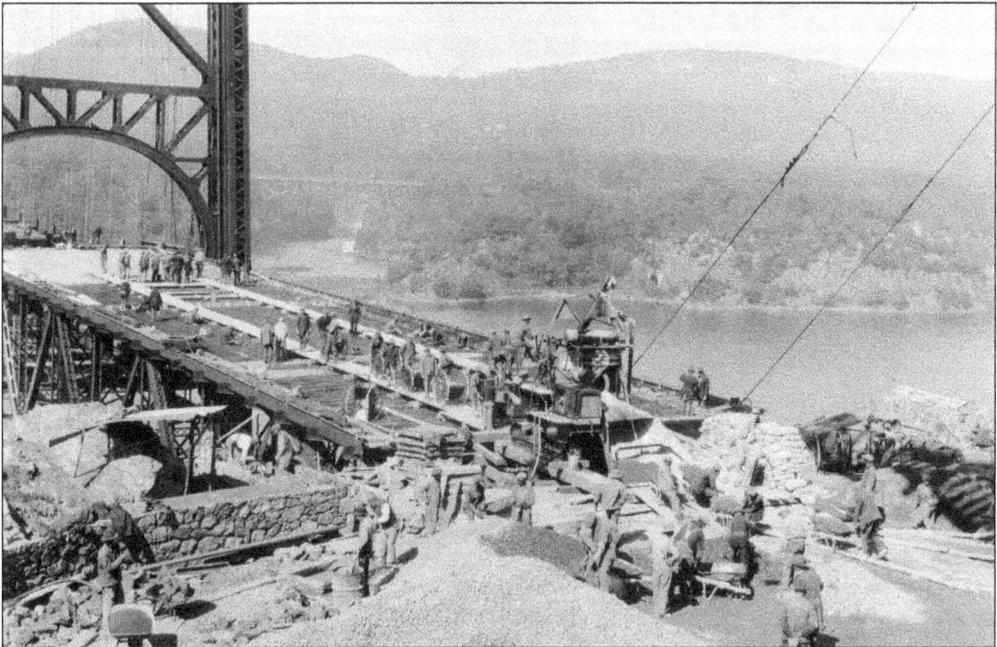

Concreting of the road surface began on the eastern approach as work continues on the center span. Most work is done by hand as supervisors in jackets and ties, seen on the right side of the bridge, direct the activity. The suspenders are all in place. The truss system to support the deck has advanced about 200 feet from each tower.

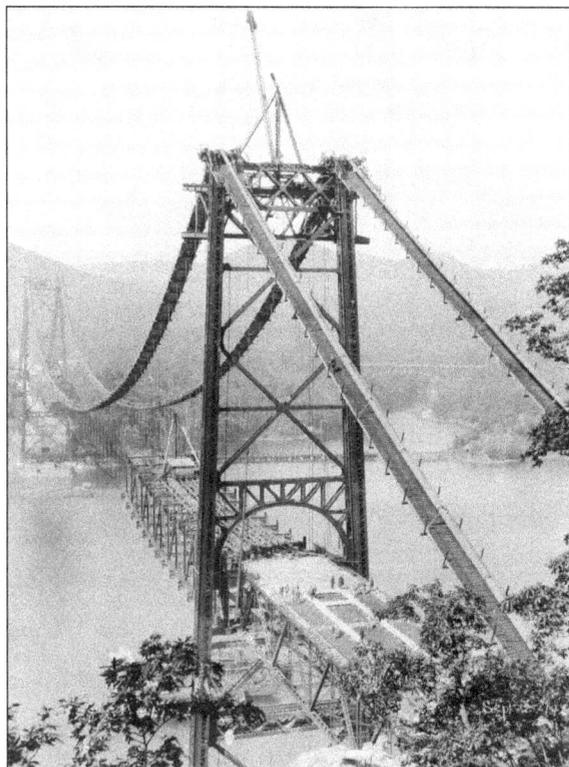

Erection of stiffening trusses started in September 1924, as the lower chords, web members, bracing, and most of the floor system were placed by the equipment on the middle of the bridge seen here called a traveler. Workers advanced from the towers to the center of the span, lifting steel from barges towed into position under the bridge. Individual trusses are lifted into place by use of gasoline-driven derricks. The superstructure is erected simultaneously from both sides to equalize the load on the cable and the resulting reaction from the cables.

The cable strands are attached to the eyebar chains, which are securely anchored in solid rock. The temporary throat clamp where the group splits into separate strands ensures the individual strands diverge to their respective eyebar chains. With the main cable attached in the anchorage pit, concreting began. The concrete was mixed and poured into the pit above the attached cables. The rock chamber will be filled with concrete to within a few feet of the cable connections to provide a watertight protection for the steel members of the anchorage chain.

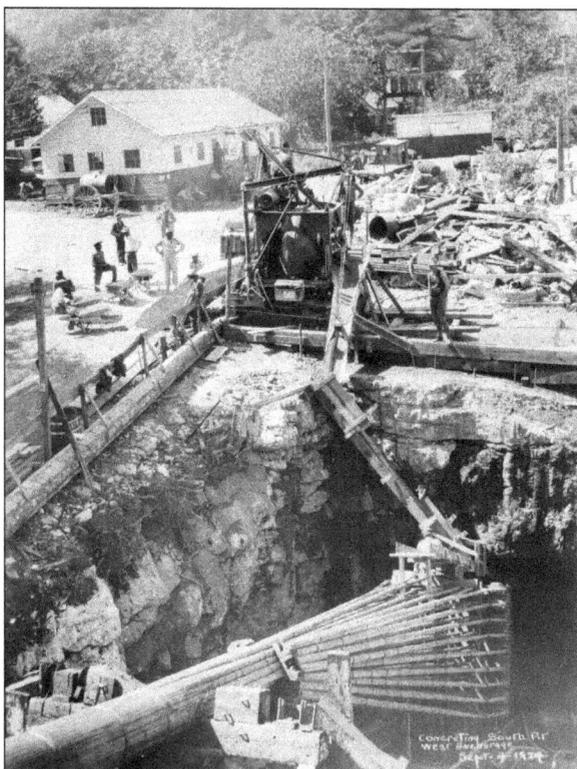

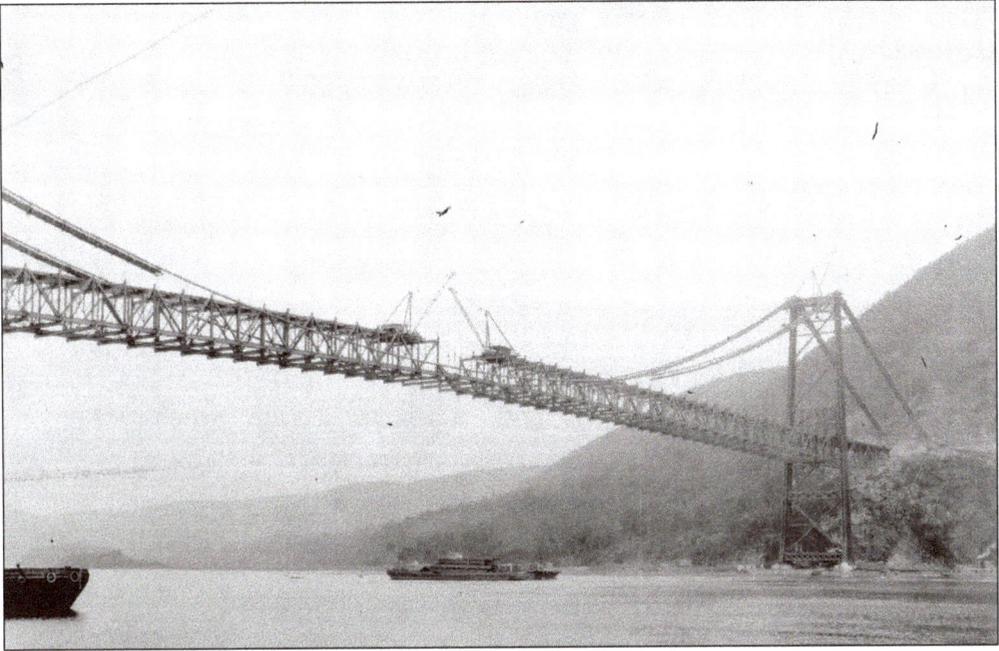

Work continued on the bridge with the connecting of the bottom chord at the center of the span. The barge remains in place to supply the remaining steel trusses. Section after section has been placed until the superstructure is nearing completion. The placing of the two lower chords creates a solid steel connection from shore to shore.

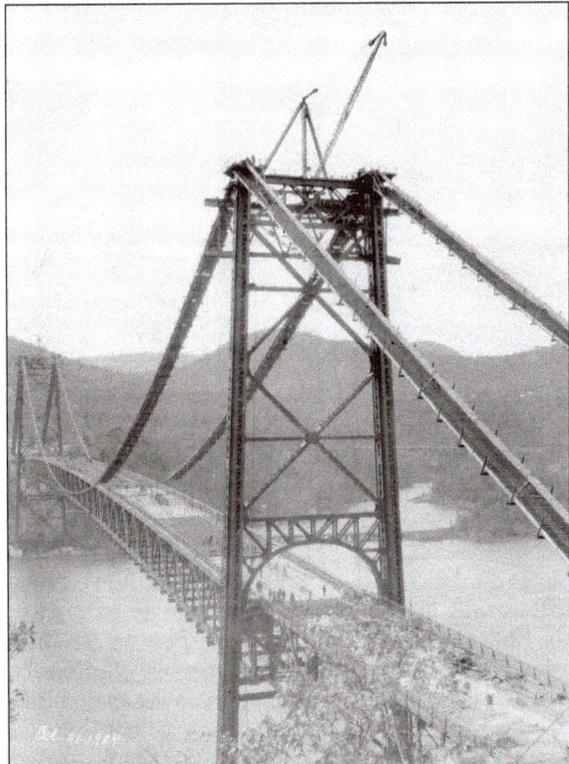

The bridge is close to completion as the concrete floor is placed. The completed structure will consist of a 38-foot-wide roadway with two 5-foot-wide sidewalks. As a deck-type superstructure, the 30-foot-deep trusses were placed below the roadway to allow a clear view of the river from the floor of the completed bridge. The main cables have been completed above the foot walk. Finishing touches are needed to prepare the bridge for its November 1924 opening.

BEAR MT. HUDSON RIVER BRIDGE

Mr. David: for your Information + files.

H. C. BAIRD, Cons. Engr.
H. D. LEOPOLD, Res. Engr.

FORT MONTGOMERY, N. Y.

H.D.L.

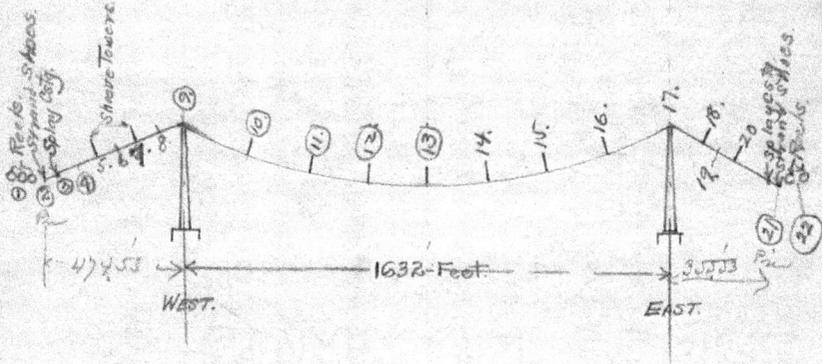

|← 47'53" →| ←————— 1632 Feet ————— →| 30'53" |

WEST. EAST.

Complement of Men.

Location	So Cable.	No Cable.
At N° (1)	4.	3.
(2)	4.	4.
(3)	1.	1.
(4)	1.	1.
(5)	3.	2.
(6)	2.	2.
(7)	2.	2.
(8)	1.	1
(9)	9.	8.
(10)	2.	2.
(11)	2.	2.
(12)	2.	2.
(13)	6.	5.
(14)	2.	2.
(15)	2.	2.
(16)	2.	2.
(17)	9.	8.
(18)	2.	2.
(19)	2.	2.
(20)	2.	2.
(21)	4.	4.
(22)	5.	4.
Waterboys	3.	3.
Foreman	2.	2.
Watchmen	1	1.
Splicing + heating Wires	2.	2.
Carpenters	1.	
Derrick Gang	5	5.
Total	82.	77.

Grand Total. 159 Men.
Based on 2600 feet
from Anchor to Anchor.

H.D. Leopold,

7/26/24.

1900 Tons

Began Spinning June 7 - 24
Last wires - Aug 22 - "

Notes on the construction were made by H. D. Leopold, engineer. The information contained specifies the number of workers needed for each part of the construction of the main cables on the bridge. The construction of the Bear Mountain Hudson River Bridge was an architectural marvel. It paved the way for a golden age of bridge building in the New York area and beyond. The wire that went into the main cables of the Bear Mountain bridge was provided by John Roebling and Sons Company, which at that time was presided over by Washington Roebling, who completed the construction of the Brooklyn Bridge.

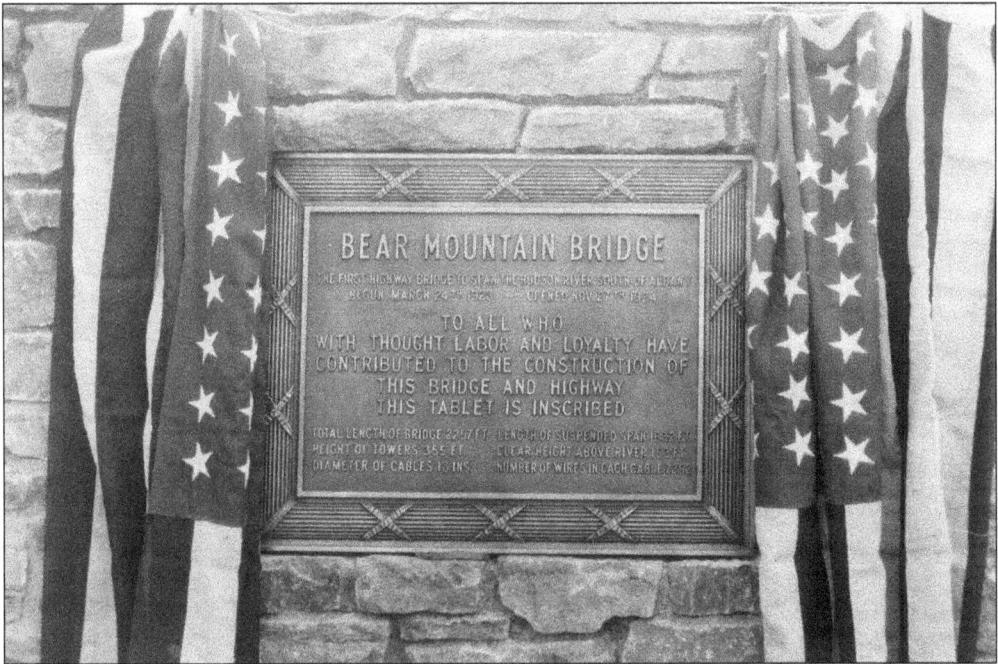

The Bear Mountain bridge was officially opened to traffic on Thanksgiving Day, November 27, 1924. The formal ceremony took place the day before. Observers traveled from New York City by train to the Peekskill Railroad train station. They were then transported by motorcade to the east approach to the bridge where the West Point Band played "The Star-Spangled Banner." A ribbon was cut, and the motorcade proceeded across the bridge where the dignitaries sat. E. Roland Harriman, president of the Bear Mountain Hudson River Bridge Company, introduced his mother, Mary Harriman, donator of the land that formed the Palisades and Bear Mountain Park who was to pull the cord that drew apart two American flags to unveil the large bronze tablet dedicated to all who contributed to the building of the bridge.

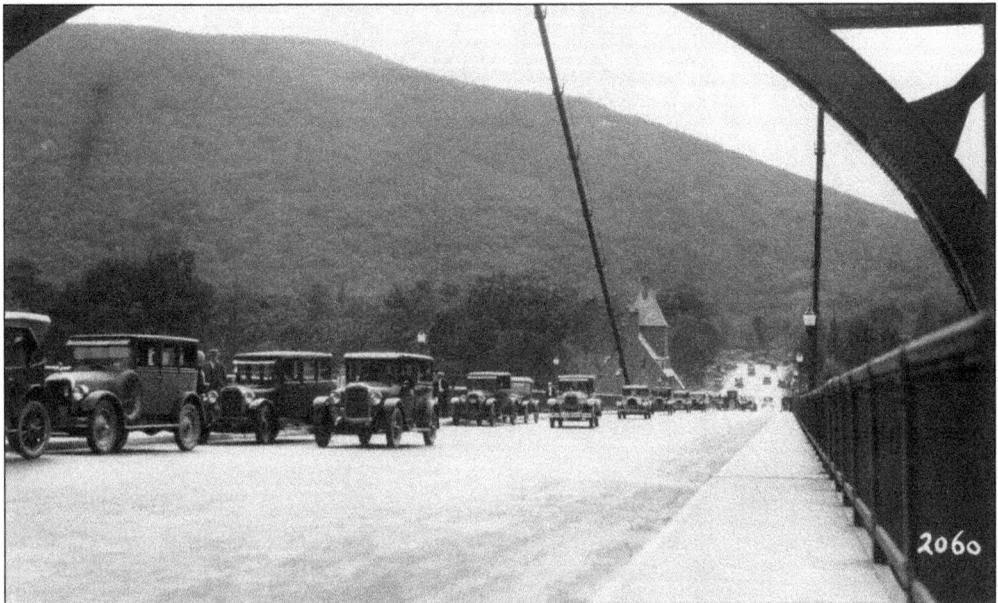

Automobiles traveling across the new Bear Mountain bridge in 1924 with a family of four inside paid $1.15 in tolls to cross the bridge each way. The toll for the car and driver was 80¢, each additional adult was 15¢, and each child was 10¢. Walking a bicycle across the bridge cost 20¢ each way. The cost was so prohibitive, some families were known to hide children in the automobile's trunk to save the toll charge for each child. At that time, the Ford they were driving could cost as little as $500.

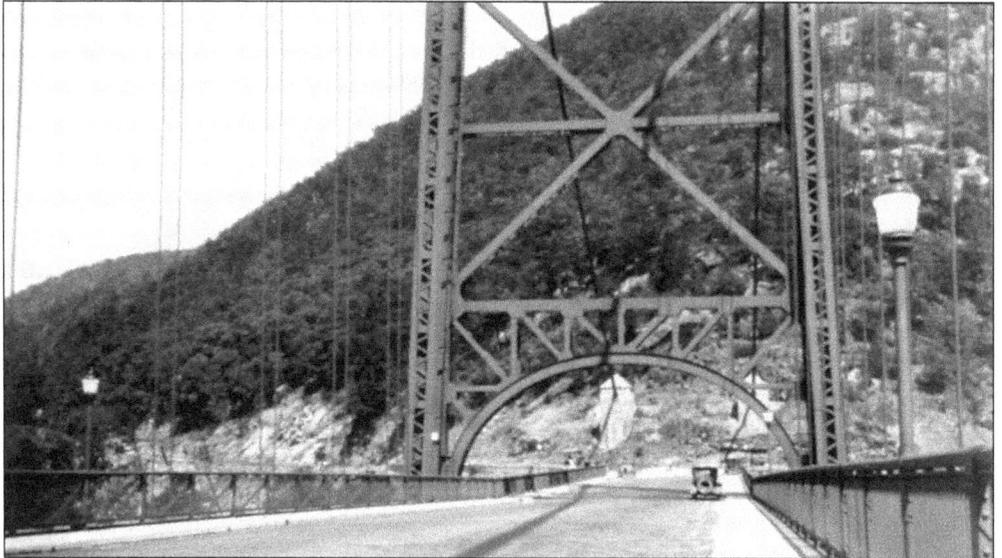

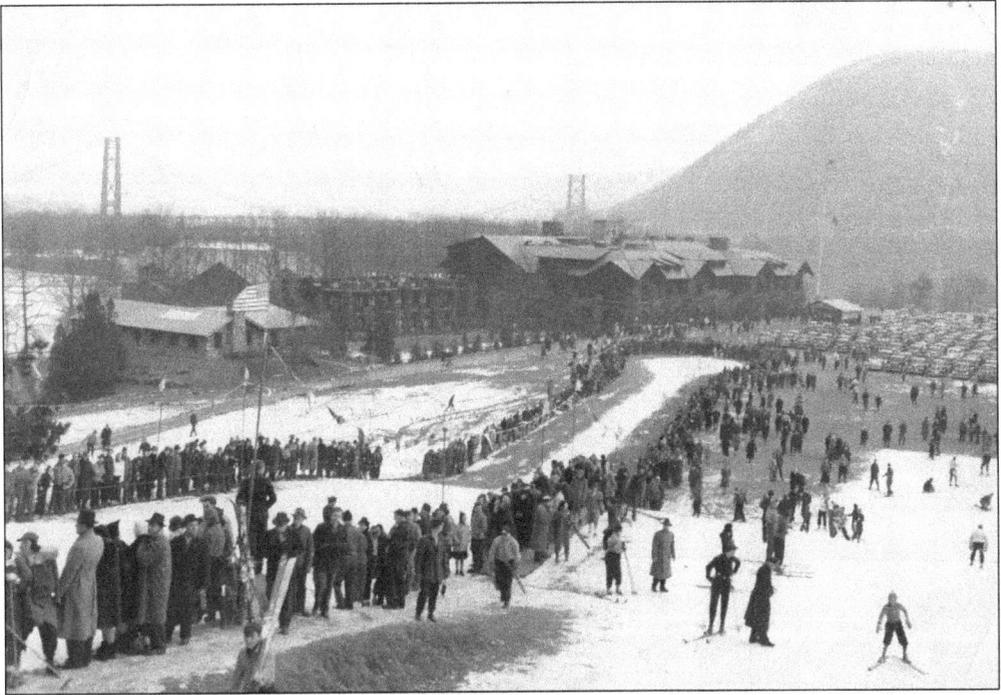

Although the Bear Mountain bridge was a technically a success, setting the standard and paving the way for the bridge-building boom, it was a financial disaster. Although the crowds still continued to use the bridge to visit the popular Bear Mountain Inn and Park, the bridge operated at a loss for 13 of the 16 years of operation until it was sold. Vacationers are seen here in the winter months, skiing and playing in the cold. The bridge can be seen in the background behind the Bear Mountain Inn.

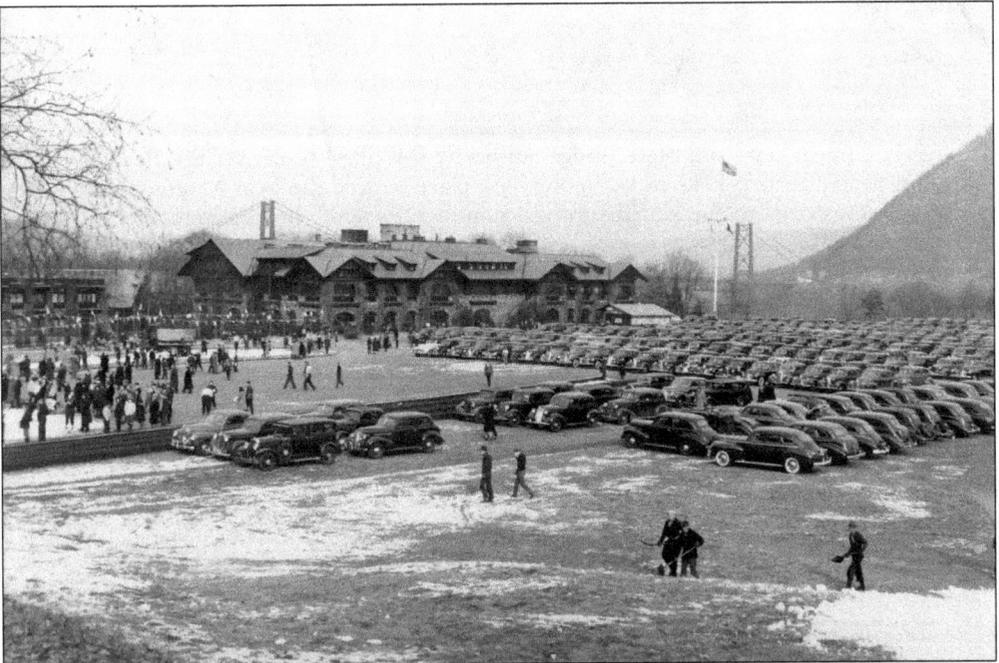

The newly formed New York State Bridge Authority (NYSBA) took over the Bear Mountain bridge on September 25, 1940. A ceremony took place outside the Bear Mountain Inn as the bridge was transferred to the NYSBA for the sum of $2,275,000. Immediately after the bridge authority took over, the toll was reduced to 50¢ each way for passenger cars, and the toll on the east highway approach was eliminated. In 1945, the tolls were again reduced to 25¢. By then the ferries were driven out of business as people used the more direct and cost-efficient bridge.

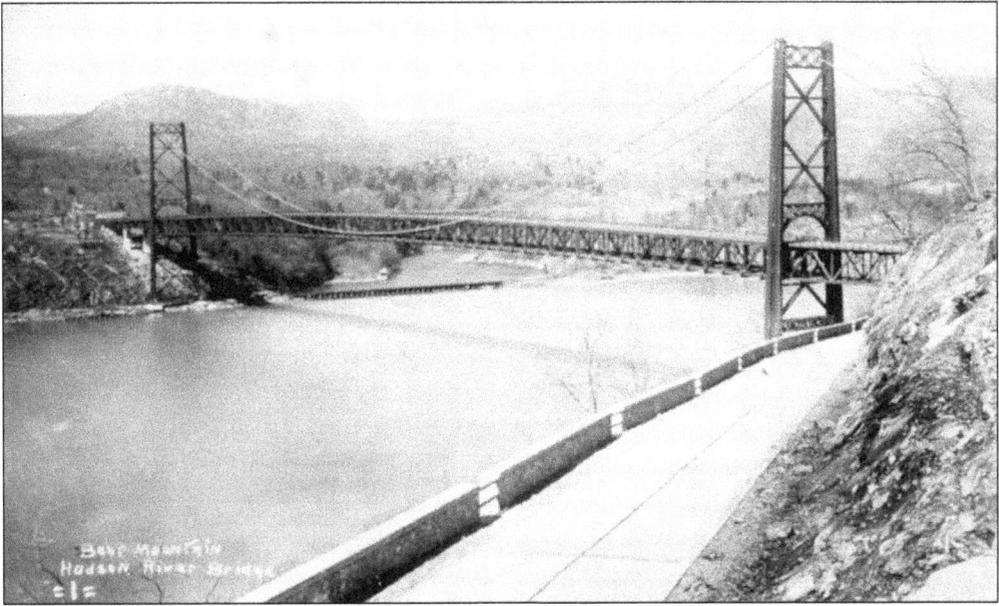

Concern about the destruction of the beauty of the Highlands area voiced prior to the construction of the Bear Mountain Hudson River Bridge proved to be unfounded. As this postcard and message indicates, the bridge was truly a magnificent structure and fully enhanced the beauty of the area.

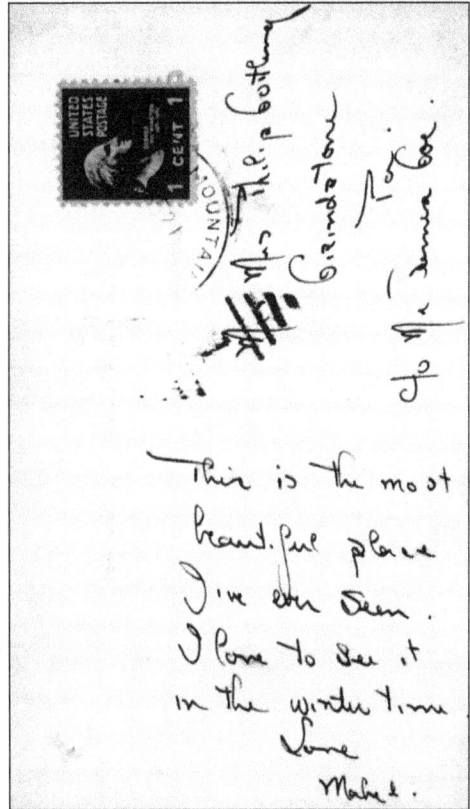

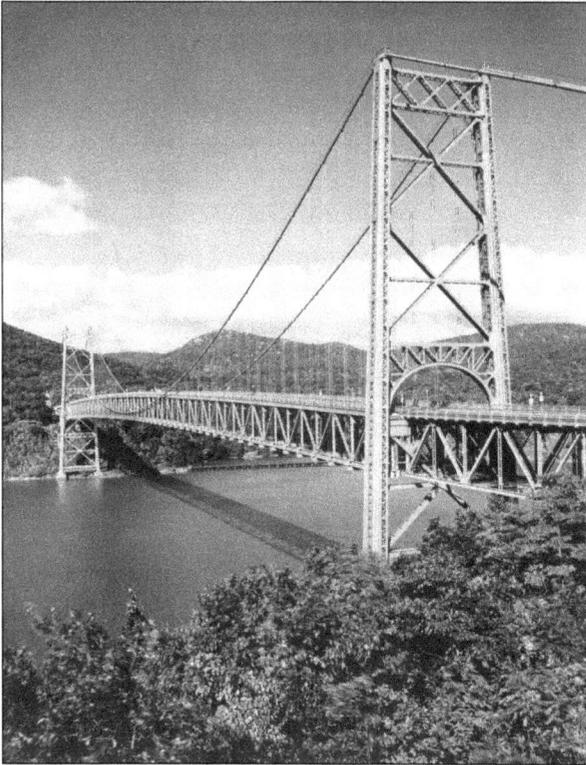

The Bear Mountain bridge was the longest suspension bridge in the world when it was built in 1924, 32 feet longer than the Williamsburg Bridge over the East River in New York City. It was also the first vehicle crossing over the Hudson River south of Albany. The bridge was constructed just 20 months and 4 days after the signing of the contracts. This feat was accomplished with no loss of life. The bridge was financed by the Bear Mountain Hudson River Bridge Company, and E. Roland Harriman was the president and principal backer. E. Roland was brother to W. Averell Harriman, who would later become governor of New York.

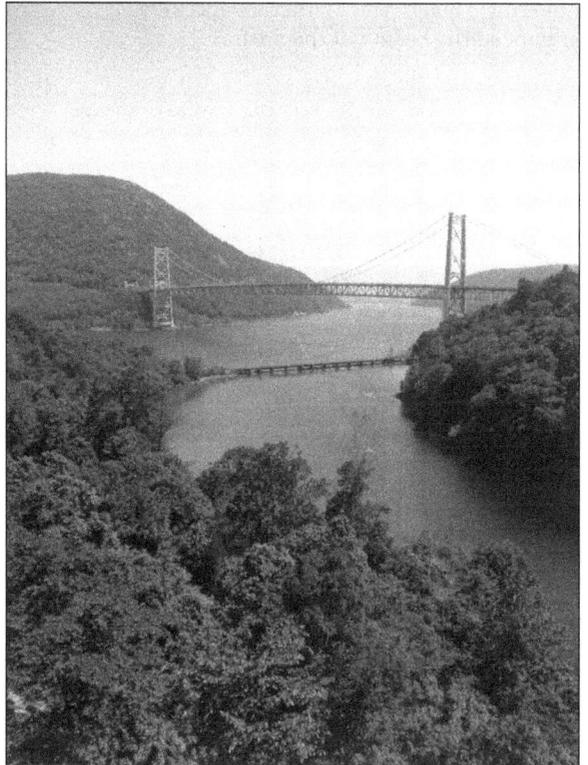

Three

MID-HUDSON BRIDGE

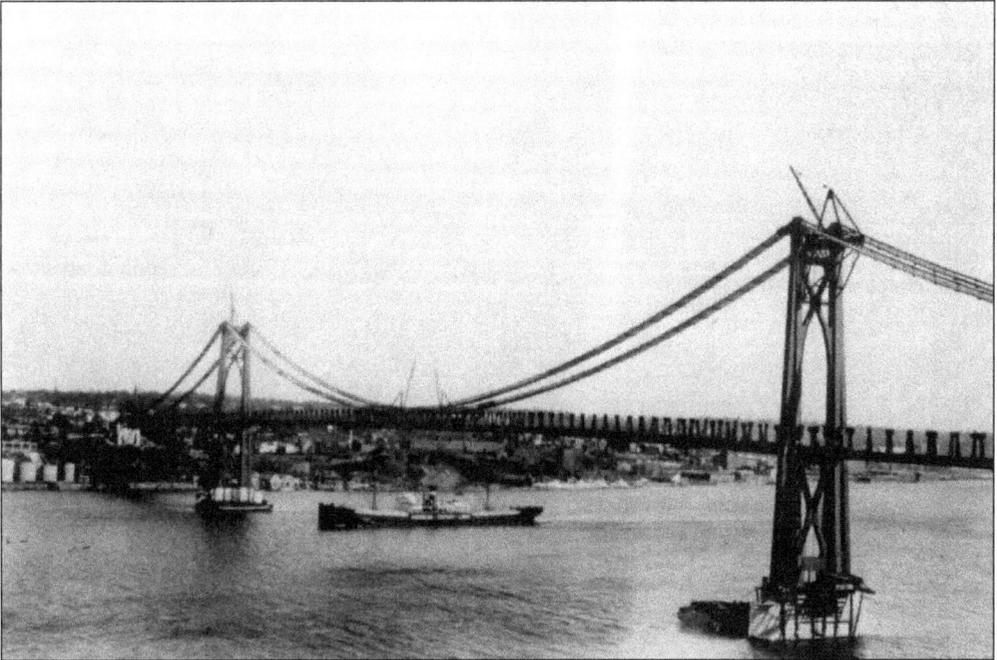

Although the idea for the Mid-Hudson bridge was introduced to the New York legislature in 1923, construction began in May 1925. The New York State Department of Public Works directed the work that was to be designed and constructed by Ralph Modjeski, one of the most distinguished bridge designers in the United States in the 1900s. At an overall length of 5,000 feet, the main bridge is a parallel wire cable suspension bridge with both main span and side spans suspended.

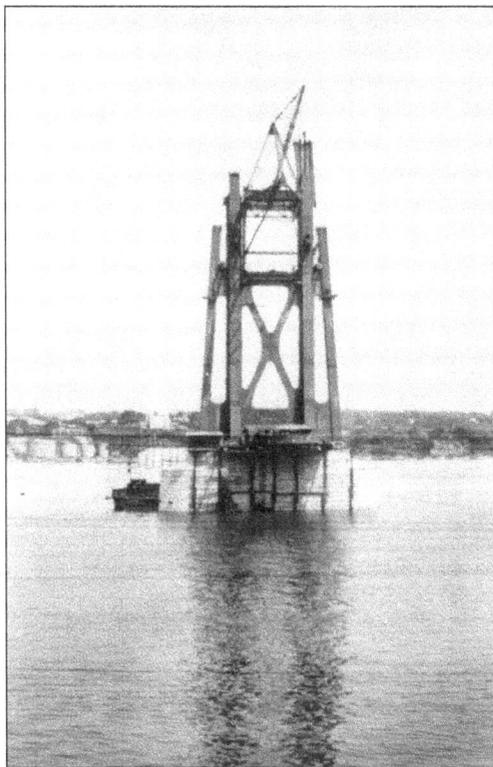

The Mid-Hudson bridge was built using manned caissons. Men would get into the pressurized cavity of the caisson. They would slowly remove the earth with pickaxes and shovels. The dirt and the men would leave the caisson through an air lock that ran from the top of the caisson to the work chamber. In 1927, work was delayed for about a year when one of the caissons slipped and developed a severe tilt. Workers had to use pulleys and dredging to right the caisson, moving it only about a foot and a half a day.

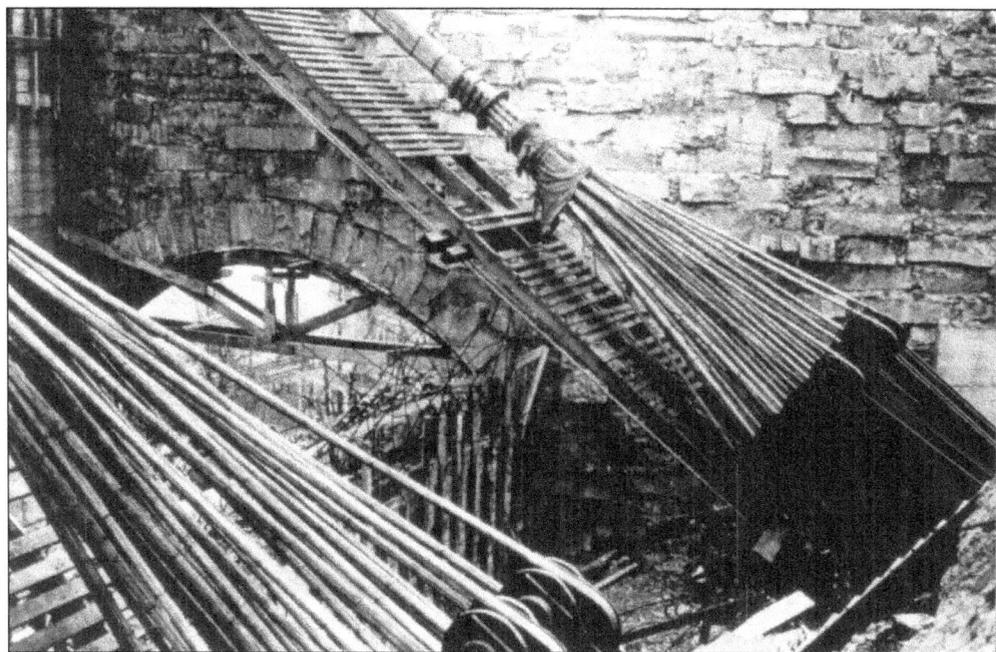

The main cables have been attached to the anchor plate. The foot walk is still in place under the cables for workers, allowing for free movement along the cables. The two parallel cables will carry the full weight of the completed structure. With proper care and maintenance, the cables will last an unlimited amount of time.

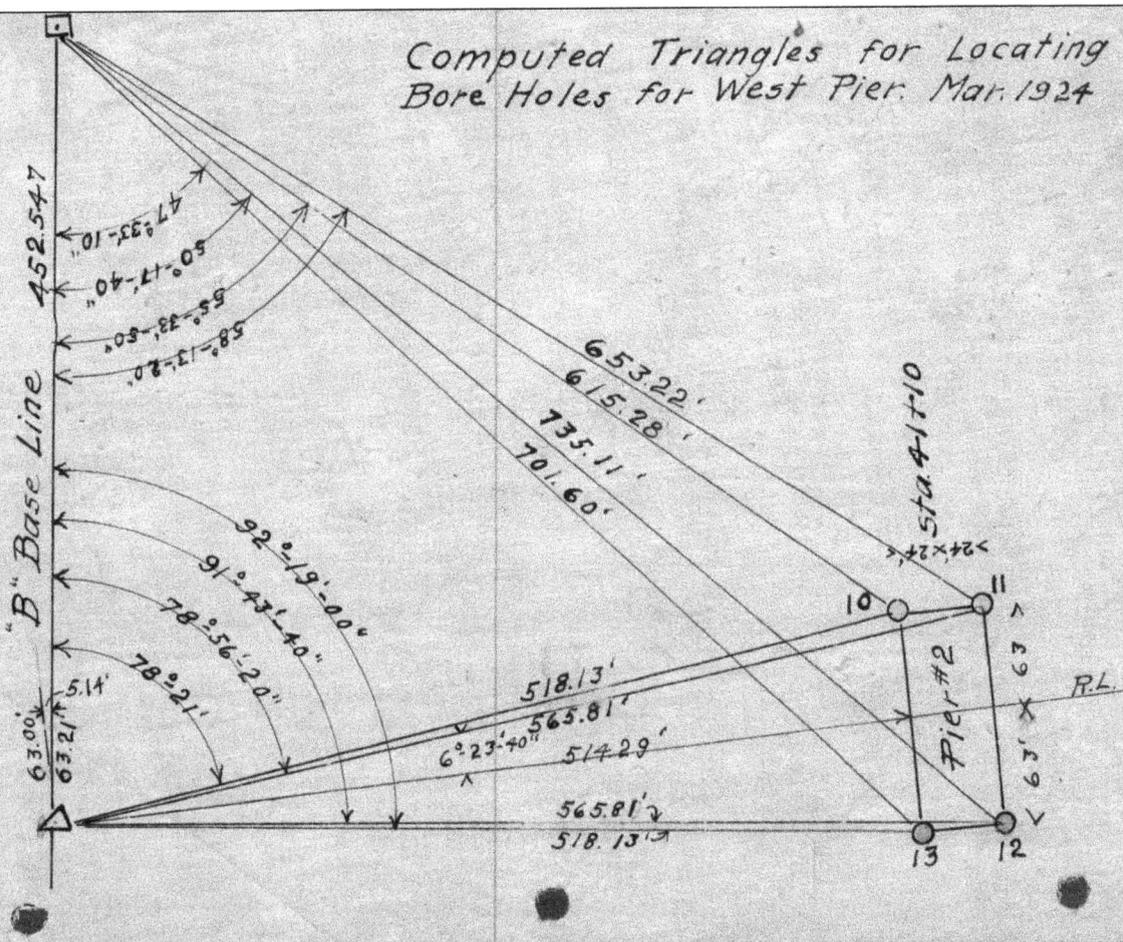

Computed Triangles for Locating Bore Holes for West Pier. Mar. 1924

"B" Base Line 452.547

47°35'-10"
50°-47'-40"
55°-23'-50"
58°-12'-20"

653.22'
615.28'
735.11'
701.60'

92°-19'-00"
91°-43'-40"
78°-56'-20"

78°-21'
63.21'
5.14'
63.00'

518.13'
565.81'
6°-23'-40"
514.29'

565.81'
518.13'

10
11
13
12

Pier #2

sta.4-1+10
>2+2 X 2+2<
63'
63'

R.L.

The diagram dated March 1924 illustrates the importance of exact measurements when drilling the boreholes beneath the pier site for the suspension bridge. The bridge will have only two piers in the water to support each of the two main towers. Boreholes are necessary to determine the composition of the ground under the proposed site for the piers.

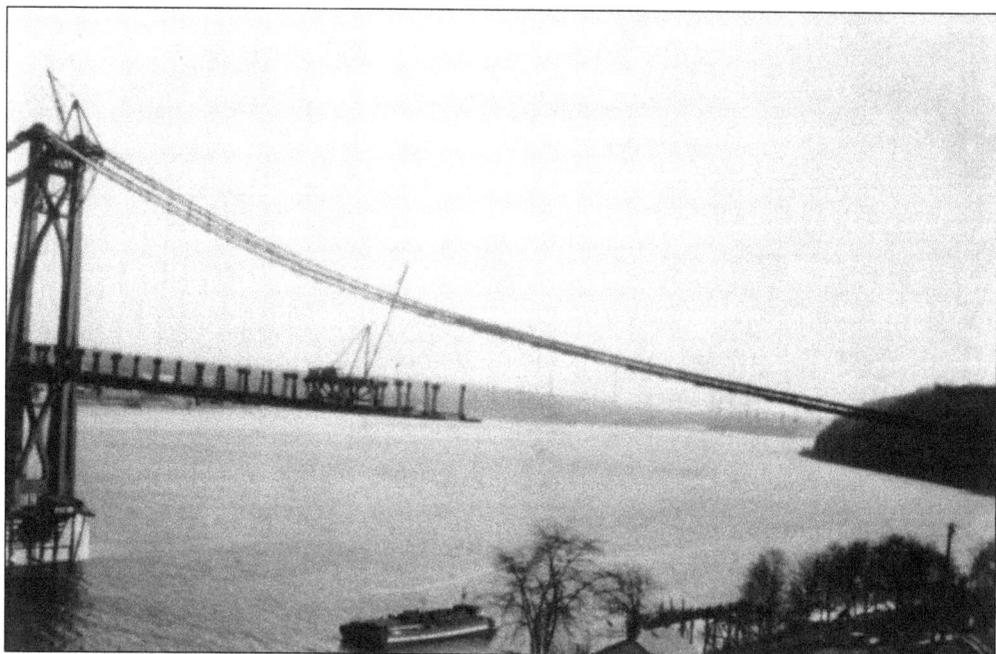

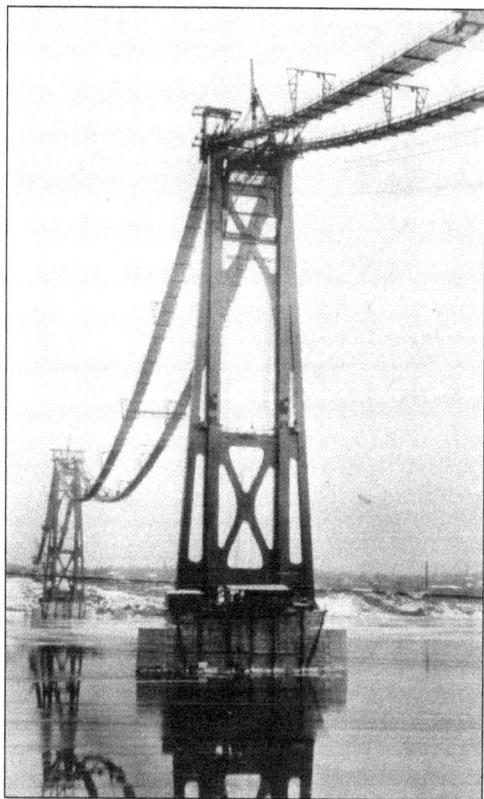

The construction photographs here illustrate a process very similar to the construction of the other suspension bridge across the Hudson River at that time. The Bear Mountain Hudson River Bridge had been completed and in use for two years when the Mid-Hudson bridge was begun. A year after the completion of the Mid-Hudson bridge, another important suspension bridge over the Hudson River, the George Washington bridge, would open for traffic between upper Manhattan and Fort Lee, New Jersey. Suspension bridges are very imposing structures, and those three bridges would remain the only suspension bridges over the Hudson River.

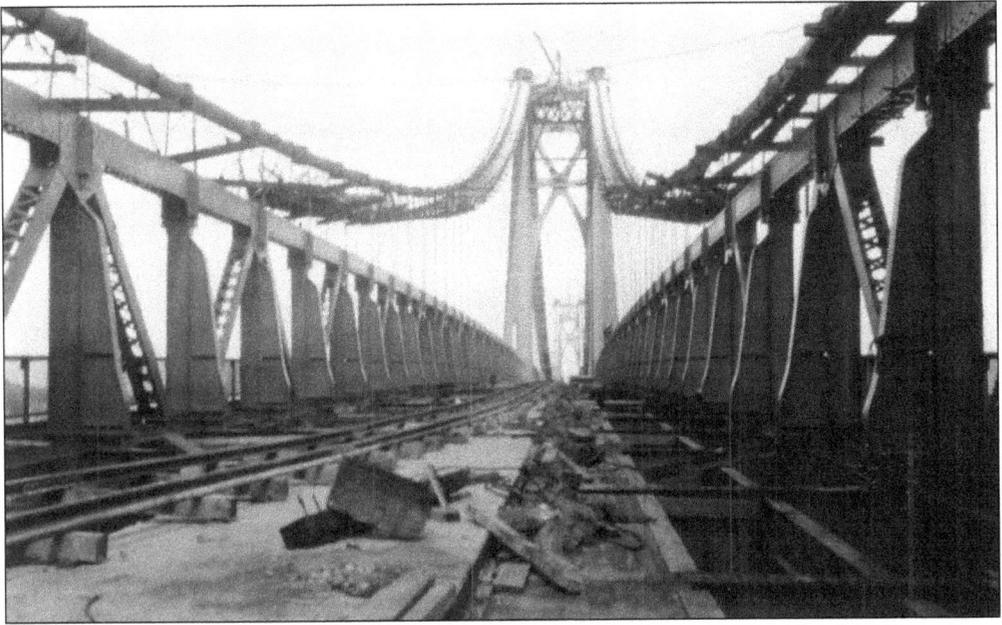

Construction of the superstructure on the Mid-Hudson bridge began in April 1929 and was completed 16 months later. It was built by the American Bridge Company for a total cost of nearly $6 million. If it were built today, it would cost approximately $175 million, about 30 times the original amount. The final structure had two lanes for traffic, one in each direction.

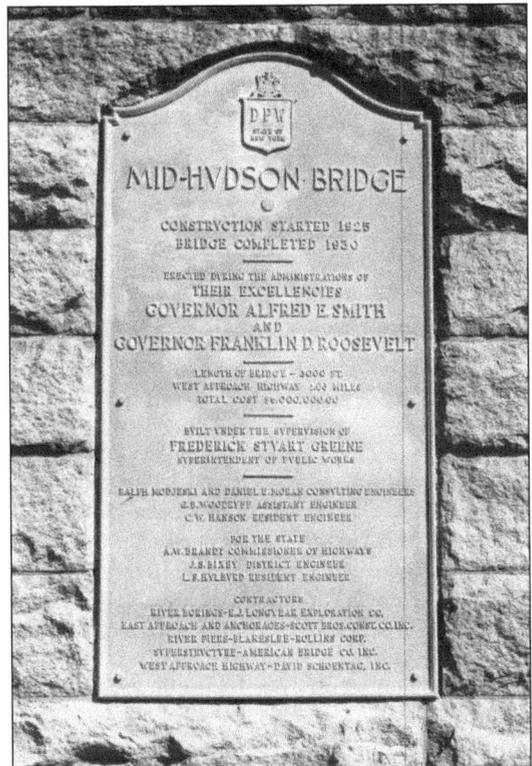

The Mid-Hudson bridge officially opened on August 25, 1930. At the celebration were then governor Franklin D. Roosevelt and Eleanor Roosevelt and former governor Alfred E. Smith, who was governor at the time the legislation was signed to begin the bridge. Eleanor cut the ribbon on the west side; Catherine Smith cut the ribbon on the east side. An automobile procession following the ribbon cutting met at the center of the bridge to exchange greetings.

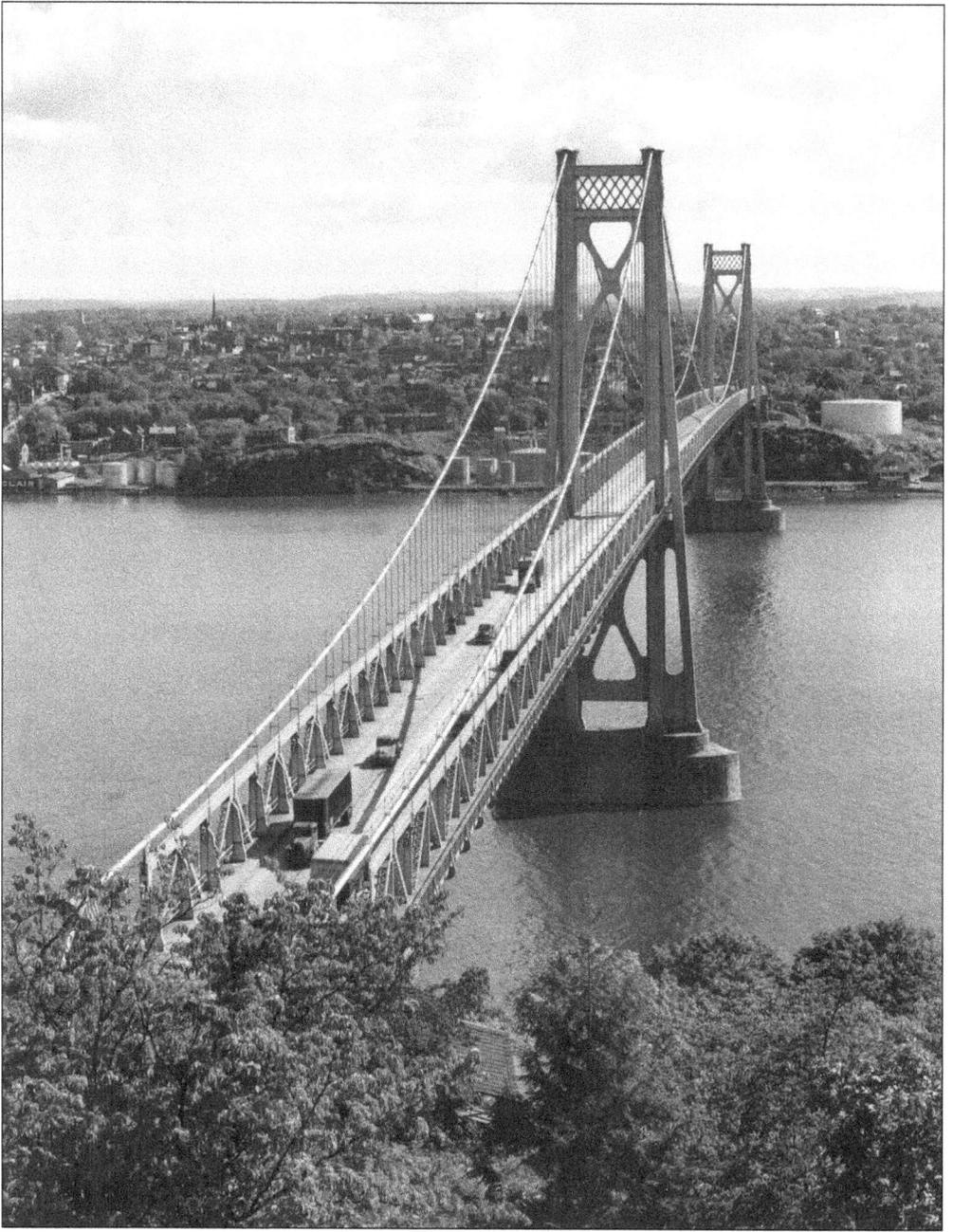

When the Mid-Hudson bridge opened, it won recognition as the most beautiful suspension bridge in the Northeast. Completed in 1930 by the New York State Department of Public Works, it was acquired by the NYSBA in 1933. At that time, the tolls were 80¢ per car; each passenger was an additional 10¢. A saddled horse and rider were 30¢, and a bicycle and rider were 20¢. Taking a cow, horse, oxen, or yearling across the bridge cost 20¢ each way. But the smaller calves, hogs, sheep, and lambs cost only 10¢ each way.

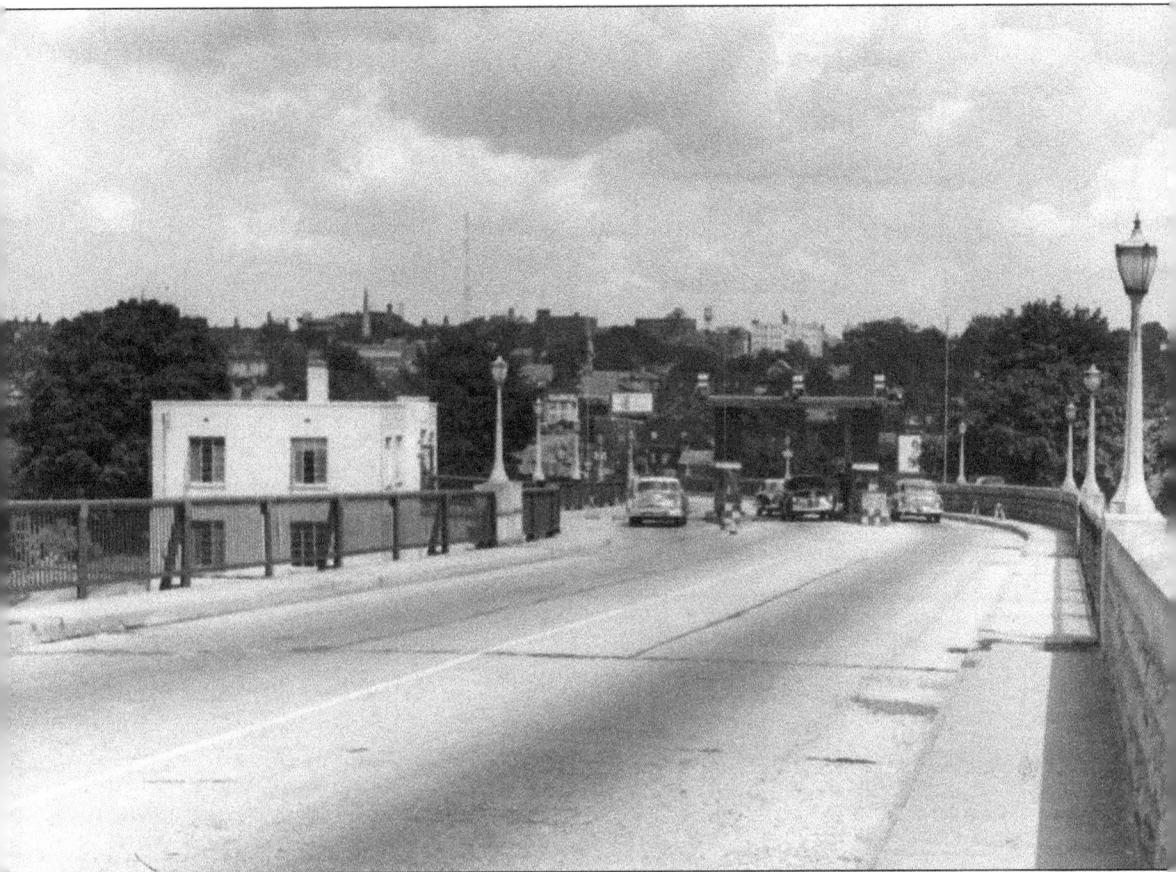

Beginning on December 12, 1941, although war never reached the continental United States, armed guards were put on patrol on the Mid-Hudson bridge. As a result of the declaration of war signed in Washington, D.C., the NYSBA placed two guards, changed every eight hours, on patrol on each end of the bridge. In addition, a patrol car toured the bridge every 20 minutes. Free tolls for the military were also instituted.

The Mid-Hudson bridge was heavily traveled at rush hour times of the day and on the weekends. The traffic made it difficult for pedestrians crossing the Poughkeepsie city streets. The woman in the photograph waits for a break in the traffic to complete her crossing. A traffic study would illustrate the need for changes in the traffic pattern. A widened approach on the Poughkeepsie side would increase to allow two to three lanes of traffic, and the setting up of a third tollbooth would speed the traffic along.

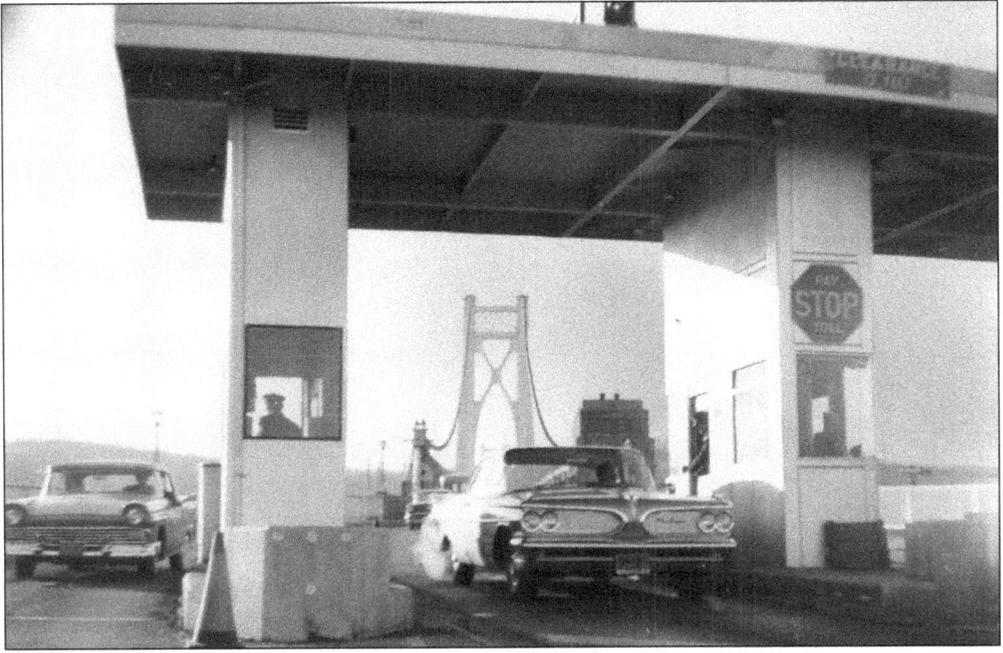

A new toll plaza opened at the eastern end of the Mid-Hudson bridge in December 1967. It boasted new electromechanical toll-collecting equipment that was connected to the accounting system in the headquarters building. It would be another 30 years or so before E-ZPass toll collection would be instituted on the bridges.

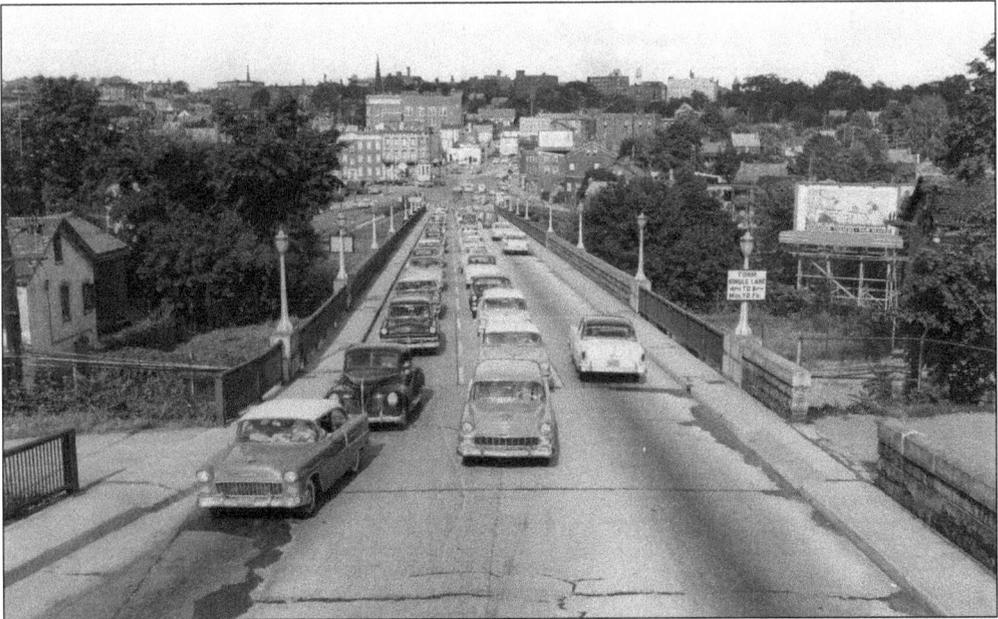

To assist with traffic, a third lane was designated on the Mid-Hudson bridge. The center lane also assisted with the rush hour and weekend traffic. Bridge workers would specify the direction of the center lane, depending on the time of day. Traffic coming into the city in the morning would have an additional lane. The lane would then switch direction for taking workers away from the city at night.

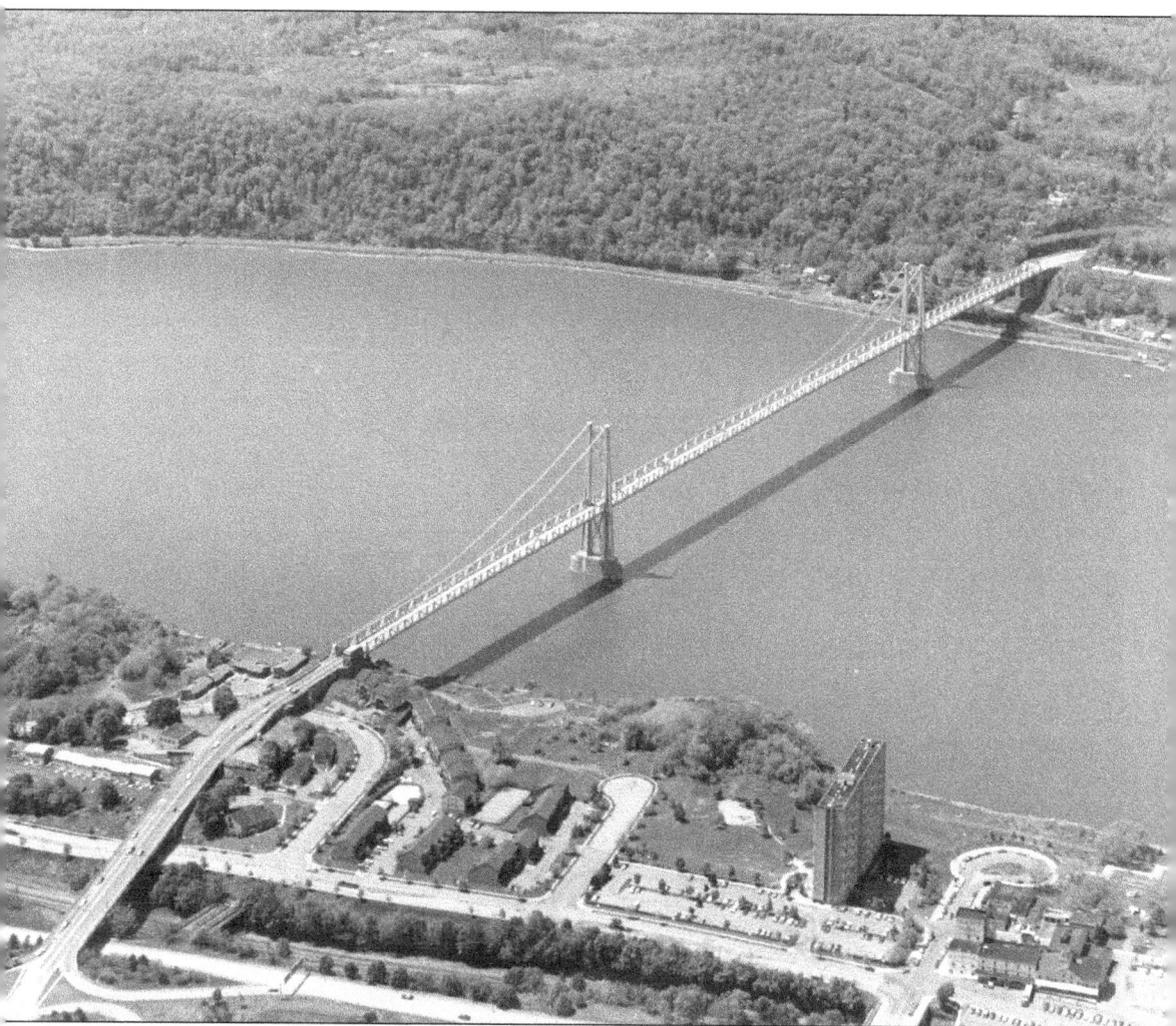

Further traffic studies over time required the later development of an elevated approach to enable free movement of traffic on the busy Route 9. The lower portion of this aerial view illustrates the new safer traffic pattern. In 1994, Gov. Mario Cuomo signed into law a bill formally renaming the Mid-Hudson bridge in honor of Franklin D. Roosevelt. The name was officially changed to the Franklin D. Roosevelt Mid-Hudson Bridge in 1995 at the ceremony to mark the 50th anniversary of the Mid-Hudson bridge.

Four

GEORGE WASHINGTON BRIDGE

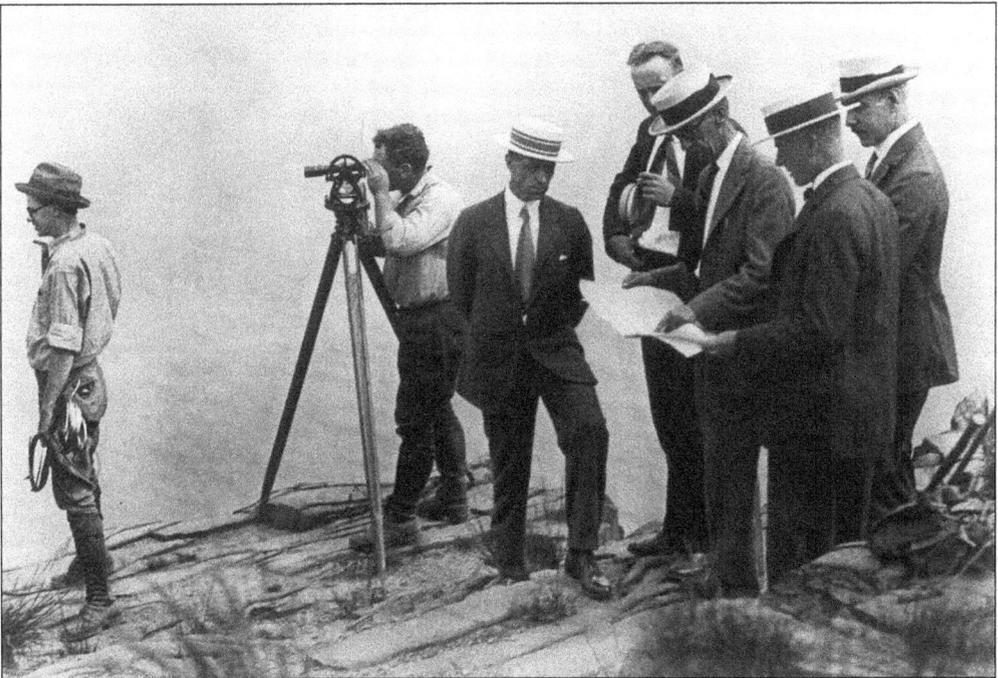

Although considered by many in New York and New Jersey for several years before its construction began, the George Washington bridge, or the Hudson River bridge as it was referred to then, was designed by Othmar Ammann, chief engineer for the Port Authority of New York and New Jersey. His initial design was submitted in 1923. Ammann, seen here in the center of the photograph holding the papers, is surveying the area along the Hudson River. (Courtesy Port Authority of New York and New Jersey.)

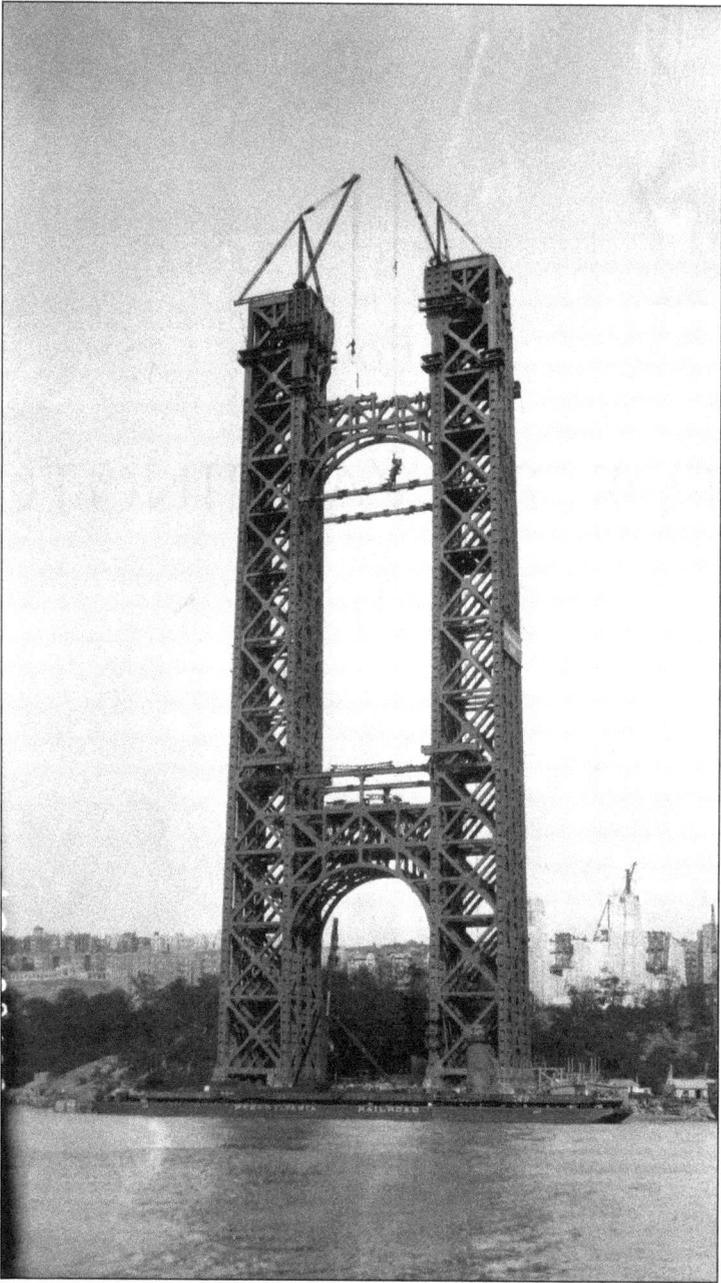

Groundbreaking ceremonies took place in Fort Lee, New Jersey, on September 27, 1927, and construction began that October. The tower shown here is on the shore in the Fort Washington section of Manhattan, not in the water due to the steep drop from the Manhattan shoreline. The tower on the New Jersey side of the bridge is 76 feet out into the water on a concrete pier. Both towers are more than 600 feet above the surface of the river. The steel for building the towers is being hoisted up from barges in the river. There were 12 50-foot-long sections. An elevator is in each leg of the tower. Exposed latticework of the 20,000-ton steel towers would be more than sufficient to carry the load, and the frame's flexibility would reduce the total weight. (Courtesy Port Authority of New York and New Jersey.)

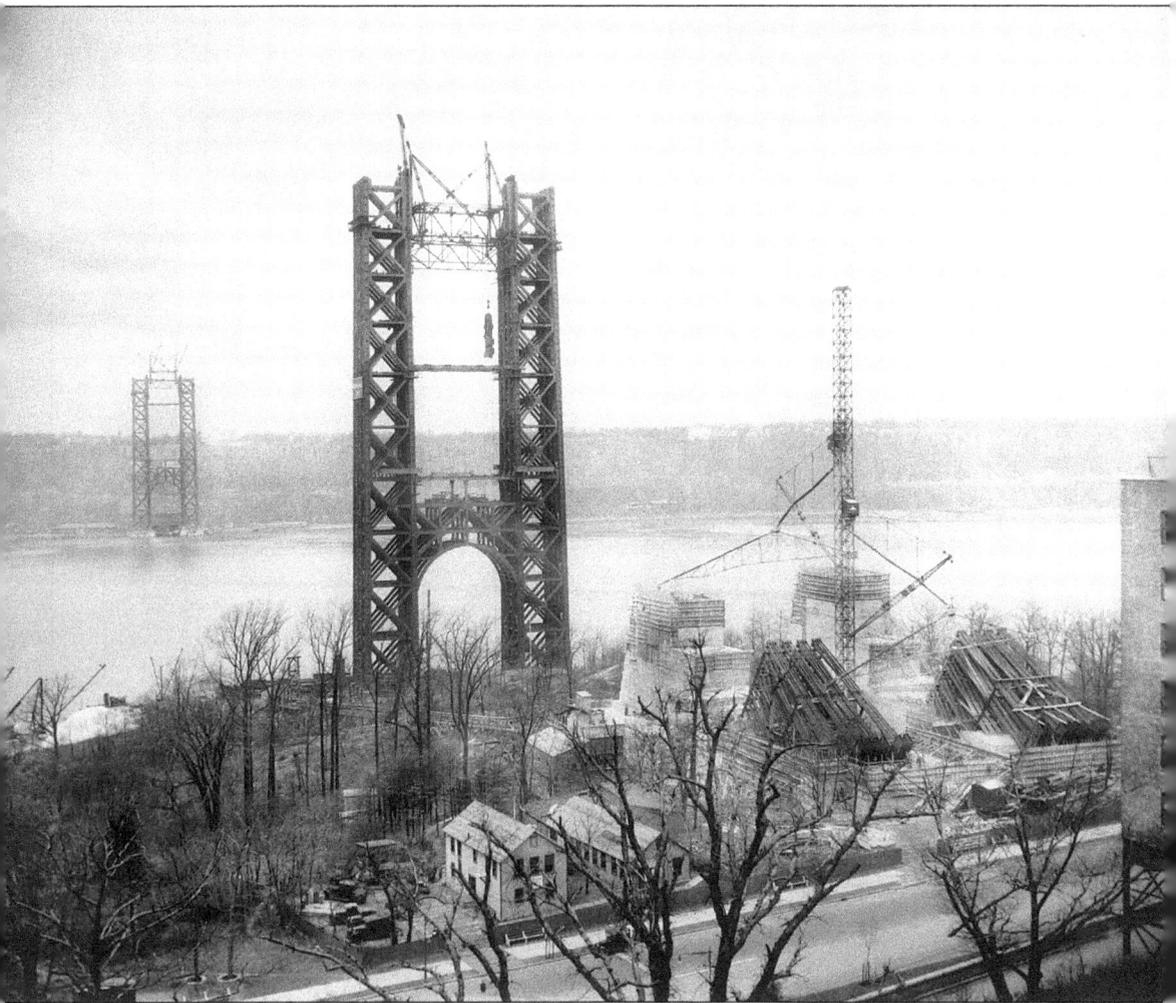

The cable anchorages are being constructed between the tower and the roadway in Fort Washington Park. Concrete masonry weighing 350,000 tons forms the anchorage. On the New Jersey side, the anchorage lies on the rock of the Palisades, which can be seen north of the New Jersey tower across the river to the right in the photograph. The largest cofferdam ever constructed was sunk into the Hudson River to support the New Jersey tower. (Courtesy Port Authority of New York and New Jersey.)

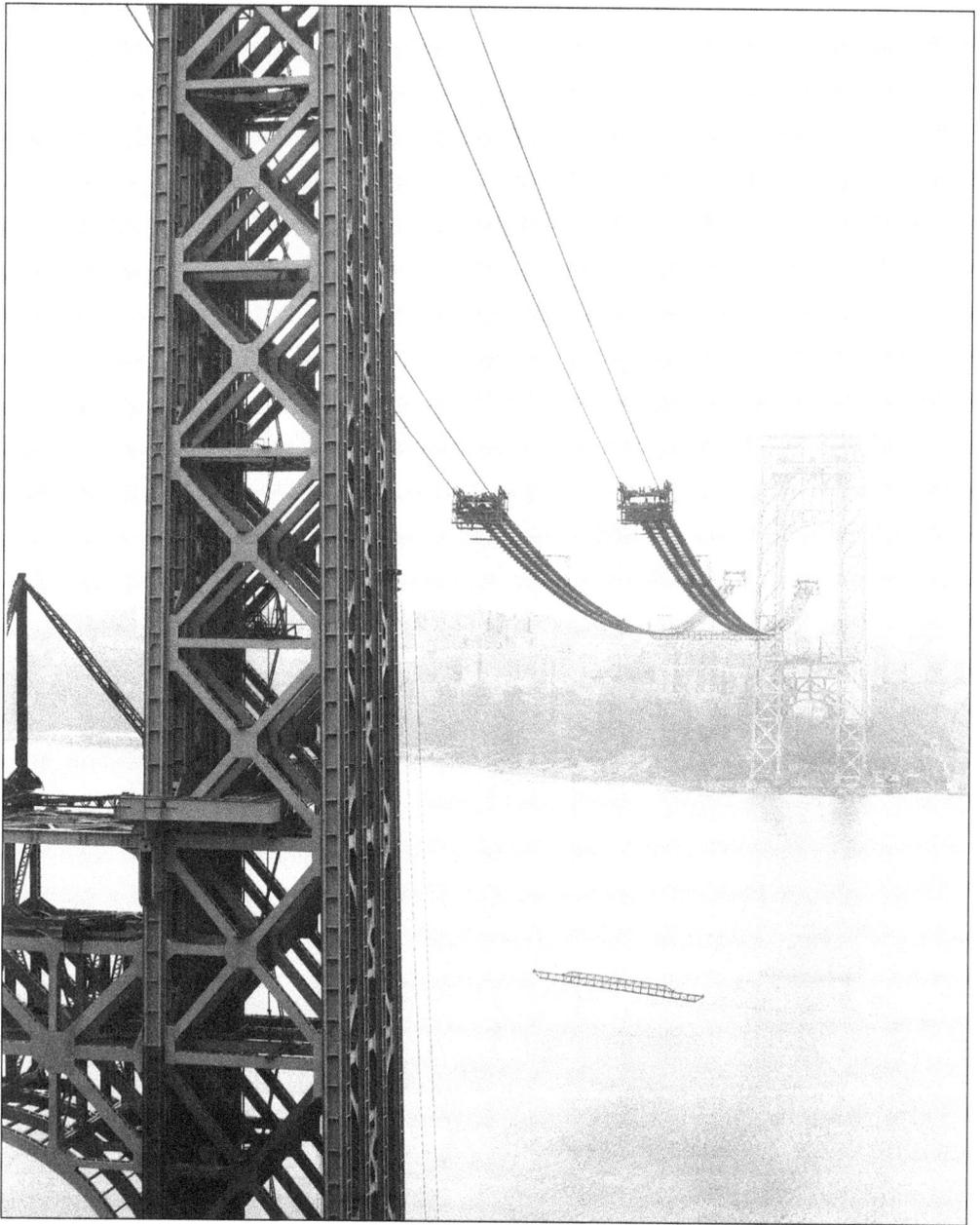

With the towers completed, the catwalk is being strung across the river between the towers. Sections are being hoisted from barges to position on the cables. A steel framework that will fit between the cables is being lifted in the photograph. It will be put in place to match the one that can be seen in the distance hanging between the parallel catwalks. Upper Manhattan can be seen behind the far tower. (Courtesy Port Authority of New York and New Jersey.)

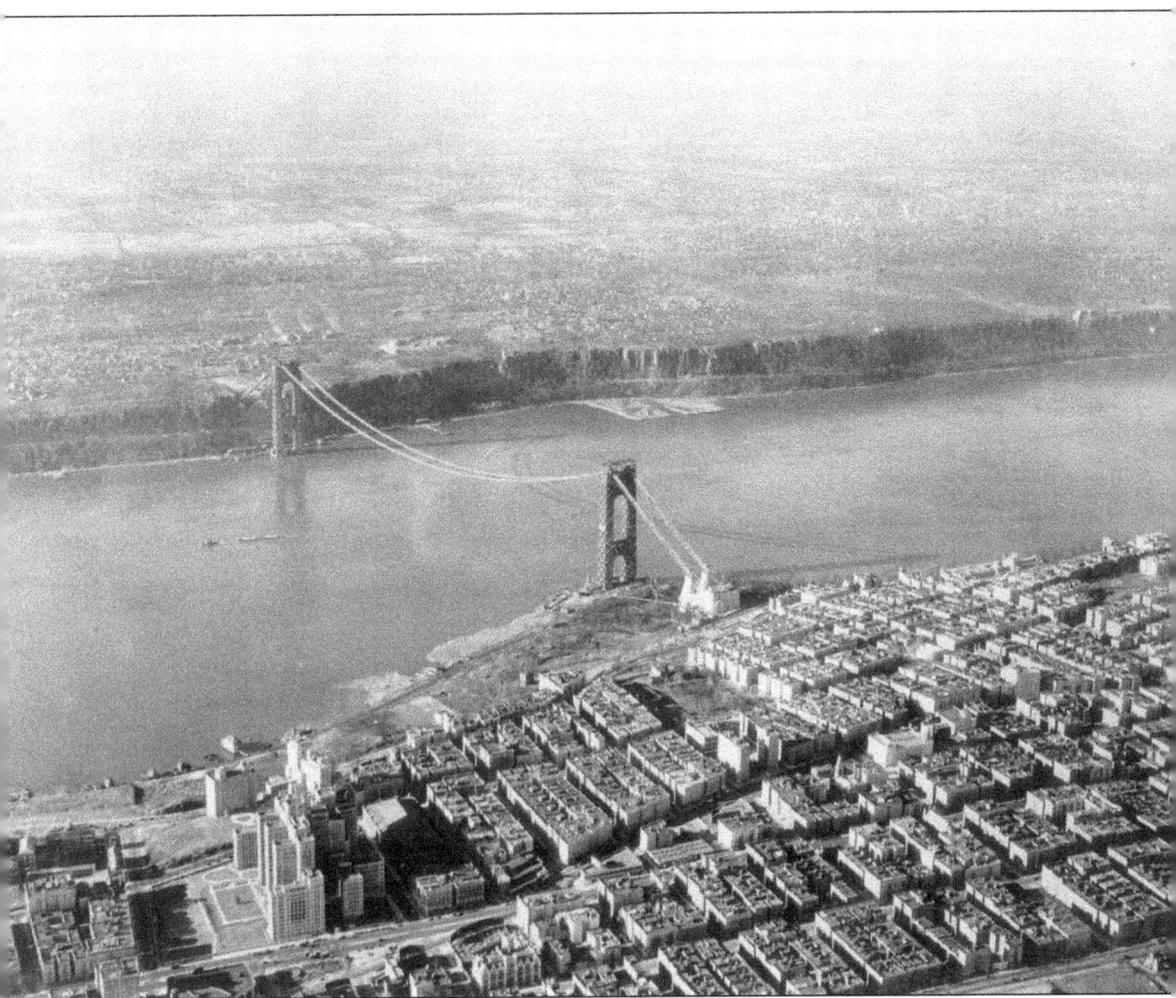

The catwalk appears completed in this aerial view of the bridge, looking from upper Manhattan into New Jersey. It is evident why this location was chosen as the river narrows at the exact location of the towers. The steep sides of the Palisades on the New Jersey side of the river are minimized by the height of the towers. The span between the towers on the developing bridge is of much greater proportion to the side spans than was usual at that time. The center span is 3,500 feet while the side spans are relatively short at only 603 feet between the anchorage and the tower. (Courtesy Port Authority of New York and New Jersey.)

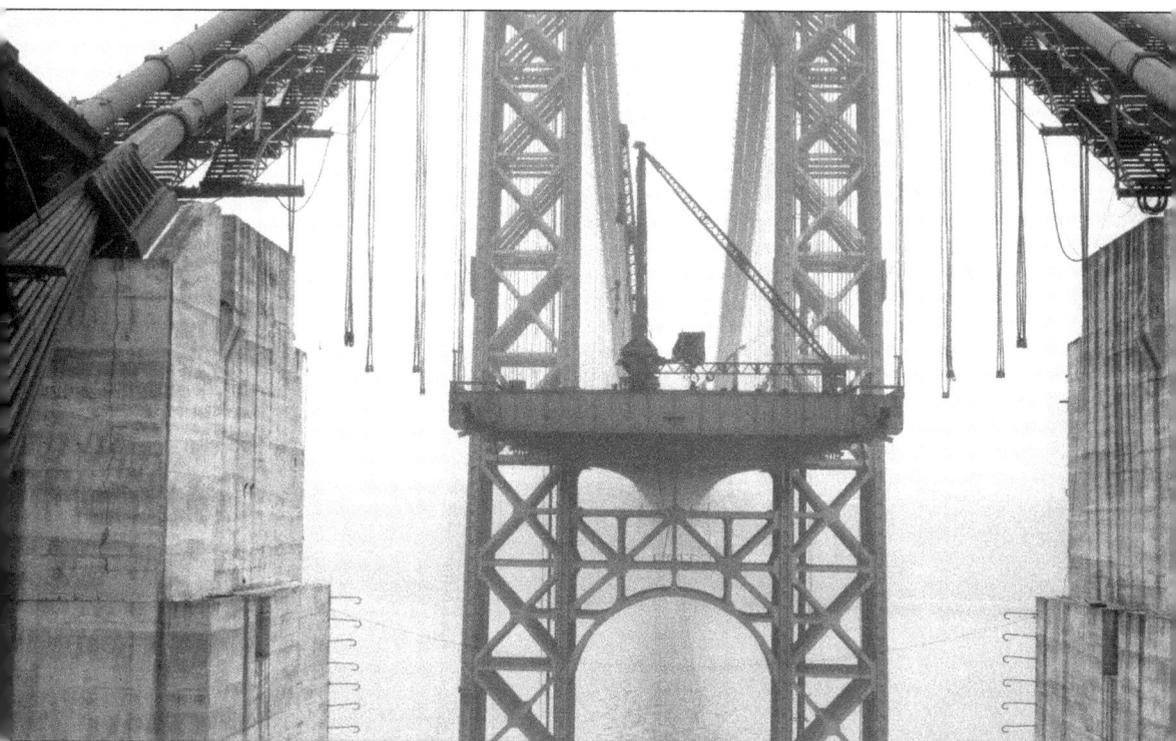

Looking between the anchorages through to the tower with the developing roadbed, the double cables can be seen on the top corners of the photograph. Chief engineer Othmar Ammann contracted John A. Roebling and Sons, well known for cutting-edge cable design and the company responsible for the cables on the Bear Mountain bridge, to produce and construct the cables on the bridge. Each of the four cables contained 61 strands; each strand was spun from 434 wires wound together across the river. The resulting cables were each three feet in diameter. To hold the cables in place on the top of the tower, Roebling used four 180-ton saddles that would eventually be covered with a protective cap. Once the main cables were in place the suspending cables were hung. The roadway was added one piece at a time as the men worked from each shore to meet in the middle. (Courtesy Port Authority of New York and New Jersey.)

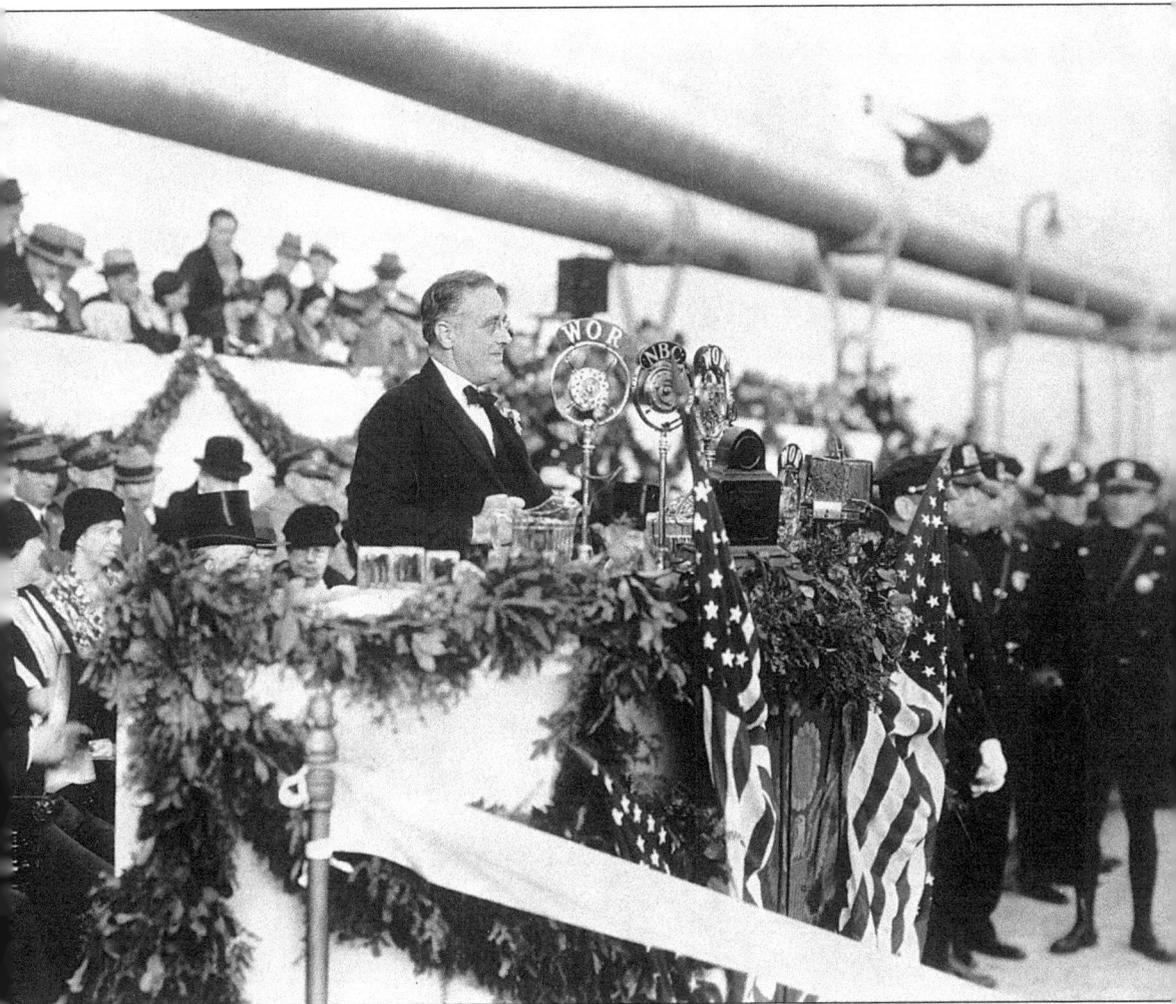

The bridge was completed on October 25, 1931, eight months ahead of schedule and at a cost of $59 million. By that time, the port authority had decided on the name, George Washington Memorial Bridge, later shortened to George Washington bridge. Gov. Franklin D. Roosevelt dedicated the bridge along with Gov. Morgan F. Larson of New Jersey as the ceremony was broadcast over the radio. At the time of its opening, the George Washington bridge was the longest suspension bridge in the world. It connected not only New York and New Jersey but as a part of the new highway network was an important beginning of what would become Interstate 95. (Courtesy Port Authority of New York and New Jersey.)

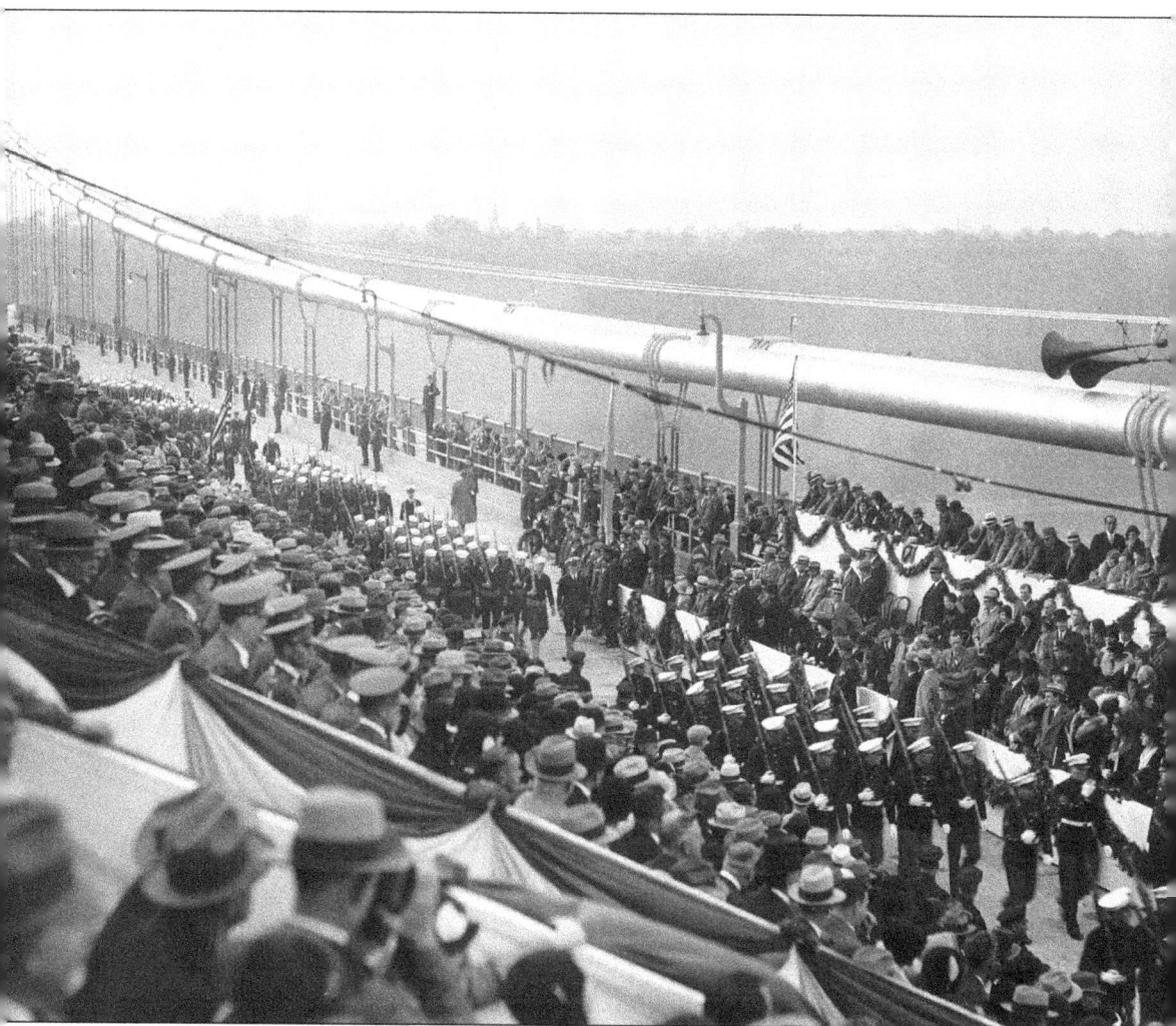

More than 30,000 people attended the opening ceremonies held here on the newly completed bridge. Dignitaries can be seen in the box to the right as the parade passes by in front of the crowds gathered for the event. The marching band led the way across the new bridge with dignitaries and spectators following behind. (Courtesy Port Authority of New York and New Jersey.)

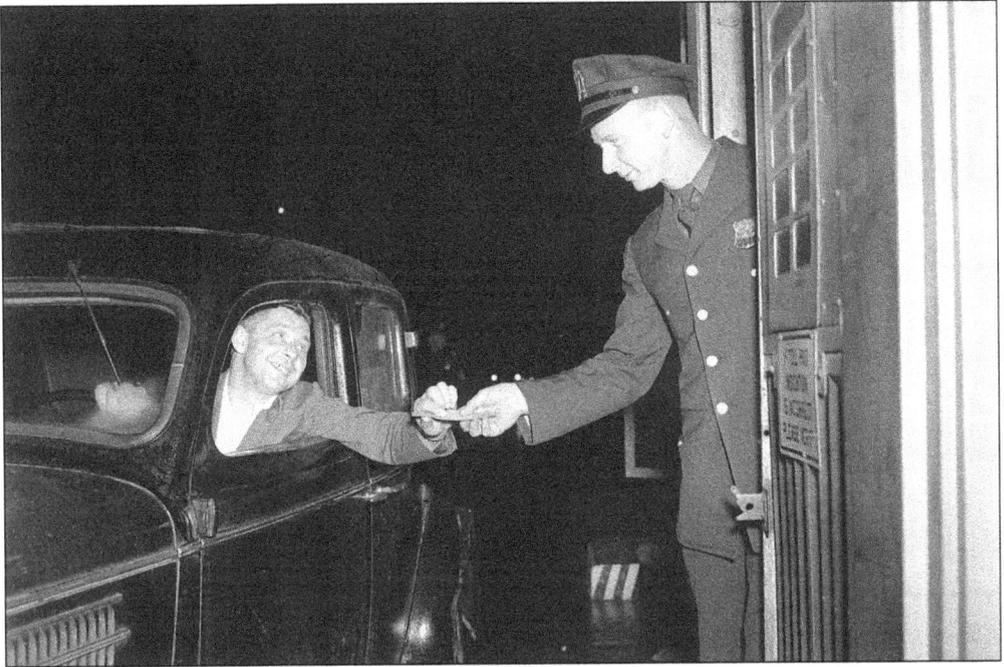

From the time of the opening in 1931, the George Washington bridge has been one of the busiest bridges ever built. A toll collector is pictured here as yet another automobile prepares to cross the bridge. (Courtesy Port Authority of New York and New Jersey.)

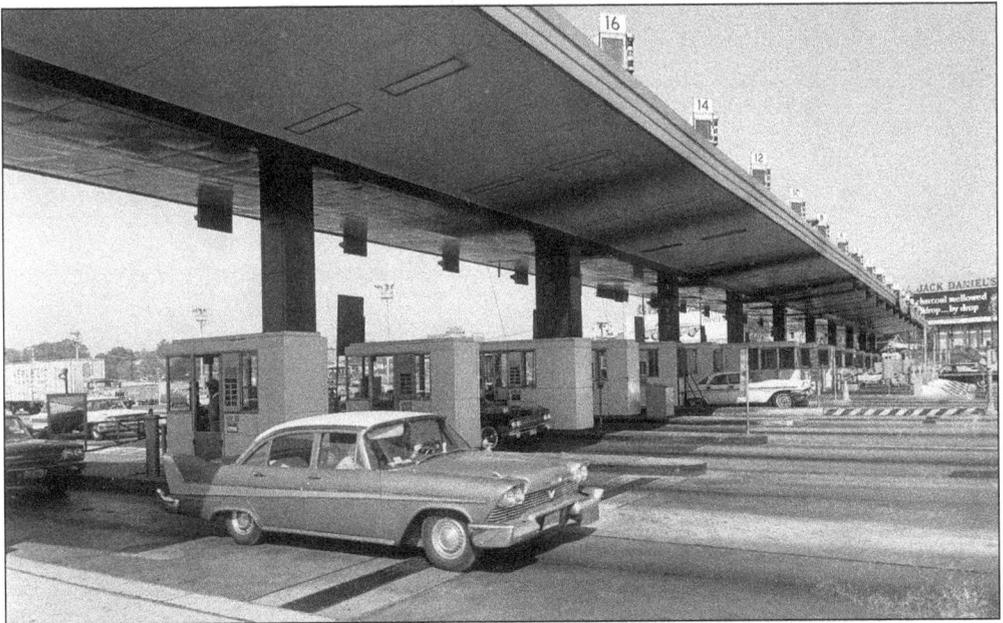

Due to high volume of traffic, in 1946 two previous unpaved lanes, originally intend for rail lines or additional automobile lanes, were constructed in the center of the original level. Excellent planning and forethought by the designer and chief engineer Othmar Ammann provided for the construction of a bridge that would be more than strong enough to provide for later additions. (Courtesy Port Authority of New York and New Jersey.)

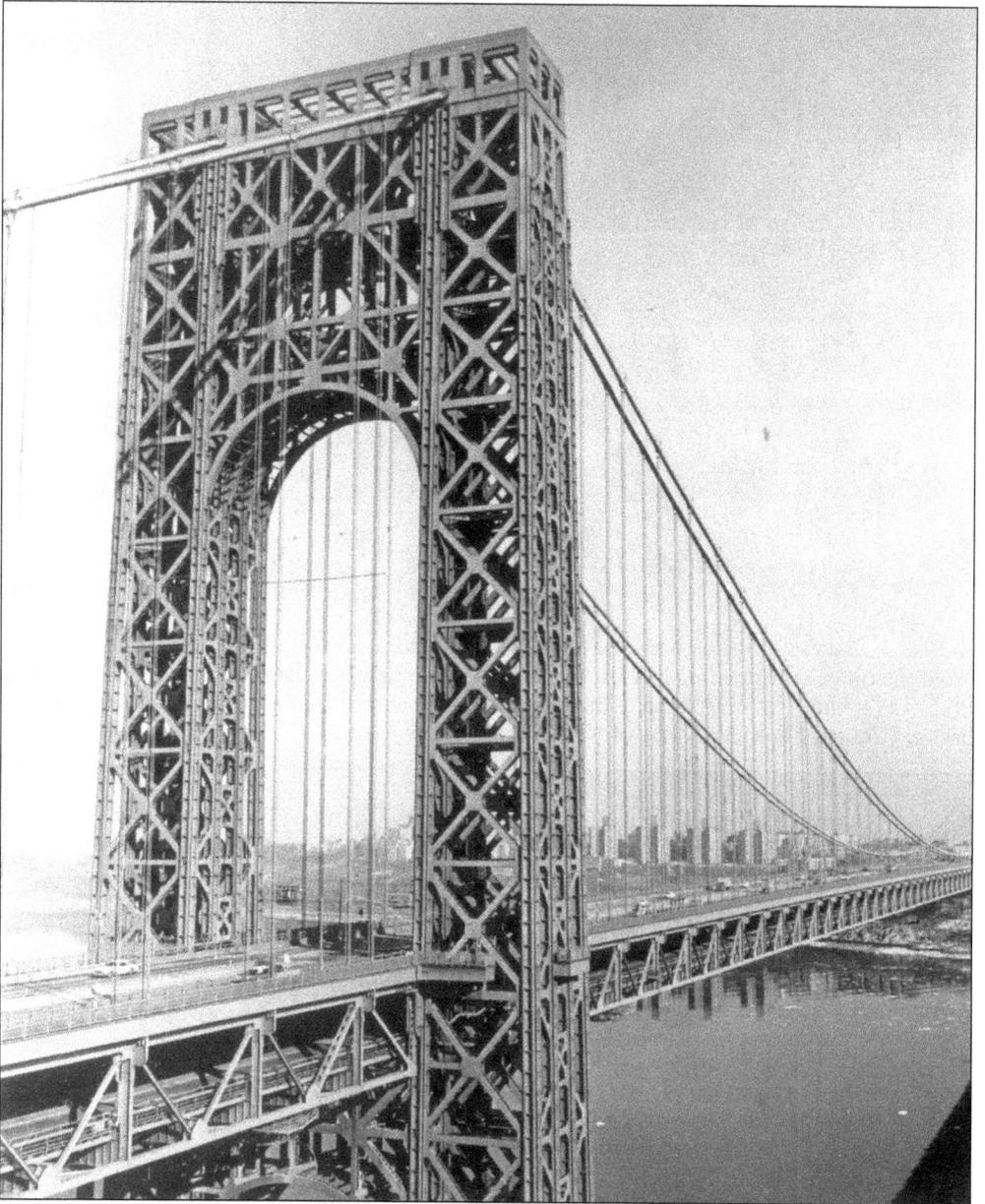

In the original design for the bridge, chief engineer Othmar Ammann left off the usual stiffening trusses, theorizing that the deadweight of the bridge deck combined with the four main cables would be sufficient to withstand heavy winds. This engineering decision provided for the possibility of the addition of a second deck. After a joint traffic study chaired by Robert Moses between the port authority and the Triborough Bridge and Tunnel Authority, a proposal was made to add a lower deck of six traffic lanes to the George Washington bridge. Construction began in 1959, adding a lower deck, seen here, with a 15-foot clearance utilizing the stiffening trusses eliminated from the original design and requiring only a slight adjustment to the rollers on top of the towers. Ammann was hired as consultant for the construction. Since the new level was built under the bridge, traffic was not affected. The new level opened on August 29, 1962.

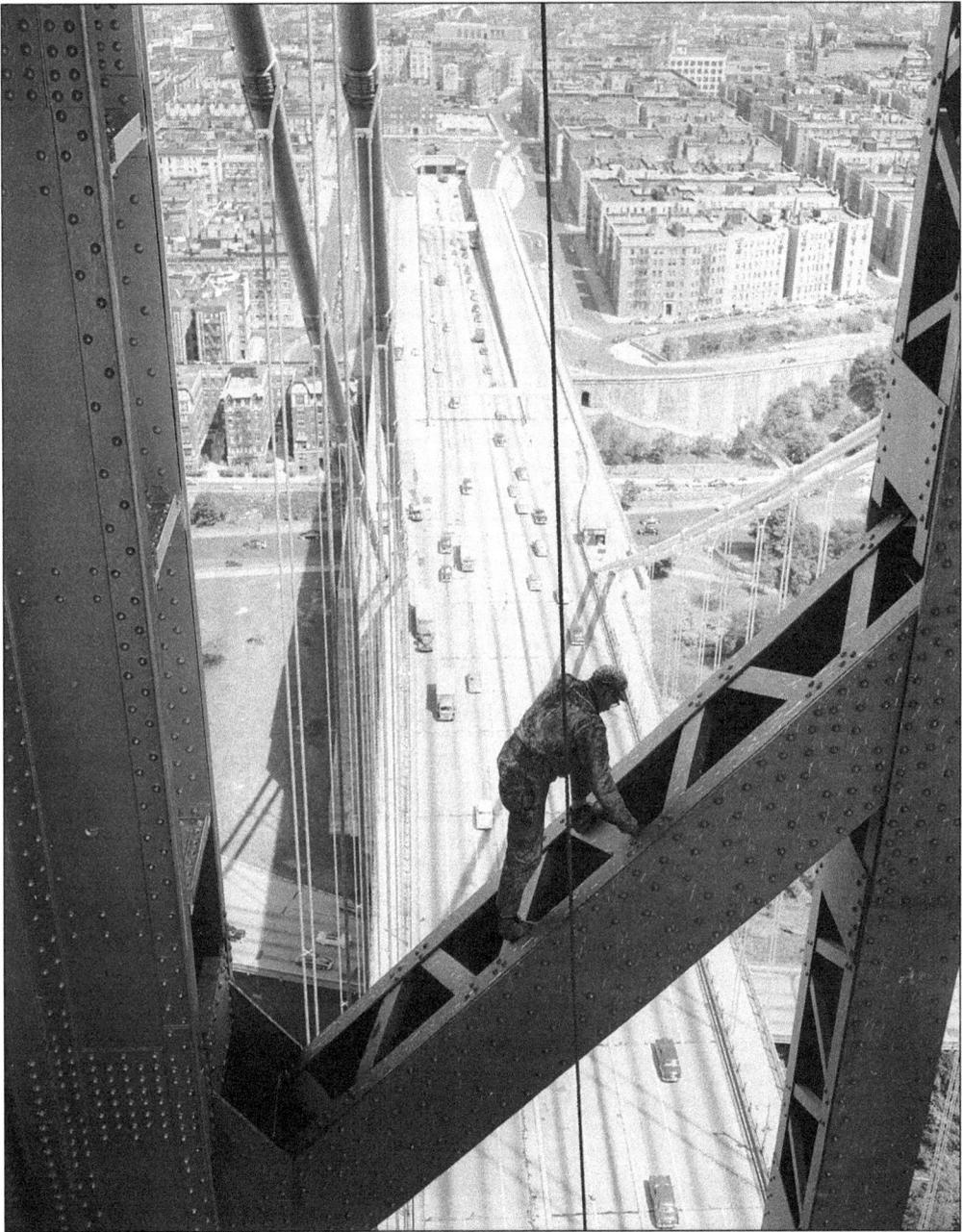

The photograph of the bridge worker scaling the tower seen here illustrates the amount of maintenance necessary for proper care of the bridge. Standing high above the Manhattan side tower, the worker carefully makes his way along the steel. Traffic can be seen far below. The upper level provides eight lanes for traffic, the lower level six more, making the George Washington bridge the only 14-lane suspension bridge in the world. (Courtesy Port Authority of New York and New Jersey.)

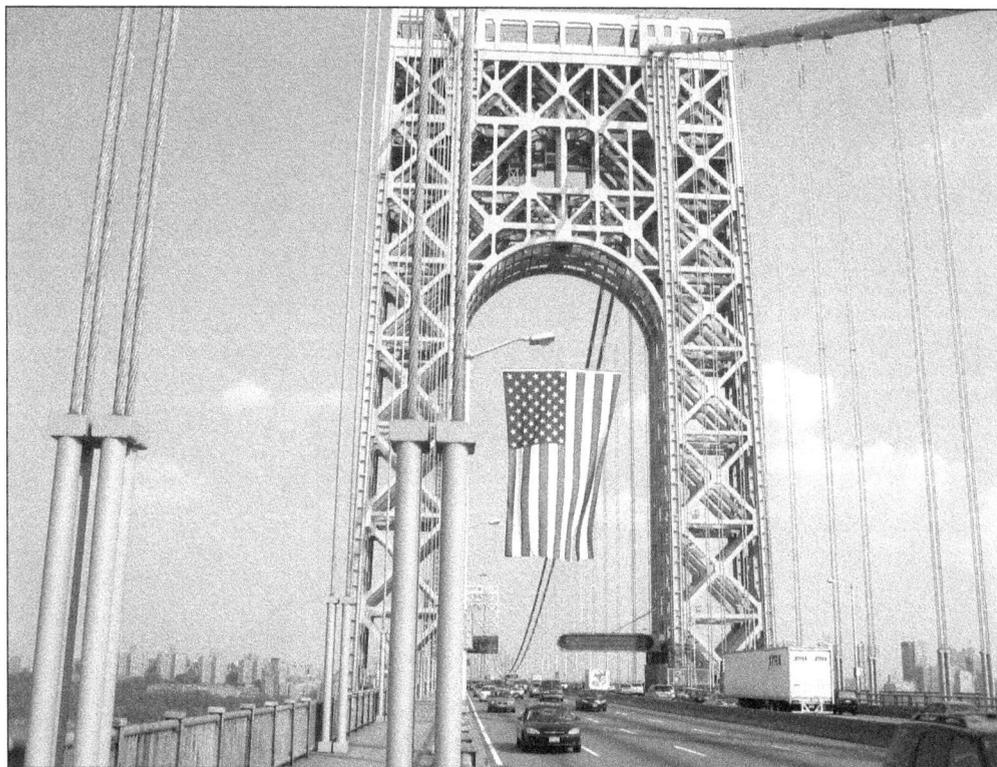

The busiest bridge in the world also boasts the largest free-flying American flag. The flag, flown on eight major holidays, hangs from the New Jersey tower. Each stripe is about five feet wide; each star measures about four feet in diameter. The flag flutters proudly in the breeze as thousands of people drive by each hour. (Courtesy Port Authority of New York and New Jersey.)

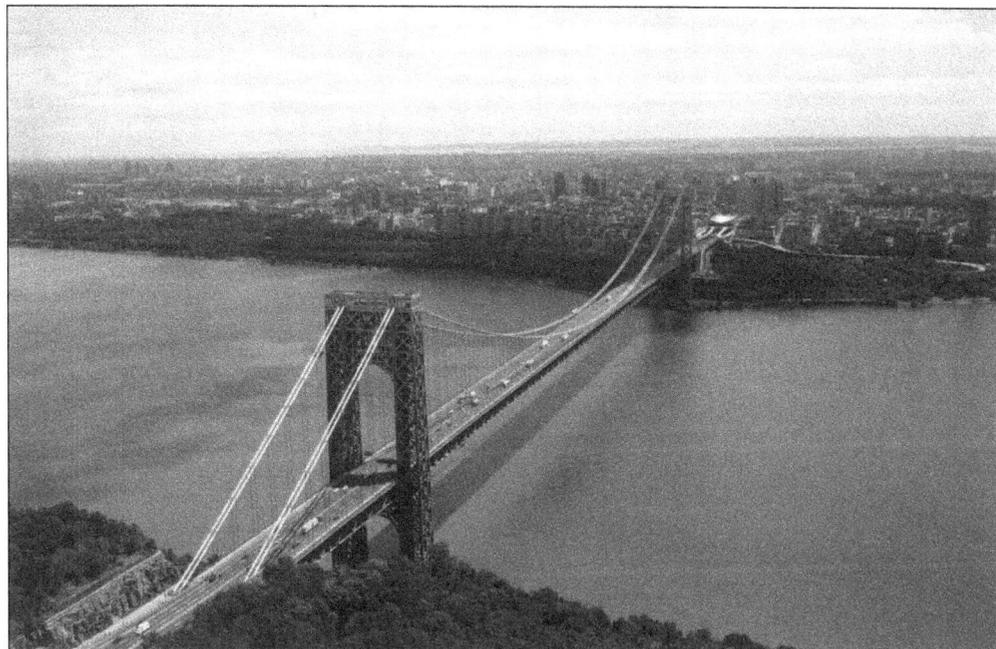

Five

NEW YORK STATE BRIDGE AUTHORITY

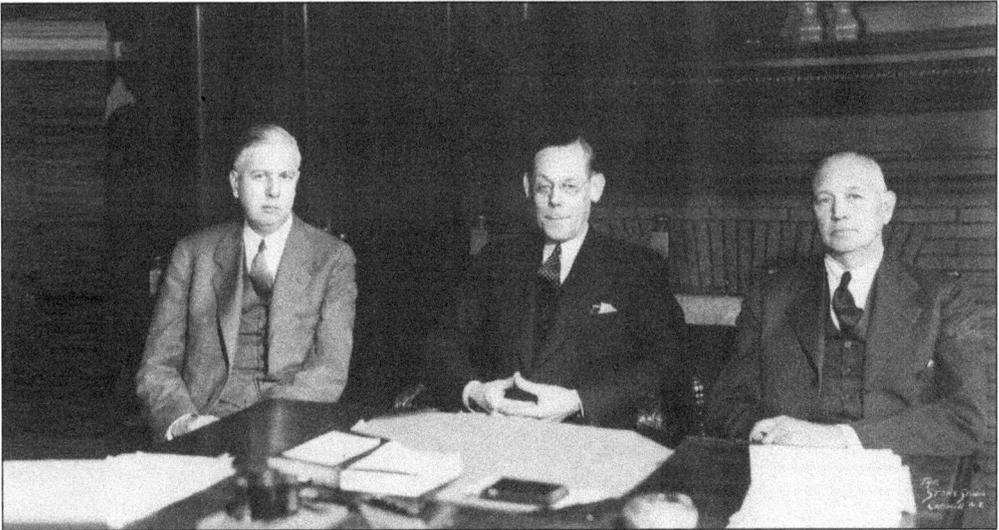

The NYSBA was created on March 31, 1932, when Gov. Franklin D. Roosevelt signed the bill into law establishing the authority to construct, operate, and maintain crossings over the Hudson River north of the present Tappan Zee bridge and south of the Castleton Bridge in Albany. The NYSBA board in office during the acquisition of the Bear Mountain bridge is pictured here. From left to right, they are Raymond D. Kennedy, chairman Addison P. Jones, and Robert Hoe. Kennedy was appointed by Gov. Herbert H. Lehman in 1936; Jones and Hoe were original board appointments by then governor Roosevelt in 1932.

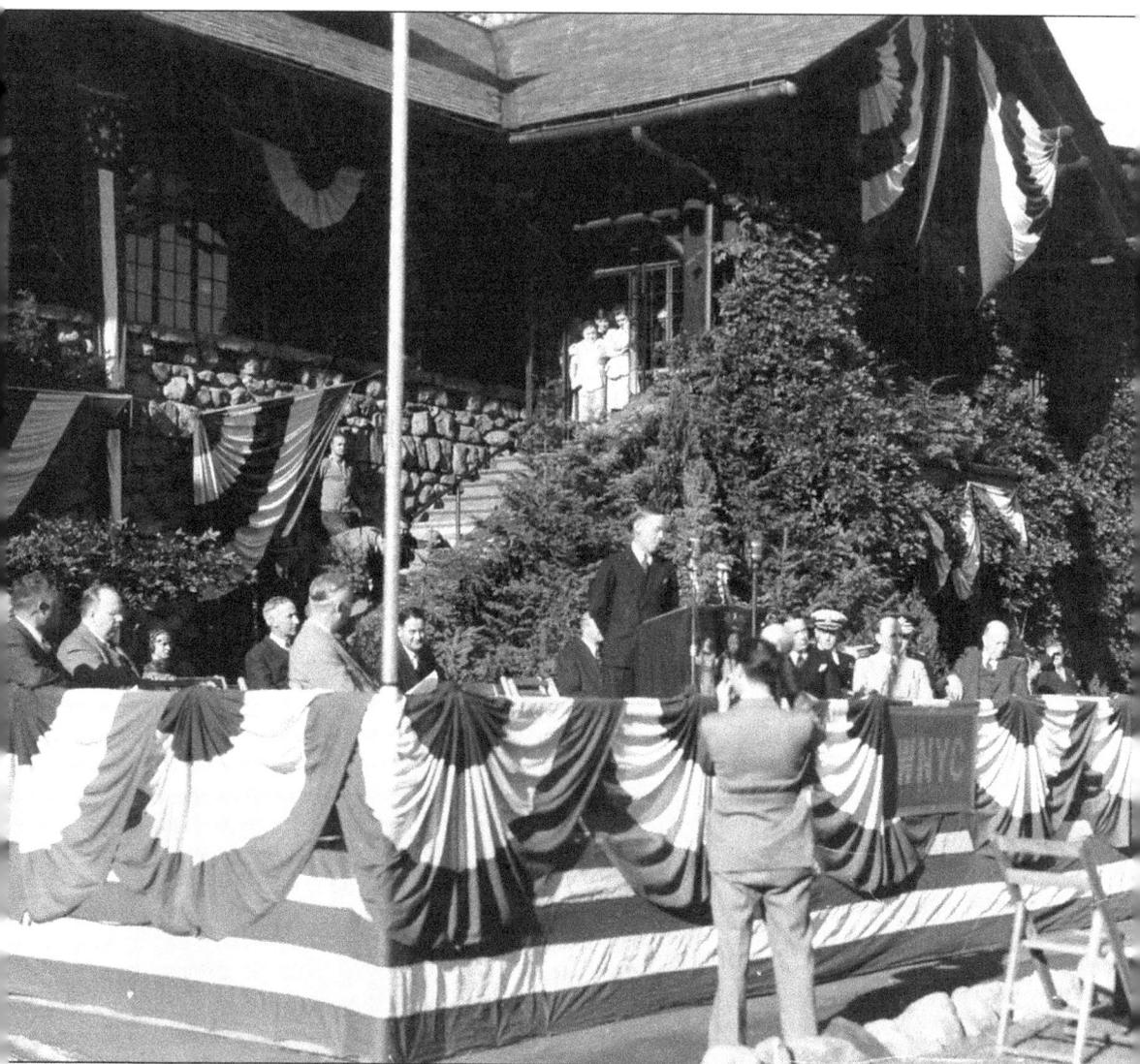

NYSBA operations are determined by a legislative charge to perform a specific mission. The first two tasks of the new NYSBA were to assume responsibility for the Mid-Hudson bridge and to secure financing, then construct the Rip Van Winkle Bridge connecting Catskill and Hudson. Then on September 25, 1940, the NYSBA purchased the Bear Mountain bridge, from the private company that had built it, for $2,275,000 by the issuance of bonds. In a ceremony seen here at the Bear Mountain Inn, chairman Addison P. Jones is making a speech to the audience. Provisions set by agreement between the State of New York and the Bear Mountain Hudson River Bridge Company allowed for the bridge to be taken over by the state after a period of time following the completion of construction in 1924. The NYSBA assumed operation of the bridge the next day, the first action being to reduce the toll.

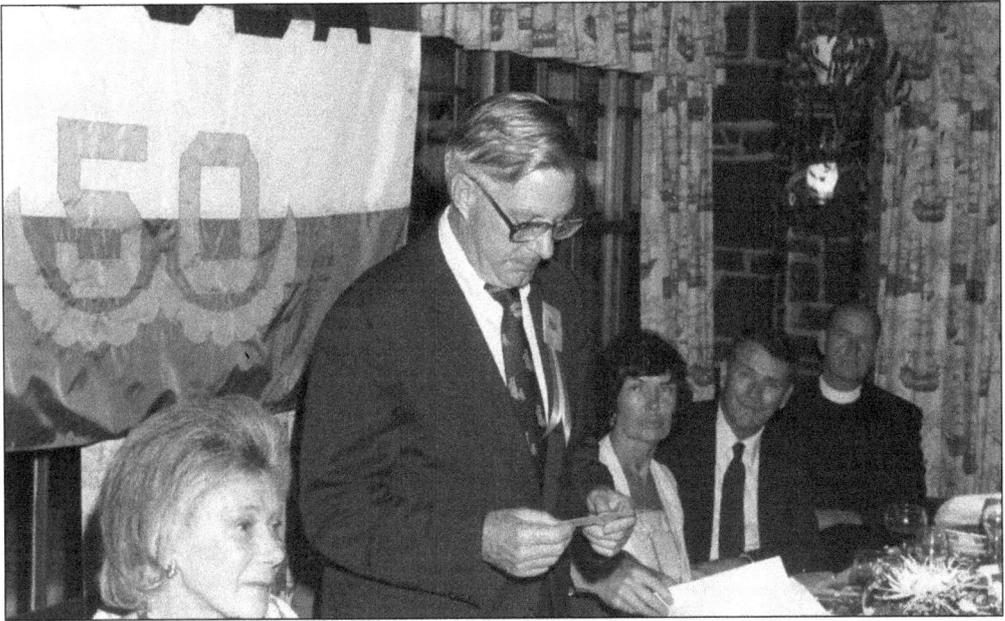

In 1982, the NYSBA recognized 50 years of serving the Hudson Valley with a celebration at the Ship's Lantern Inn in Milton. Standing in the photograph above, chairman John Stillman referred to the evening as a "family celebration" and dedicated the event to the recognition of the past and present commissioners who gave so generously of their time and energy to the NYSBA's welfare over the past 50 years.

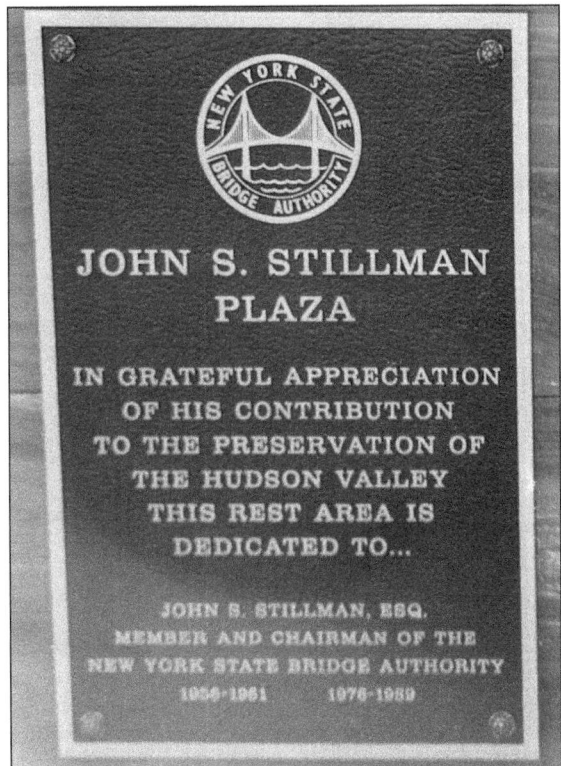

On October 24, 1990, the dedication of the John S. Stillman Plaza, a pleasant rest area beside the Bear Mountain bridge west entrance, recognized and praised the efforts of chairman emeritus John S. Stillman on behalf of both the economic development and environmental preservation of the Hudson Valley community. The plaque on the right is affixed at the area.

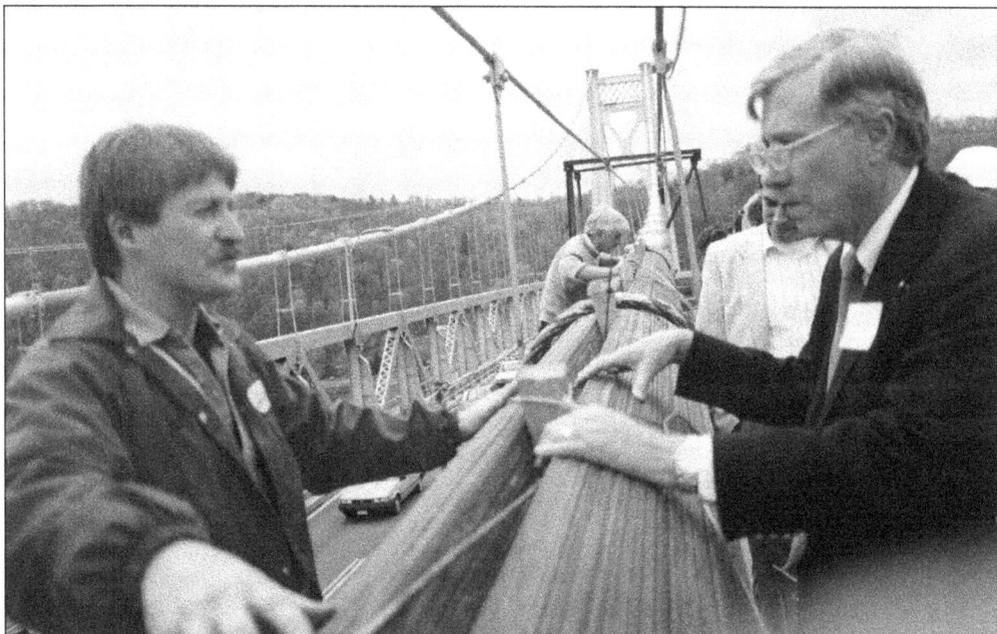

Inspection of one of the main cables of the Mid-Hudson bridge is shown here in the photograph above. With over 20 years at the NYSBA, William Moreau, on the left side of the photograph, is chief engineer. The cable inspection took place during the First International Suspension Bridge Operator's Conference in 1991. The NYSBA was the host and originator of the conference attended by bridge engineers from all over the world.

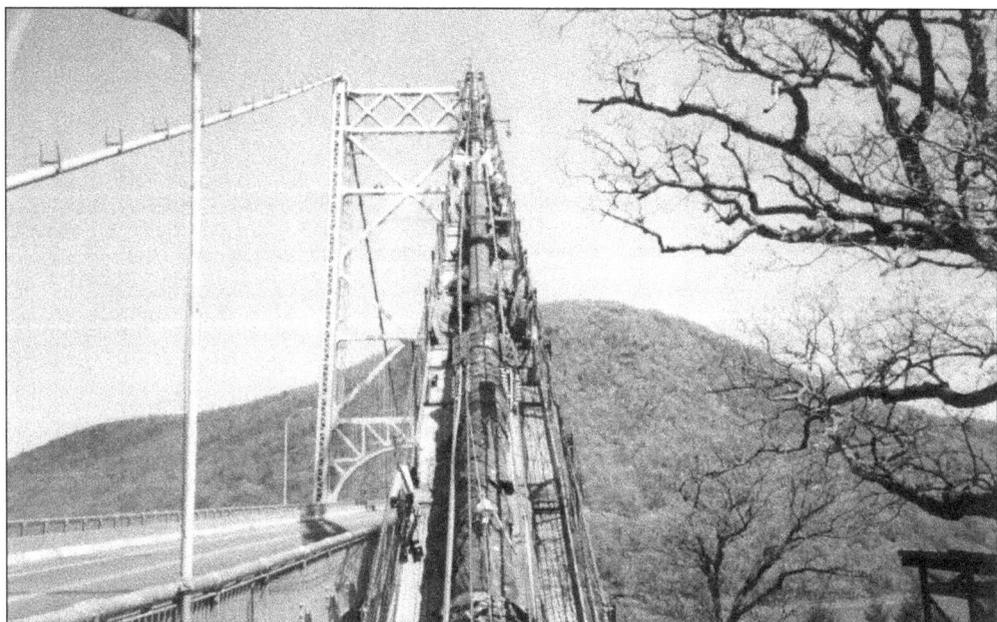

In April 2000, the Second International Suspension Bridge Operator's Conference was held at the Thayer Hotel at West Point. Seen in the photograph, a main cable of the Bear Mountain bridge has been opened for inspection. The conference was attended by approximately 125 people from around the world, including those from England, France, Scotland, and Japan.

74

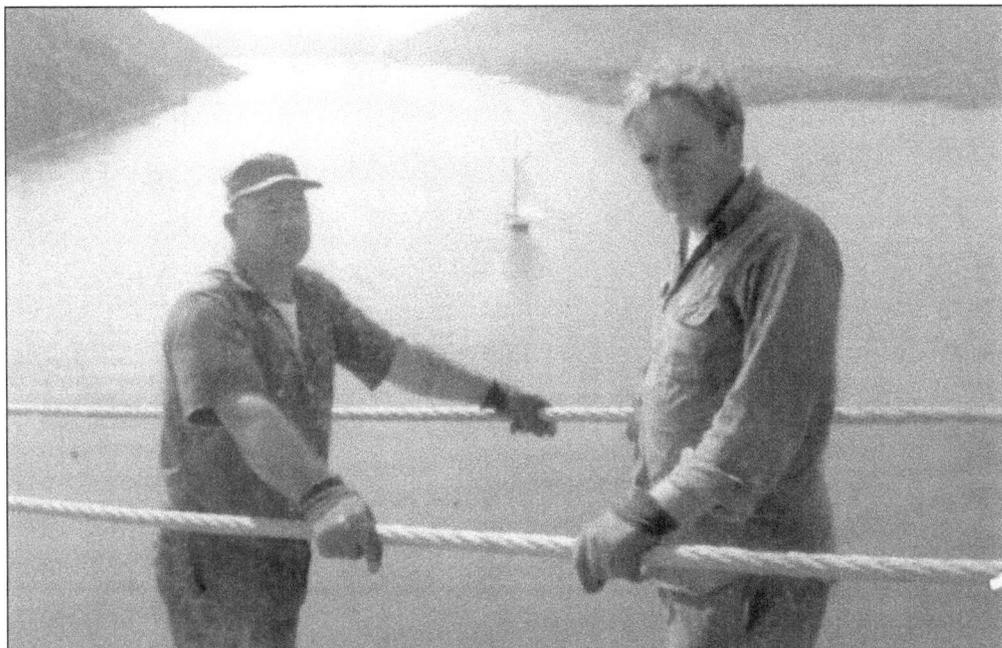

High on a main cable of the Bear Mountain bridge, with the photographer looking south down the Hudson River, are Morse Mathewson on the left and Klaus Roth. Both have since retired as foreman from the NYSBA, Mathewson after 27 years and Roth after 35 years. The sloop *Clearwater* is behind them in the Hudson River.

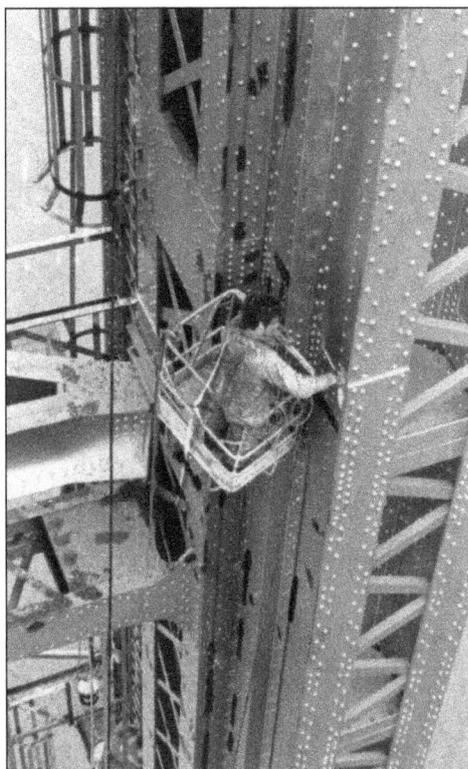

Hanging in a drum hoist, called a spider, is Rich Vacek, maintenance foreman of the Bear Mountain bridge. Vacek is painting the northeast tower. As Vacek remembers, shortly after this photograph was taken a strong gust of wind blew him from the south face to the east face of the tower. He credits Mathewson with saying the difference between bridge painters and other artists is that bridge painters cannot step back to admire their work. Vacek began with the NYSBA in 1973 as a college student intern and was full time by 1977.

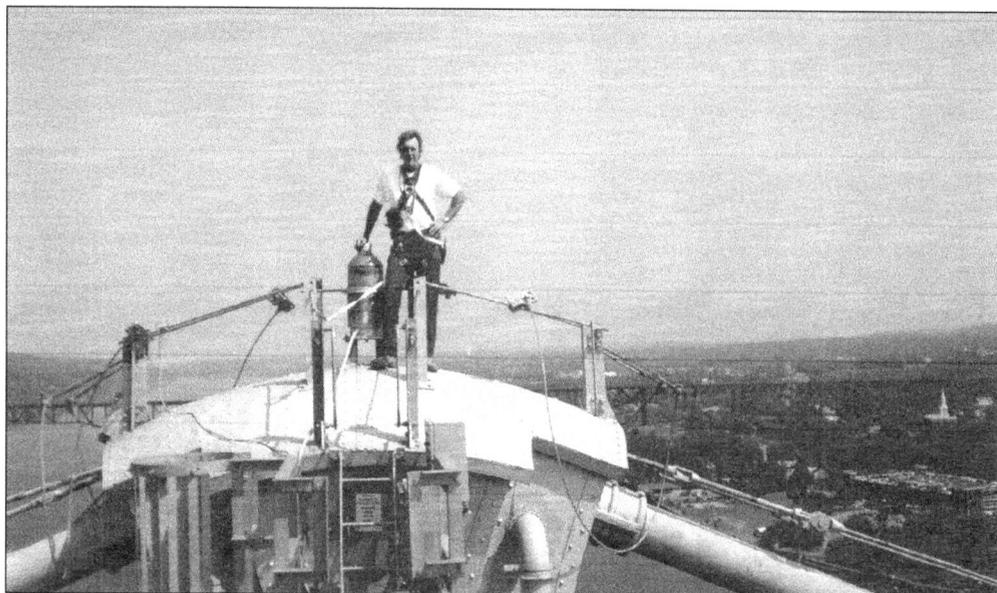

Many people over the years have contributed to the NYSBA's service to the Hudson Valley. The photograph above is of Don Faulkner, Mid-Hudson bridge maintenance foreman. He is standing on the top of the north cable of the Mid-Hudson bridge. The Poughkeepsie Railroad Bridge can be seen in the distance behind him. The photograph below is of Joe Rochfort, bridge maintenance engineer with the NYSBA since 2000. Rochfort is standing on the top of the west tower of the Bear Mountain bridge.

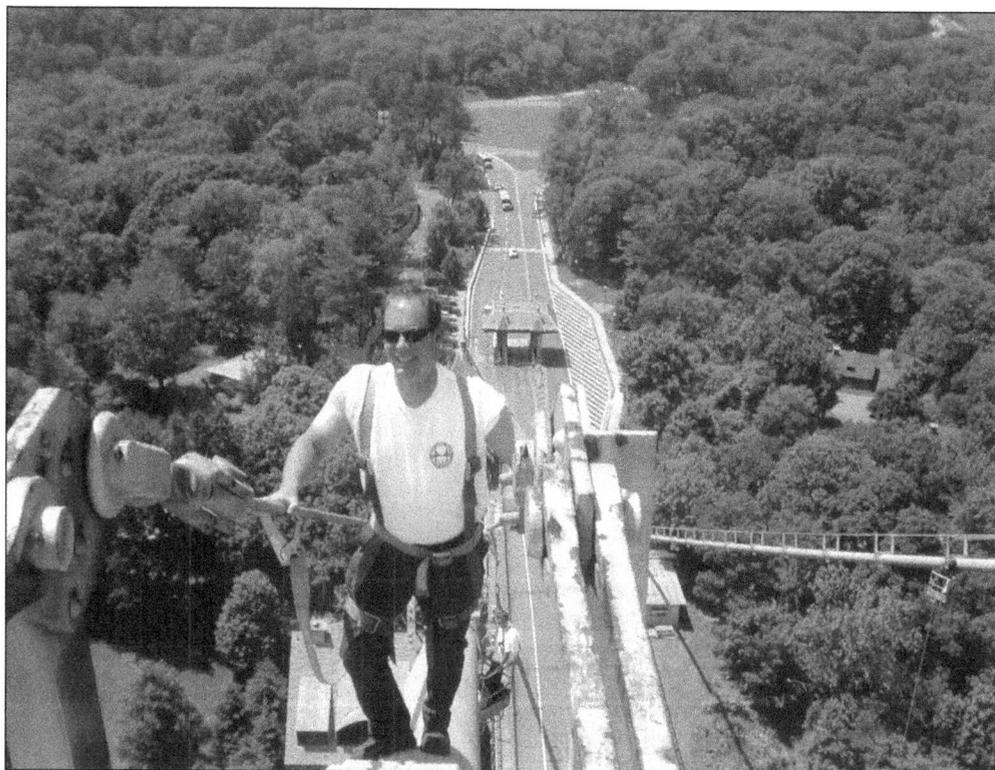

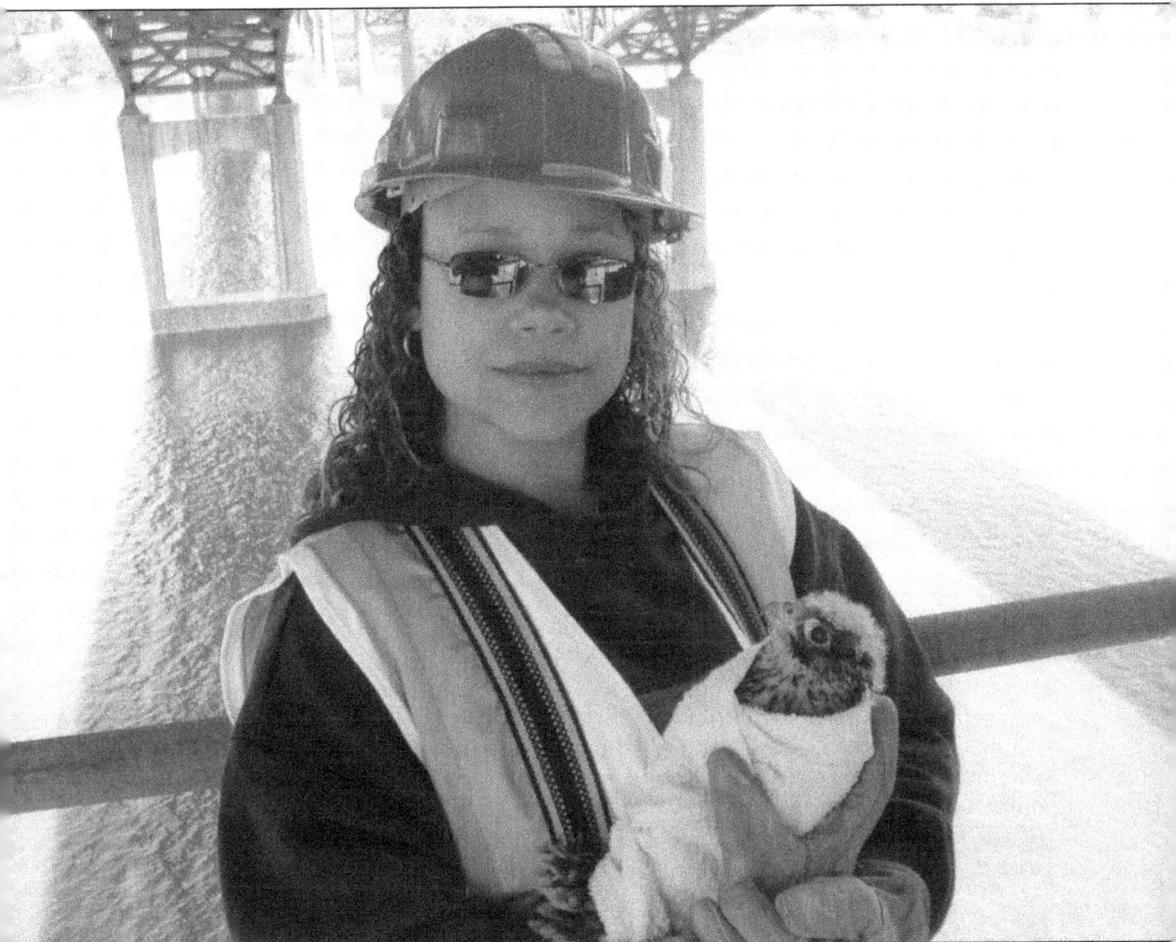

Holding a baby peregrine falcon is Olive Rose, assistant to the director of public relations and planning. Rose is under the deck of the Newburgh-Beacon bridge where one of the NYSBA's special falcon nests holds several baby falcons. Rose named the falcon Sebastian after her son; another of the babies is Olivia after her daughter. The falcons are an important cooperative effort between the NYSBA and the New York State Department of Environmental Conservation. The project was begun in the late 1970s by volunteers.

There has been a member of the Brooks family at the Mid-Hudson bridge for almost 50 years. Cecil, on the right, began working at the Mid-Hudson bridge in 1957 and retired in 1977 as assistant bridge manager. His son John, senior toll collector who started in 1966 and retired from permanent service in 1997, still works on a part-time basis. In addition to the few people highlighted here, the NYSBA employs 231 dedicated people helping to keep the bridges safe and convenient for all travelers. The NYSBA will be celebrating 75 years of service to the Hudson Valley in 2007.

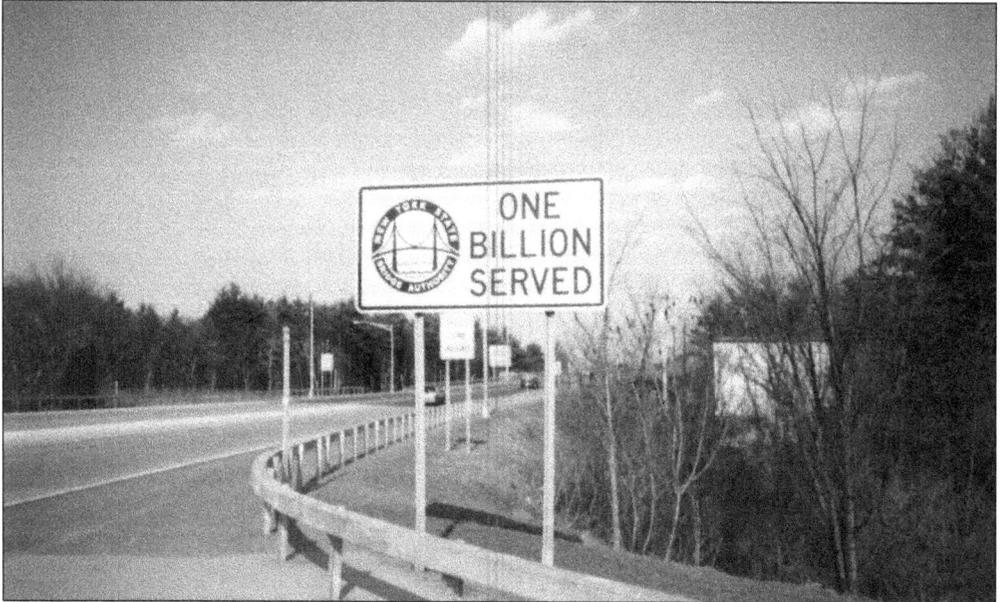

On January 10, 1994, the NYSBA served its one billionth patron since taking over the Mid-Hudson bridge in 1933. The one billionth driver paid less than half the toll that the first patron paid in 1933. In 1933, the toll was 80¢ each way; in 1994, the toll was 75¢ for the round-trip with regular commuters paying only 40¢ round-trip.

Six

RIP VAN WINKLE BRIDGE

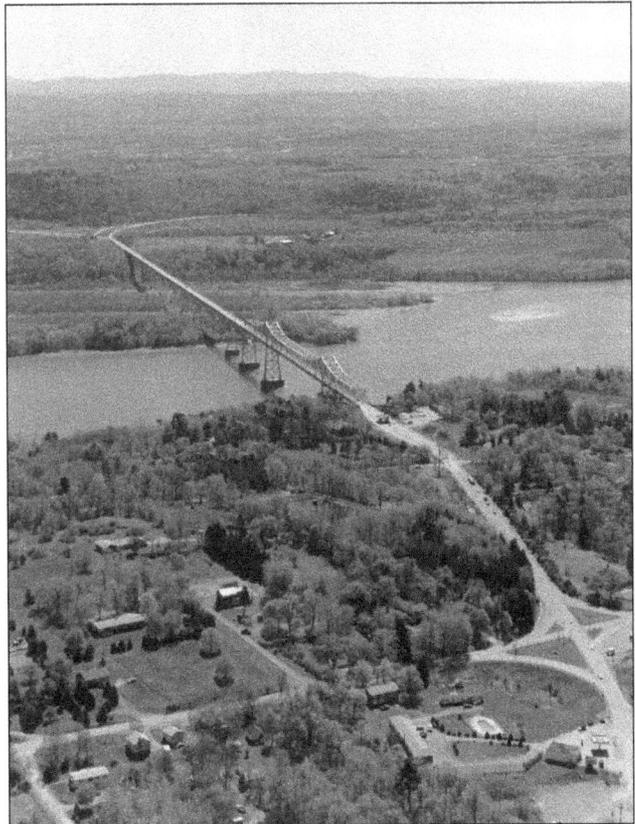

A bill in the New York State Assembly in 1930 to finance the proposed Rip Van Winkle Bridge was vetoed by Gov. Franklin D. Roosevelt just one year after he attended the opening of the Mid-Hudson bridge. He felt the bridge should be financed by the sale of bonds, not with state funds. The newly created NYSBA passed a resolution in 1932 to finance the bridge by applying for $3.4 million from the Reconstruction Finance Corporation to build the Catskill-Hudson Bridge.

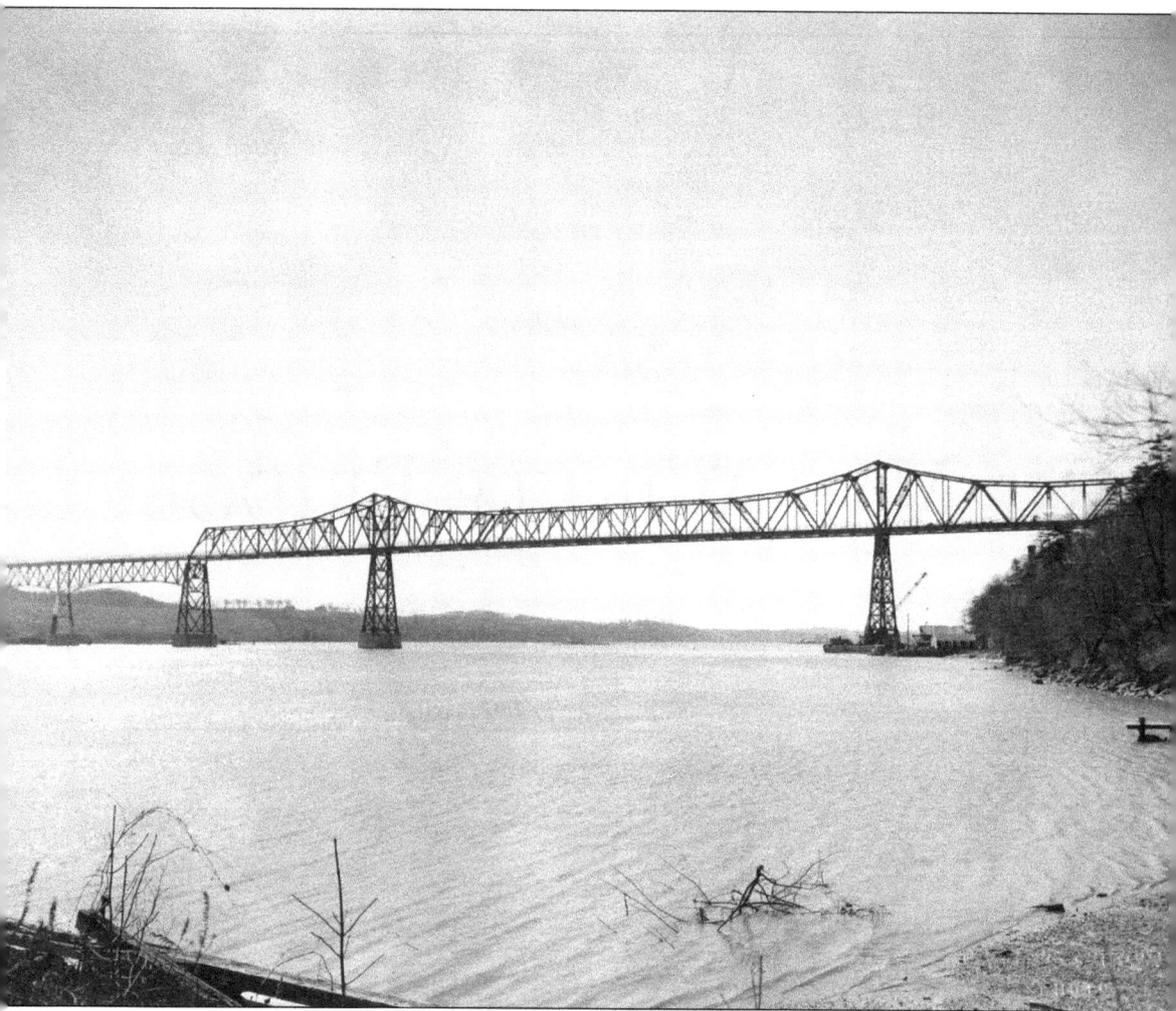

The new bridge would be a 13-span cantilever bridge design. To allow passage of freighters to and from Albany, the bridge would need to be 145 feet above the river. It would be 5,040 feet long from shore to shore. Although the new NYSBA was financing the project, the New York State Department of Public Works would be responsible for supervising the construction, as it had for the Mid-Hudson bridge.

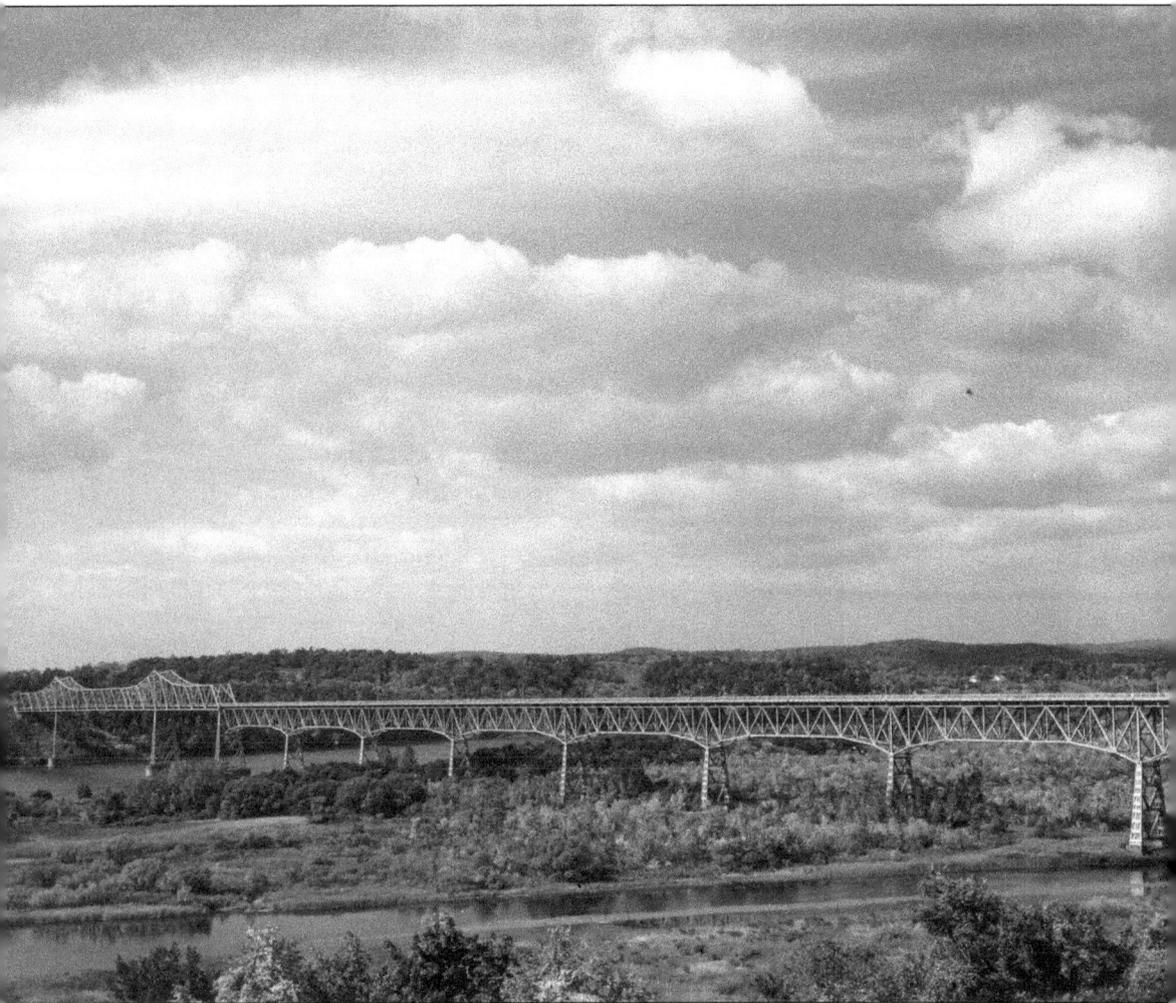

The Catskill-Hudson Bridge was needed to divert the overcrowding on the other Hudson River crossings. Ferries were not a feasible option on the Catskill-Hudson section of the Hudson River. In addition, people on the east side of the Hudson River wanted easier access to the Catskill Mountain area. People on the west side wanted easier access to the Berkshires and New England.

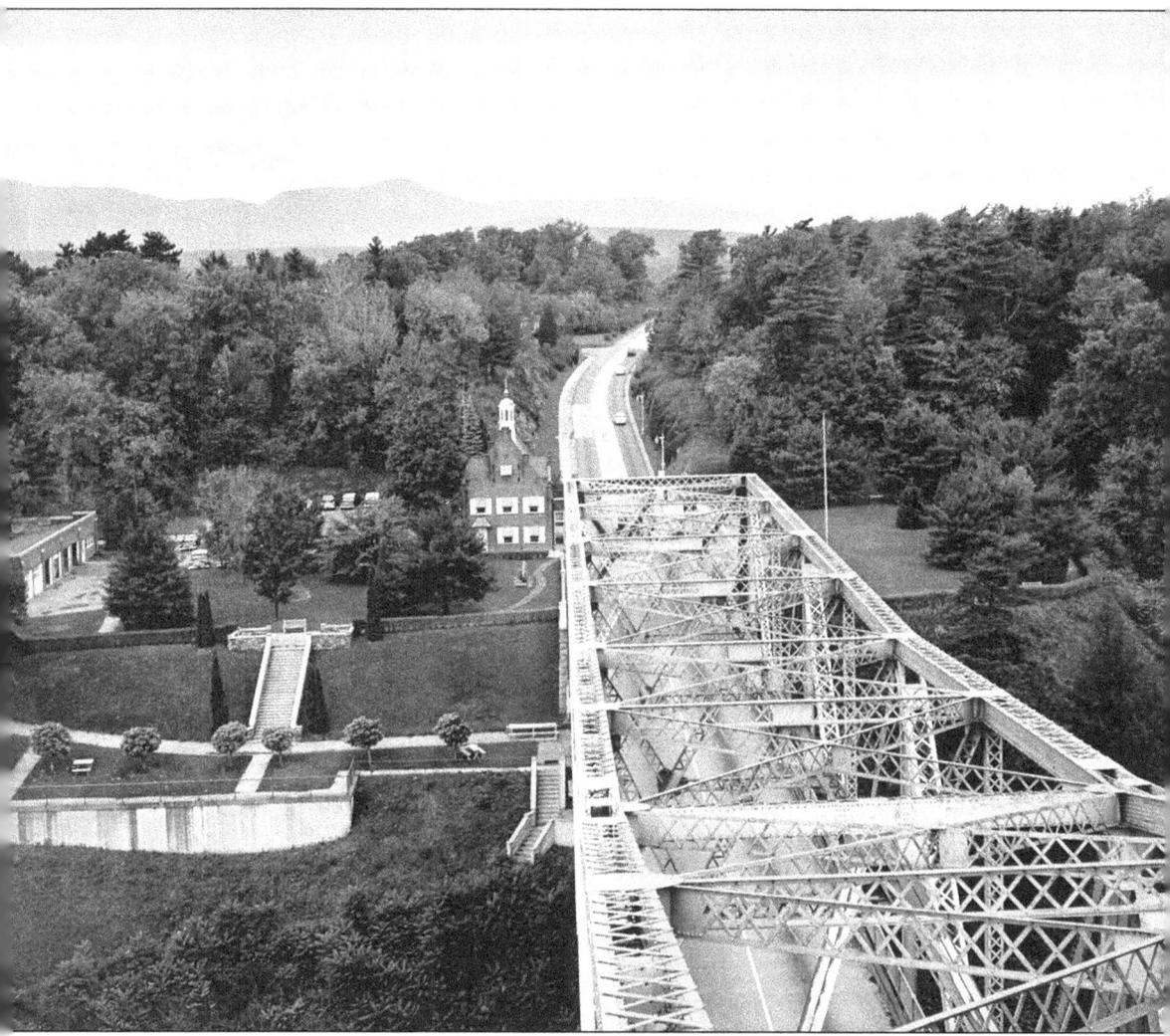

The original plan called for the western approach to be built on land owned by Thomas Cole, an artist of the Hudson River school. The heirs of Cole believed his land had historic value and wanted to receive no less than $100,000 for the property. The State of New York was offering $15,000. An agreement on payment could not be reached so the west approach was moved a bit north and the construction began.

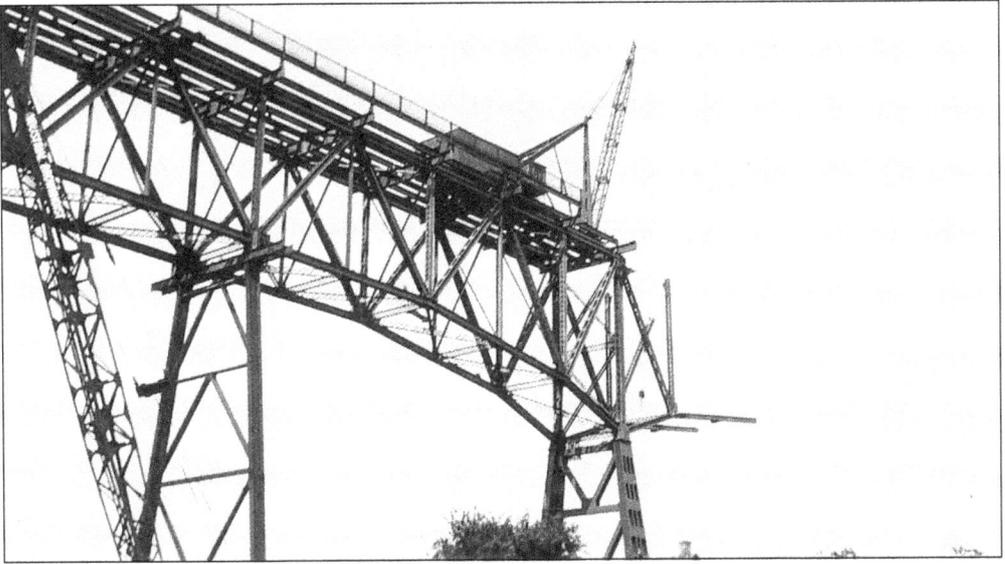

Steel used for the construction was brought to the bridge site by barges and trucks on the west side of the river and a temporary railroad built on the east side of the river. Derricks or cranes were used to lift the steel onto the bridge as the weather permitted. (Courtesy Catskill Chamber of Commerce.)

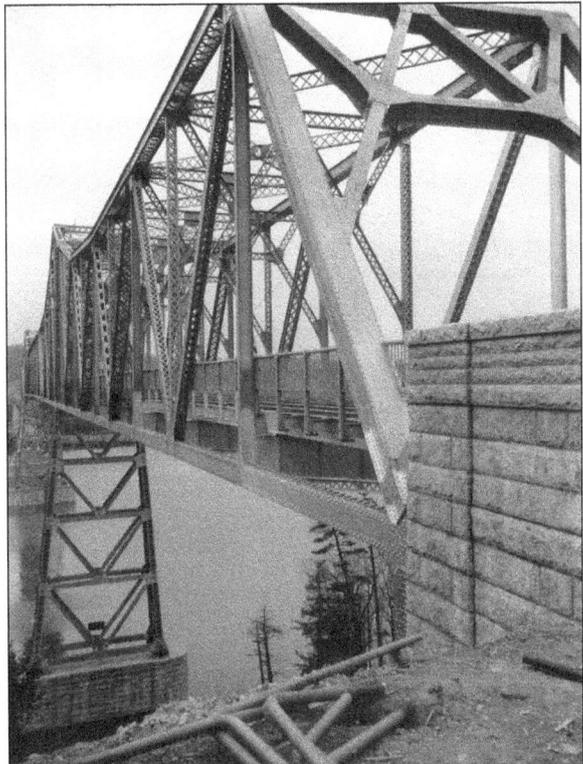

There was one strike during the construction in September 1934. Men had been earning $1 an hour for a maximum of 30 hours per week, as dictated by law at that time. In the settlement, the workers would continue to receive $1 an hour, but the work week would now consist of 40 hours, allowing for $10 more to be made per week.

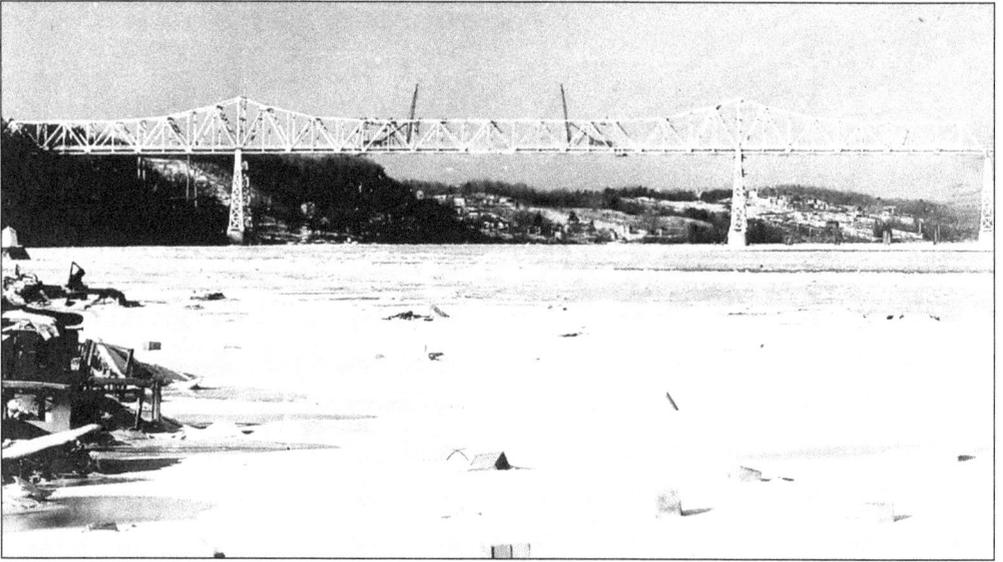

As the strike ended and work commenced, the administration building of the west end was nearly complete. The 13 piers were in place and seven of the individual sections of the span were ready to be set on the piers. Two cranes moved back and forth putting the steel girders into place. The workers followed, bolting and riveting the steel into place. Work continued through the winter and into the spring of 1935. Workers can be seen standing on the ice under the right side of the bridge. (Courtesy Catskill Chamber of Commerce.)

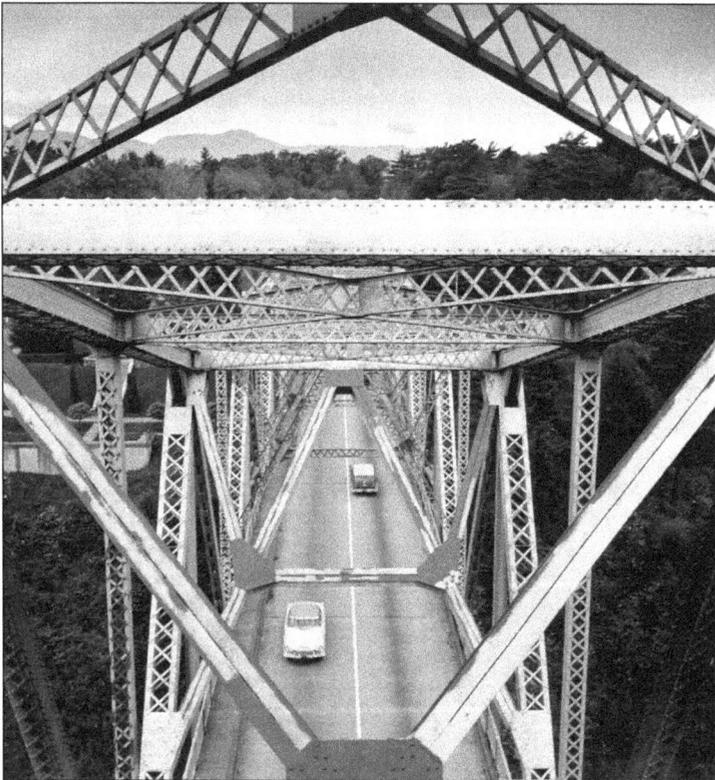

The rivets seen clearly in this photograph of the overhead bridge trusses of a cantilever section of the Rip Van Winkle Bridge were all hand driven. With careful maintenance, they will last for a very long time.

RIP VAN WINKLE
BRIDGE
ERECTED 1934–1935 BY THE
NEW YORK STATE
BRIDGE AUTHORITY
CLIFFORD L · MILLER
CHAIRMAN
ADDISON P · JONES
ROBERT HOE

FREDERICK STUART GREENE
CHIEF ENGINEER
HARVEY O · SCHERMERHORN
DEPUTY CHIEF ENGINEER
ROLAND B · SMITH
RESIDENT ENGINEER
GLENN B · WOODRUFF
CONSULTING ENGINEER

FREDERICK SNARE CORPORATION
CONTRACTOR

The Rip Van Winkle Bridge was completed, and opening ceremonies were held on July 2, 1935. Gov. Herbert H. Lehman and other state and local leaders were on hand to celebrate the opening of the first bridge built by the NYSBA and the 150-year anniversary of the city of Hudson. Ribbon cuttings were set for each end of the bridge. Unfortunately there was only one pair of scissors. One of the toll collectors had to run from one end of the bridge to the other so both ribbons could be cut on schedule. Toll-free trips were permitted until dark on July 2.

The Rip Van Winkle Bridge opened during the Depression. Over 400 men applied for the position of toll collector. Only eight of those men were fortunate enough to be hired. Of those eight men, one was Edward Burns, another was Aloysius Curran. Both men worked for the NYSBA for over 40 years. Burns served as chief operating officer for 22 years. Curran managed the Rip Van Winkle Bridge for 16 years.

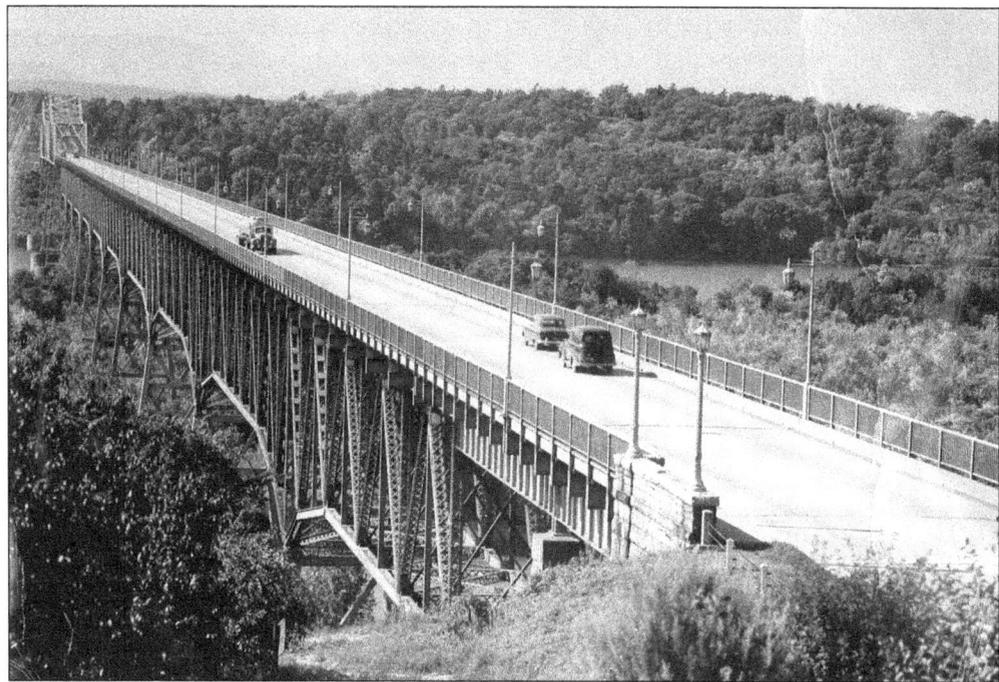

During World War II, heavily armed guards were assigned to protect the Hudson River bridges. Although the roadway of the bridge is clearly visible, the densely wooded area would present a problem if the threat had been real.

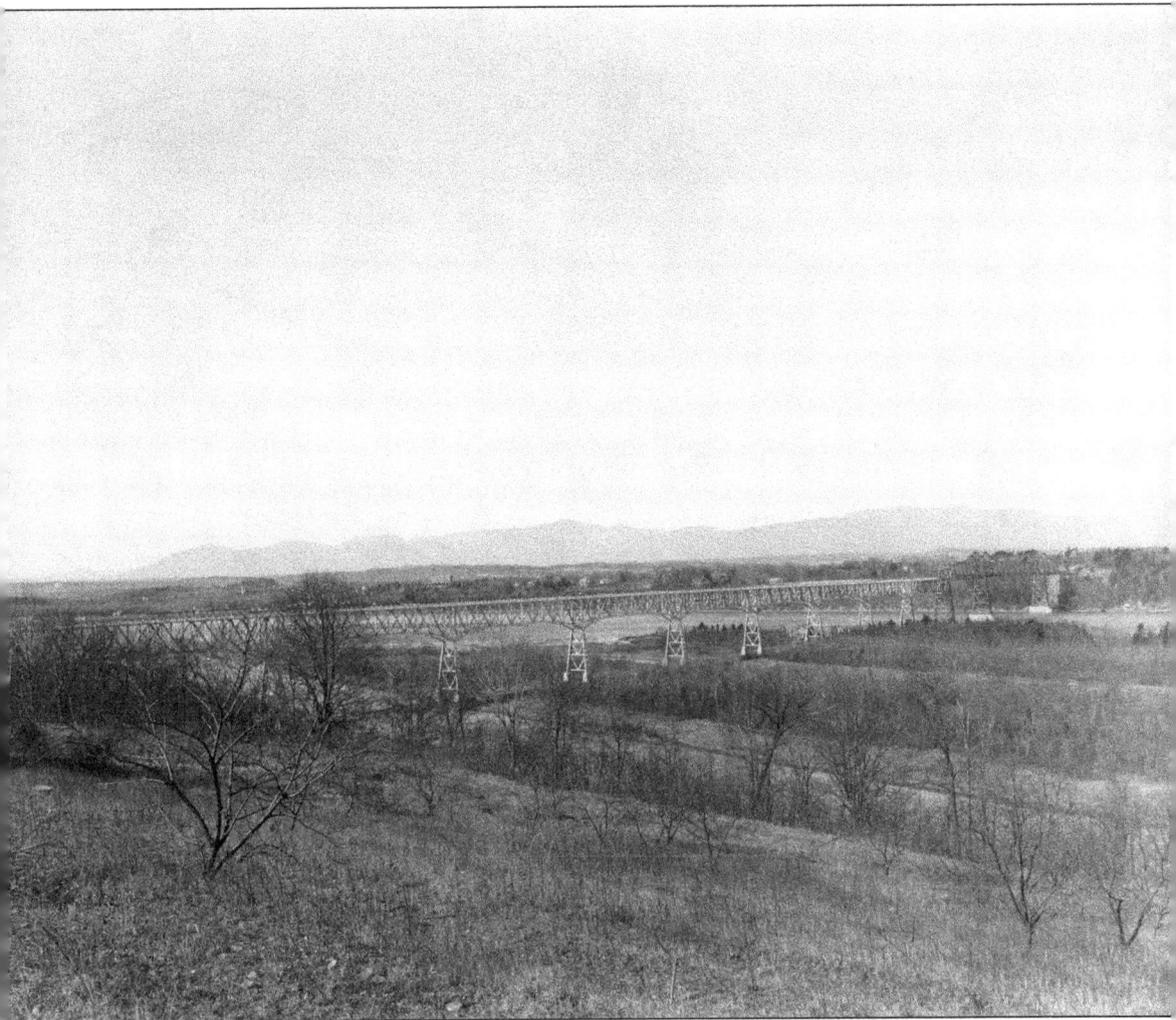

The village of Catskill can be seen here on the far shore of the opposite side of the river. The island on the east side of the river is called Roger's Island. Roger's Island was very important during the Revolutionary War. It is often the site of archaeological digs. The water around Roger's Island is an important spawning ground for the Hudson River shad, a large fish indigenous to the river.

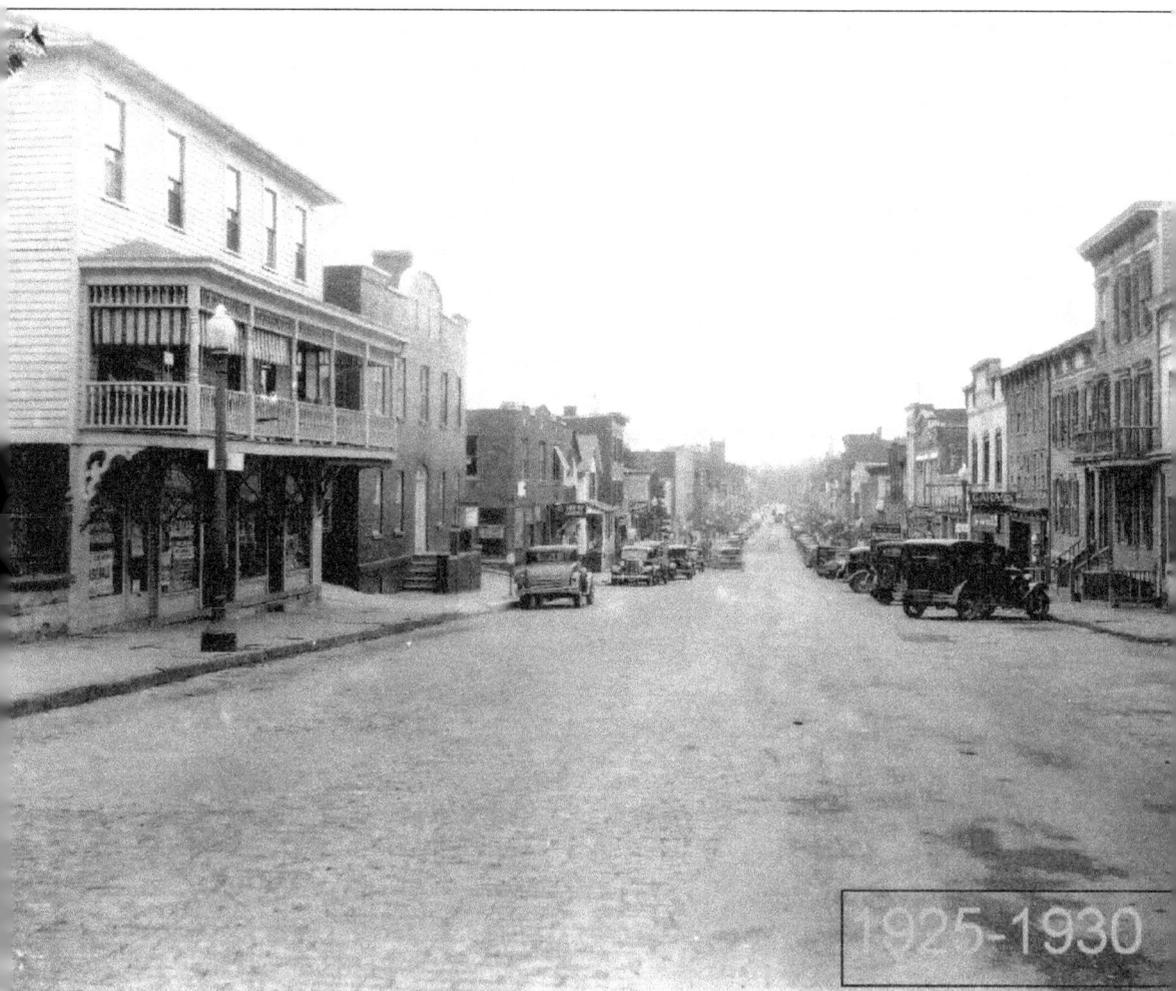

The village of Catskill is a small village at the foot of the Catskill Mountains. Seen here in 1930, it was a thriving community with its appealing main street lined with shops, restaurants, and services. (Courtesy Catskill Chamber of Commerce.)

Seven

TAPPAN ZEE BRIDGE

A bridge across the Hudson River at the widest point was first considered in the early 1920s. The development of the New York State Thruway in 1949 had the route ending in Suffern in Rockland County, with another spur running through Westchester County into New York City. A bridge across the Hudson River would connect those two arteries. The proposed site from Nyack on the west shore, seen above, to Tarrytown on the east shore was decided finally in 1951, putting the bridge just outside the jurisdiction of the Port Authority of New York and New Jersey, 25 miles north of New York City. (Courtesy Nyack Library Local History Collection.)

In the initial construction, the first pilings are driven into the river bottom as seen here from the Grandview area of Rockland County along River Road beyond the seawall. (Courtesy Nyack Library Local History Collection.)

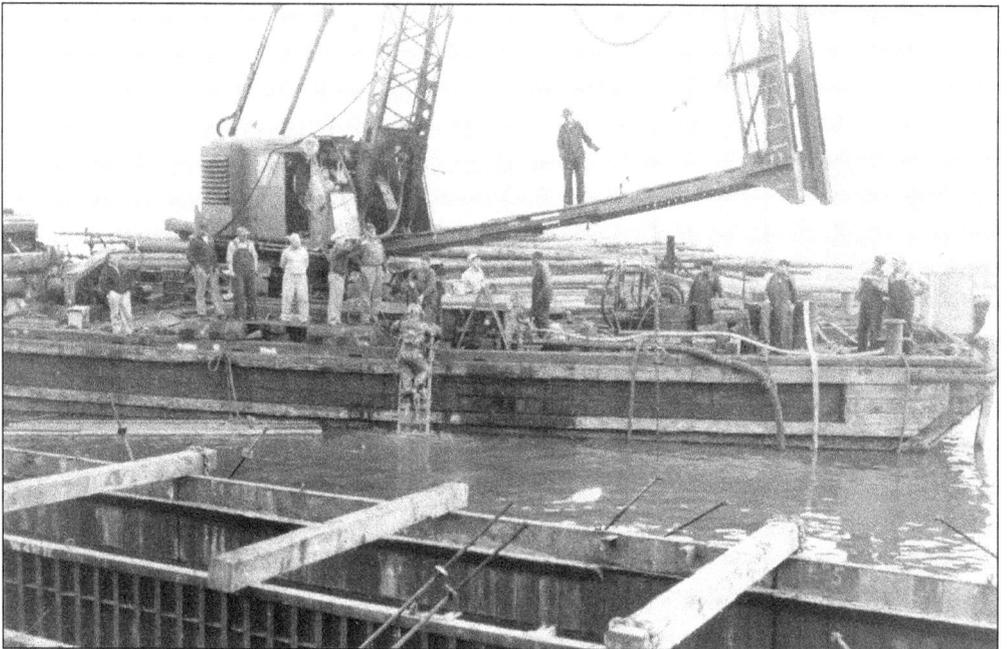

All work was done off barges floating in the river. A diver can be seen here climbing out of the Hudson River on the ladder in the center of the photograph. He is returning from a trip to the bottom of the river to guide the location of the pile driver. (Courtesy Nyack Library Local History Collection.)

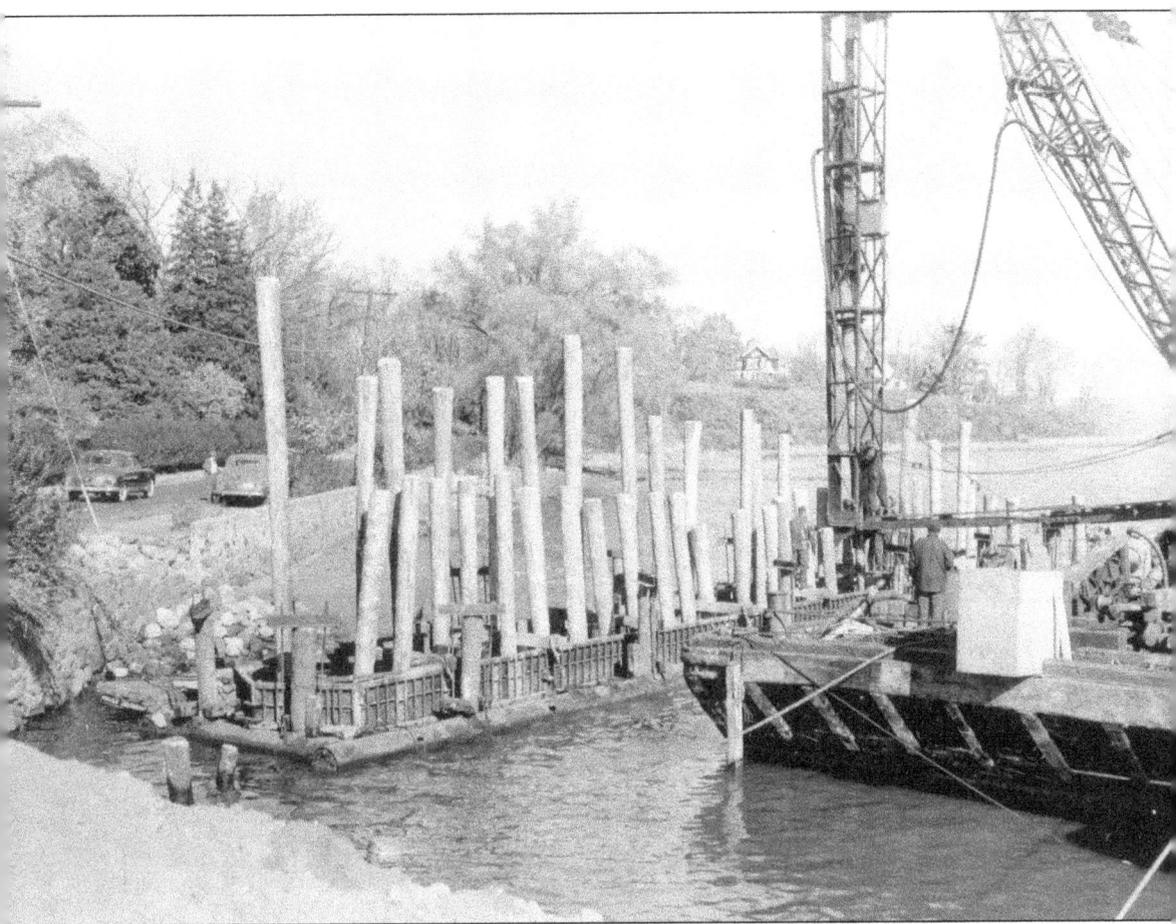

The pile driver rests on the west shore in Grandview after a yearlong trip across the Hudson River. Automobiles with spectators watching the work can be seen on River Road. (Courtesy Nyack Library Local History Collection.)

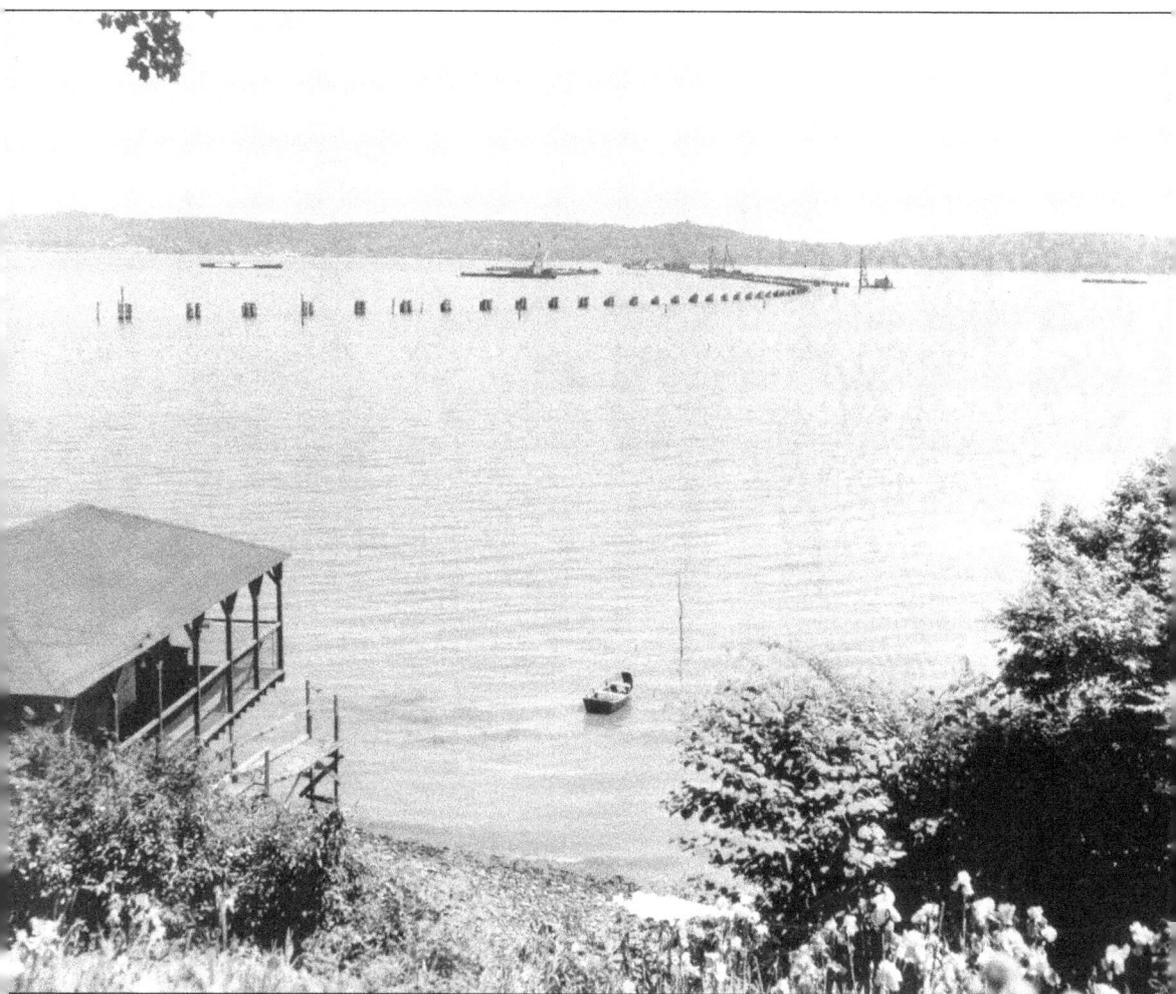

The Geist family boathouse is in the lower left of this photograph. J. Fred Geist is the photographer of many images of the collection represented here. Living right on the west shore very near the construction site, Geist was able to photograph the entire construction. Looking out into the river, the pilings curve away from the Rockland shore toward the Westchester side of the river. (Courtesy Nyack Library Local History Collection.)

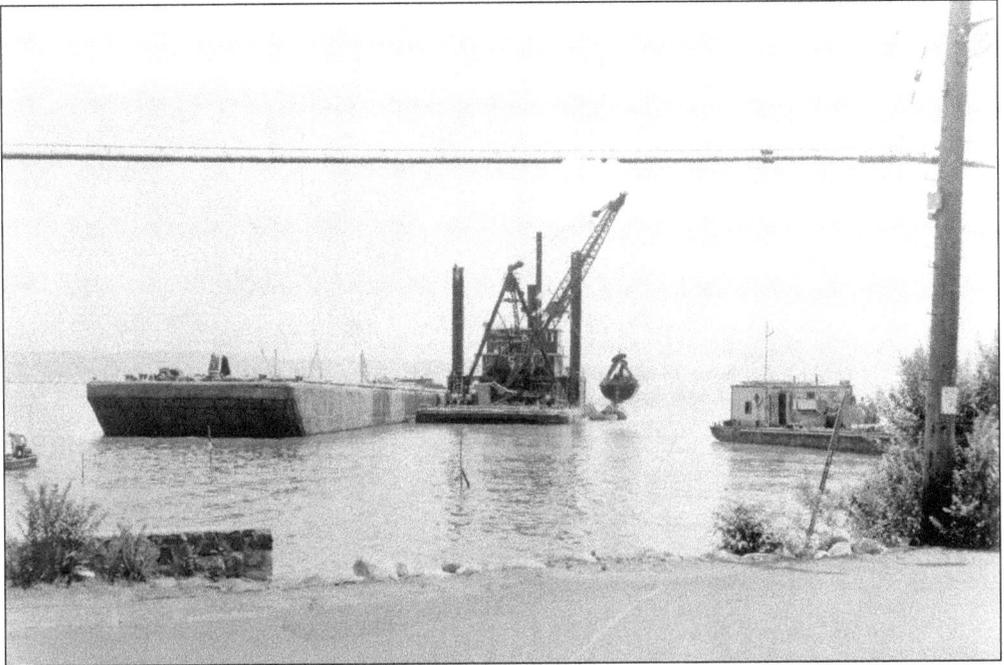

Dredging of the river bottom can be seen here. The barge to the left is being filled with Hudson River silt. A fisherman can be seen in the bottom left of the photograph. (Courtesy Nyack Library Local History Collection.)

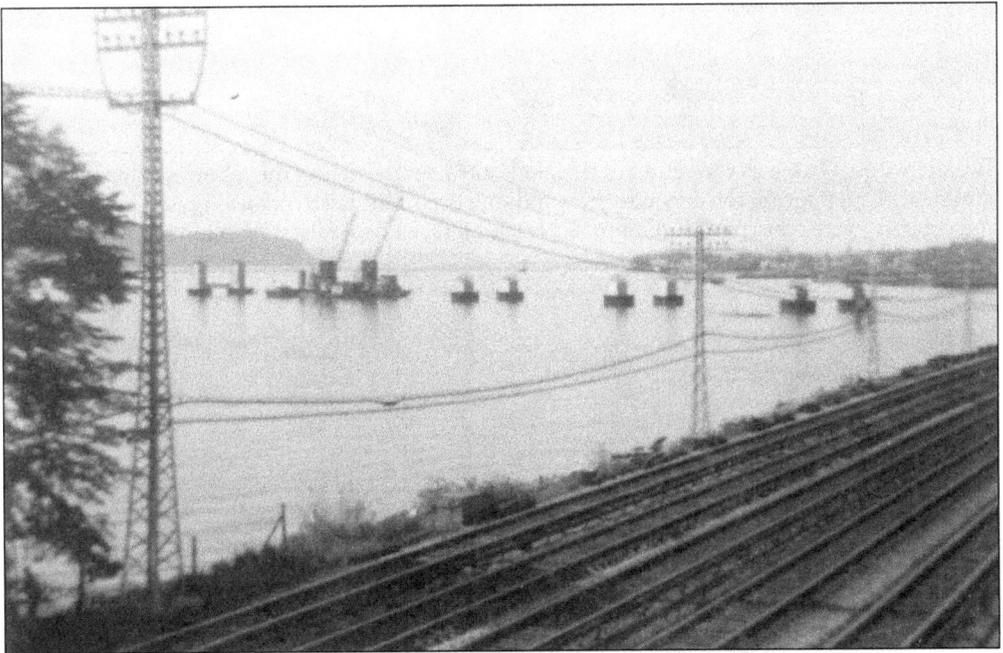

In this photograph taken from the Tarrytown side of the river in 1954, the piers can be seen over the New York Central tracks, now the Metro North and Amtrak rail lines. These rail lines travel all the way north up the east side of the Hudson River, passing under the rest of the bridges on the way to Albany. (Courtesy Nyack Library Local History Collection.)

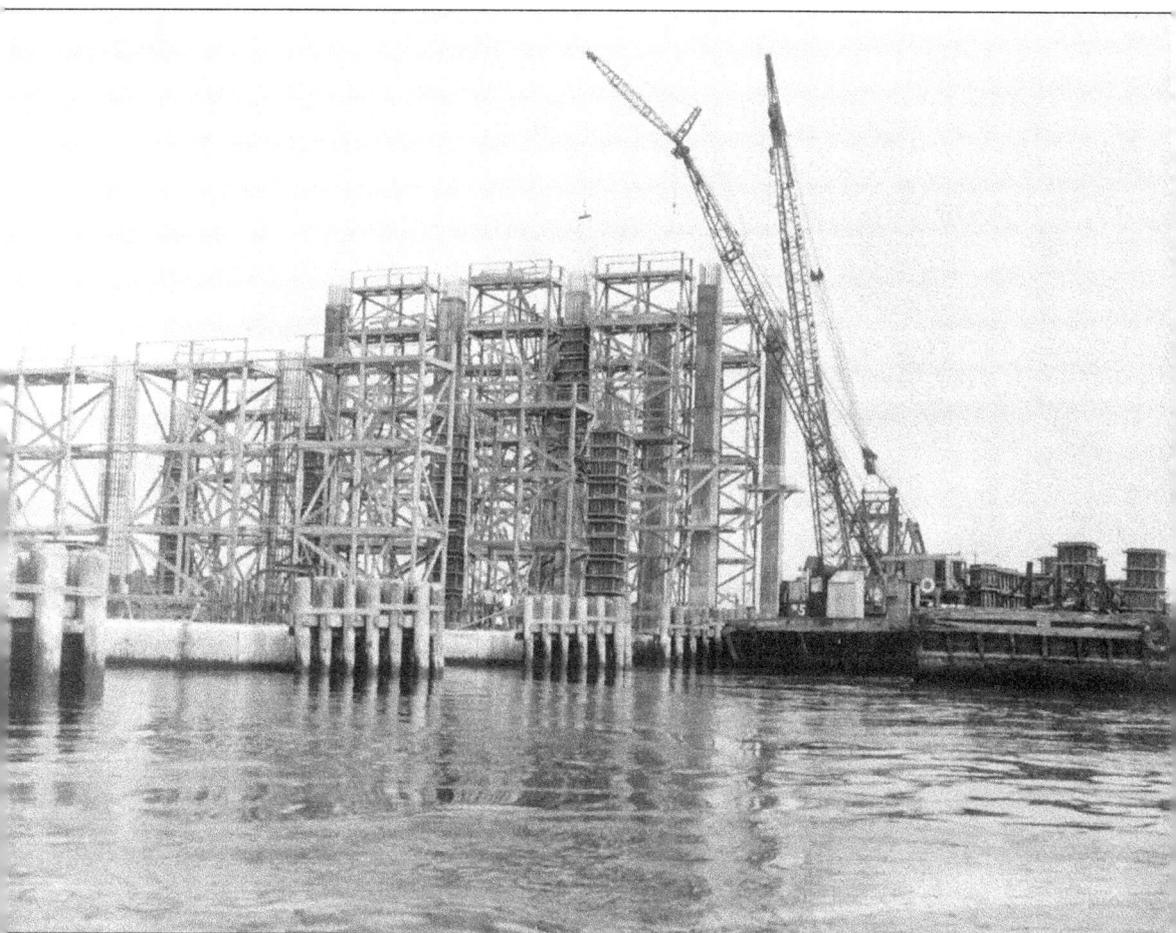

Two cranes on a barge in the center of the Hudson River are setting the falsework that is used as a framework for pouring the concrete piers and supports. This falsework was reused until all piers and supports were constructed. (Courtesy Nyack Library Local History Collection.)

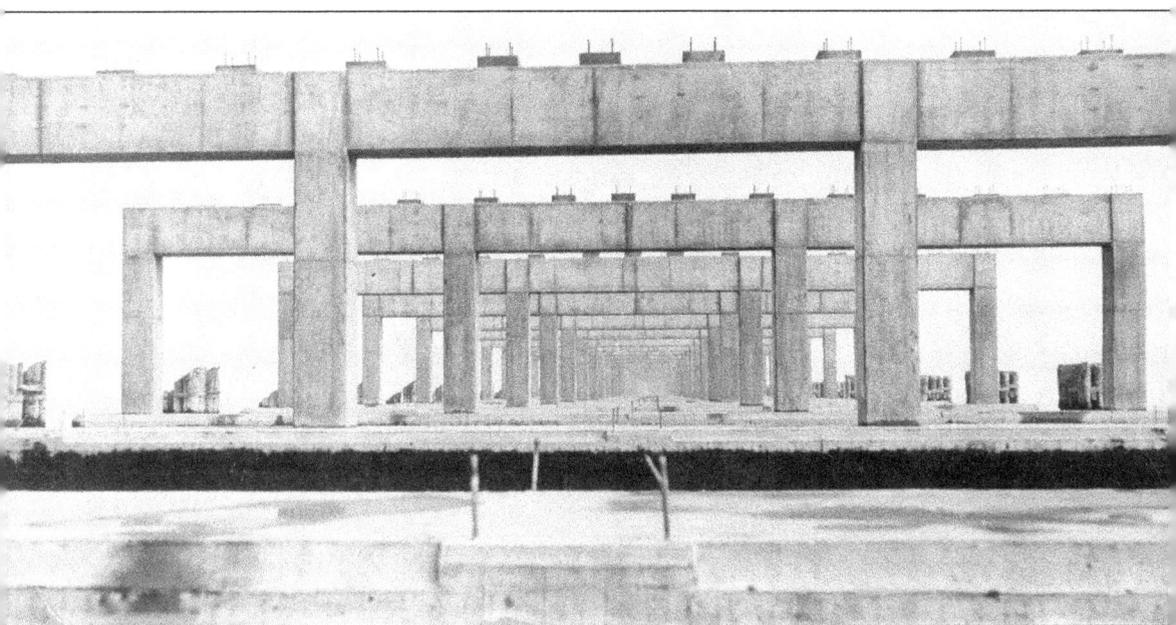

Here in this perfectly situated photograph, the view is through the concrete supports of the bridge. The supports appear to continue on forever. (Courtesy Nyack Library Local History Collection.)

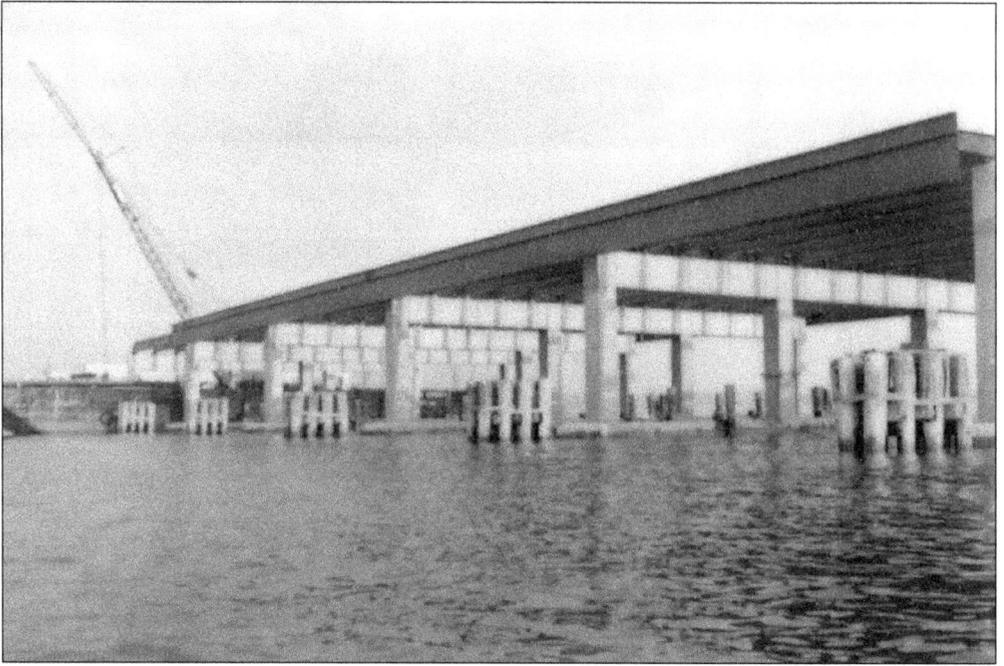

The long I beams connected with braces were assembled before the roadbed was laid. These sections form the long roadbed approaches to the center cantilevered section of the bridge. (Courtesy Nyack Library Local History Collection.)

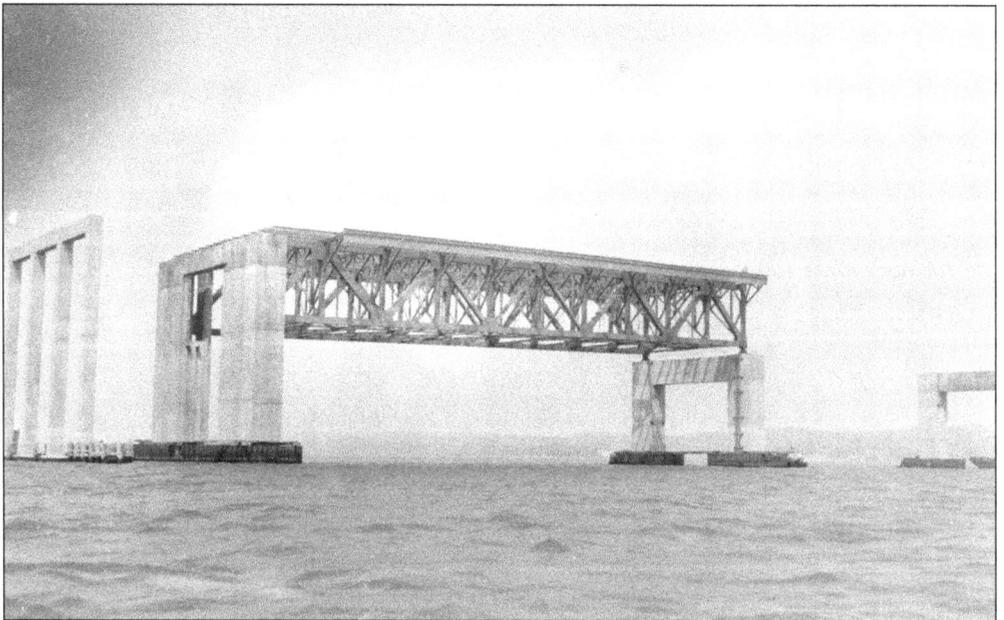

Here the concrete pillars are increasing in height toward the center span. The supports are connected with truss sections for greater stability. The deck truss spans were constructed in Grassy Point, on the Rockland County shore about 10 miles north of the bridge site. The spans were shipped by barge to be hoisted into place at the bridge site. (Courtesy Nyack Library Local History Collection.)

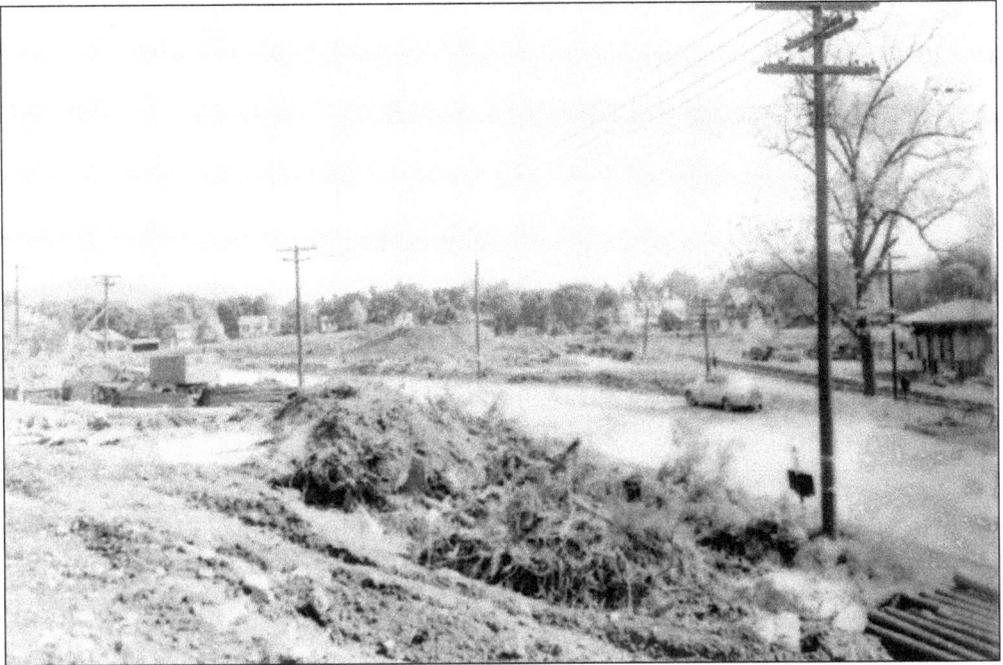

The ground is being torn up for the thruway on the Nyack side of the river. The building on the right of the photograph is the old South Nyack railroad station. The station and many homes were displaced by the building of the roadway. (Courtesy Nyack Library Local History Collection.)

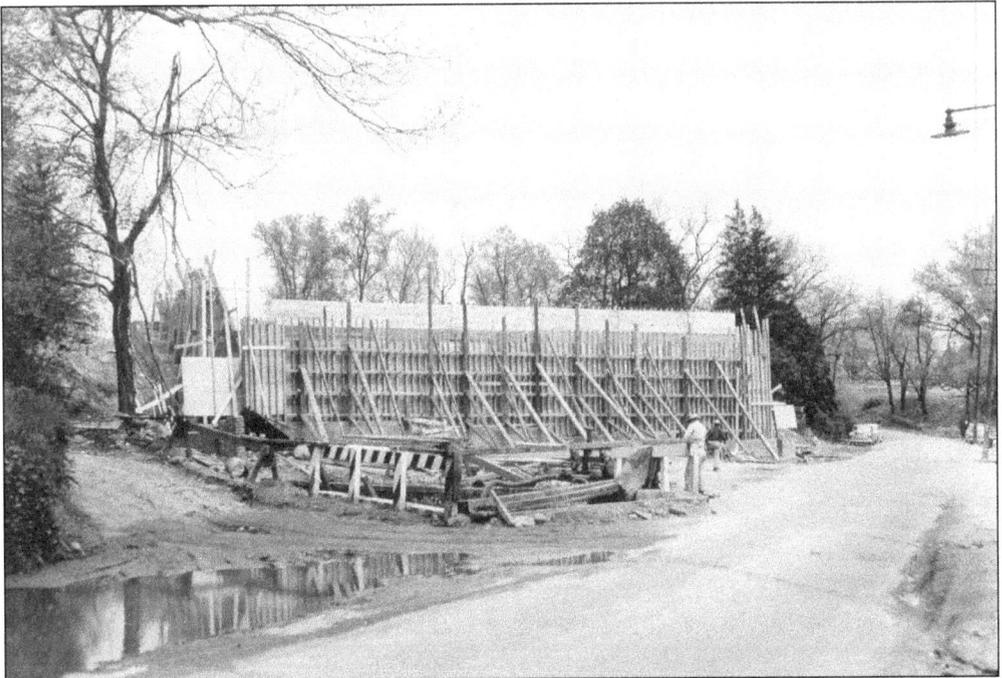

The wooden framework for the pouring of the cement for the roadway supports over River Road in the Bight section of Rockland County is seen here. These supports are for the entrance to the bridge from the Rockland side of the river. (Courtesy Nyack Library Local History Collection.)

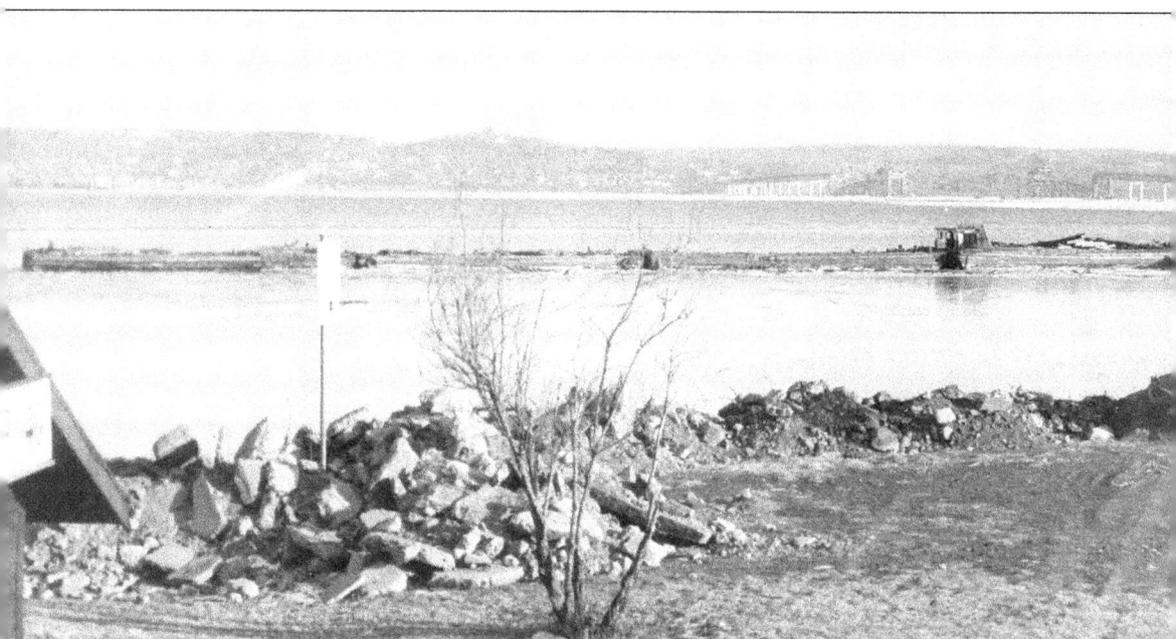

In the distance to the top right of the photograph, the main, or the cantilever, span is being constructed. The span is 1,212 feet long and provides for a clearance of an average 138 feet above the surface of the river. Two steel falseworks, each 16 stories high, with a derrick on top, were used to construct the main span with the two 293-foot-high towers. (Courtesy Nyack Library Local History Collection.)

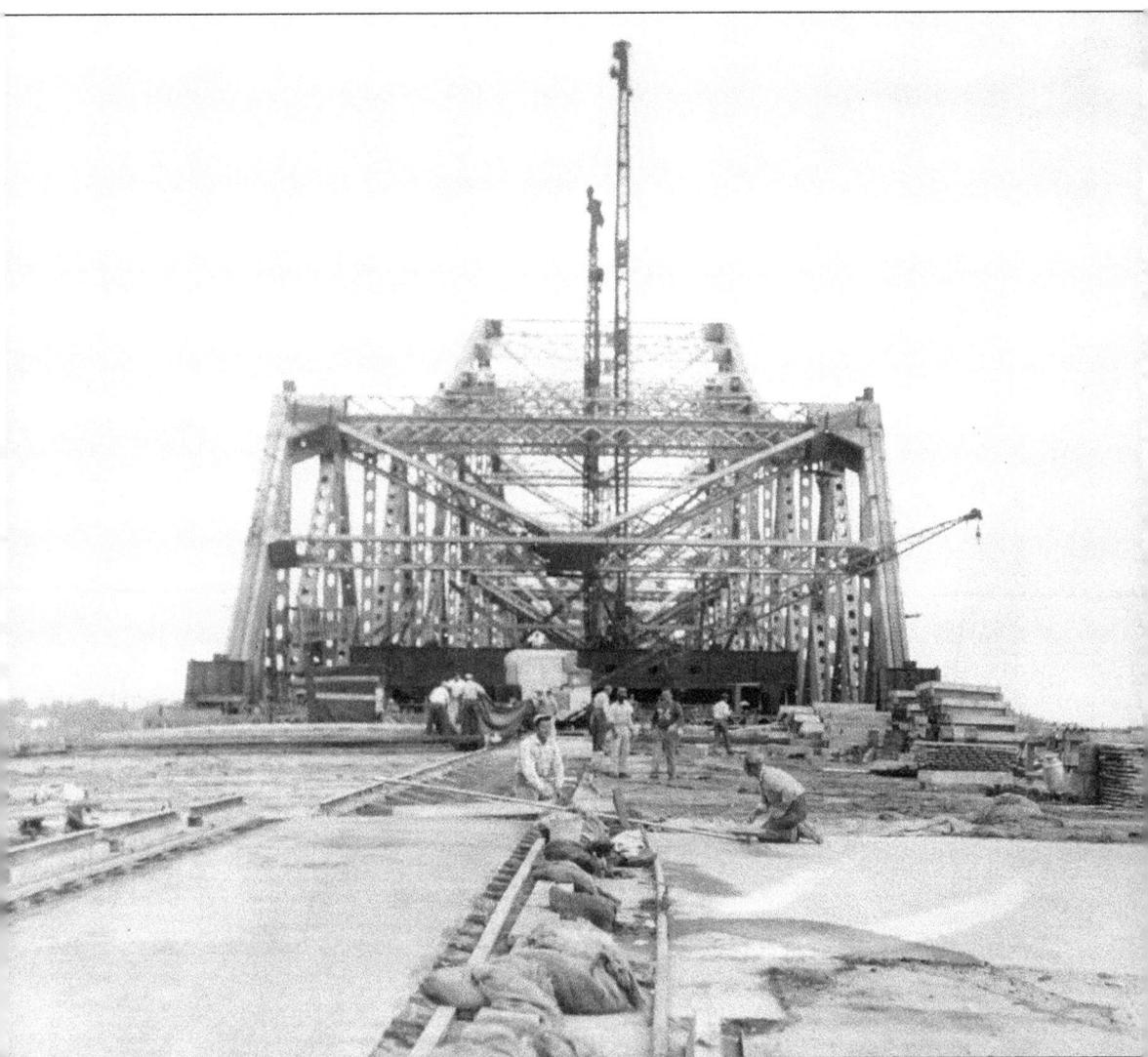

The superstructure appears complete in the background as the men in this photograph lay the roadbed. A shortage of steel due to the Korean War delayed the original construction of the bridge. (Courtesy Nyack Library Local History Collection.)

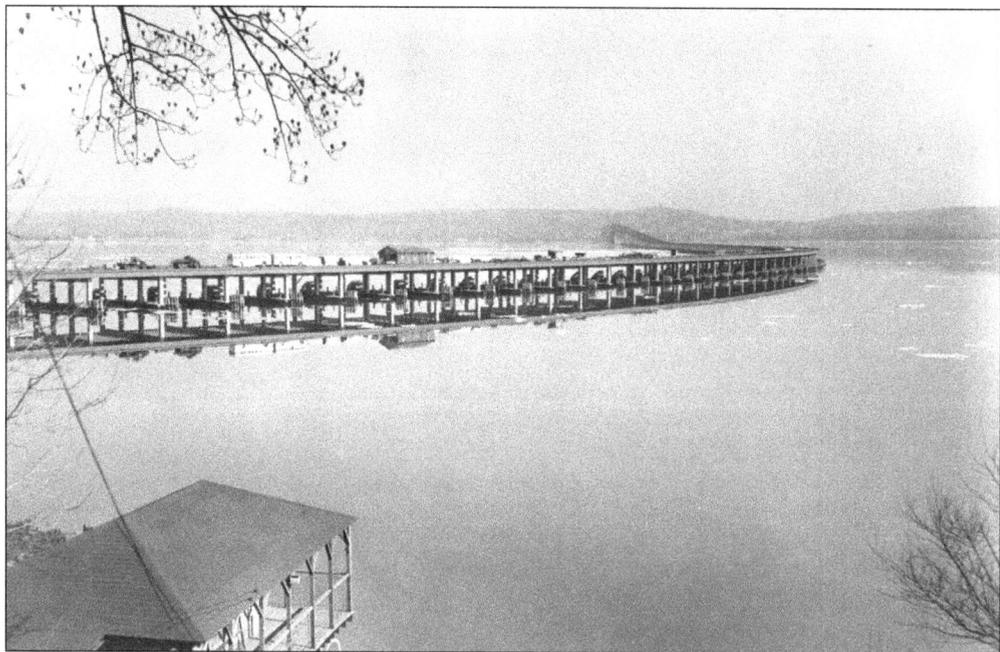

The icy Hudson River reflects the nearly completed bridge. Buses parked on the structure were used to transport workers completing the final paving of the bridge. Westchester County can be seen in the distance, almost three miles across the river, now connected by the Tappan Zee bridge to Rockland County. (Courtesy Nyack Library Local History Collection.)

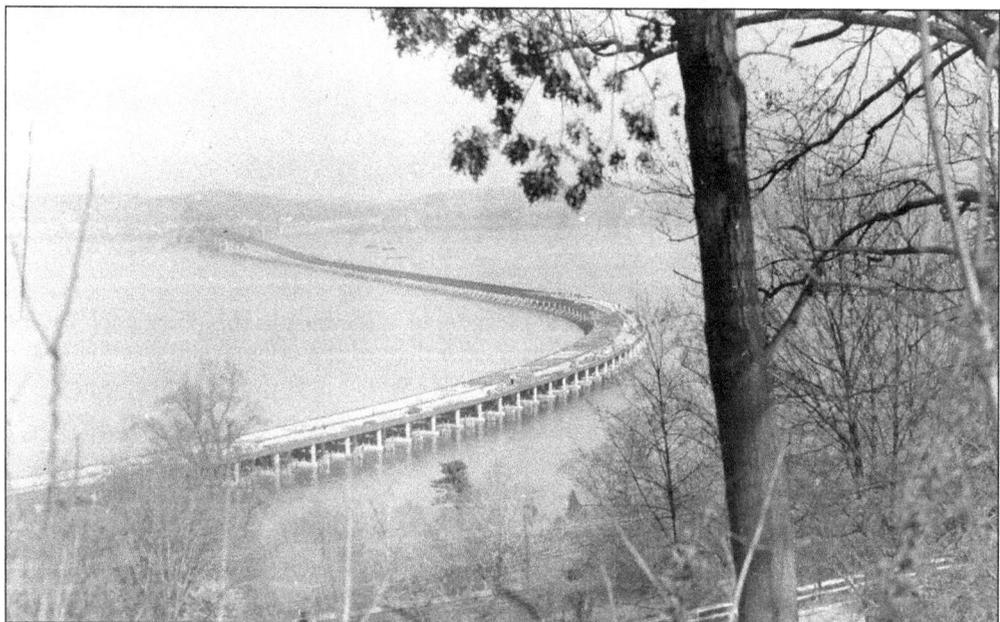

The snow sits on the completed bridge as the opening ceremony is about to begin. The final structure measures 16,013 feet long, just over three miles, and will be seven lanes wide. When the bridge opened in December 1955, it carried an average of 18,000 vehicles each day. On a clear day, the New York City skyline can be seen looking south along the Hudson River. (Courtesy Nyack Library Local History Collection.)

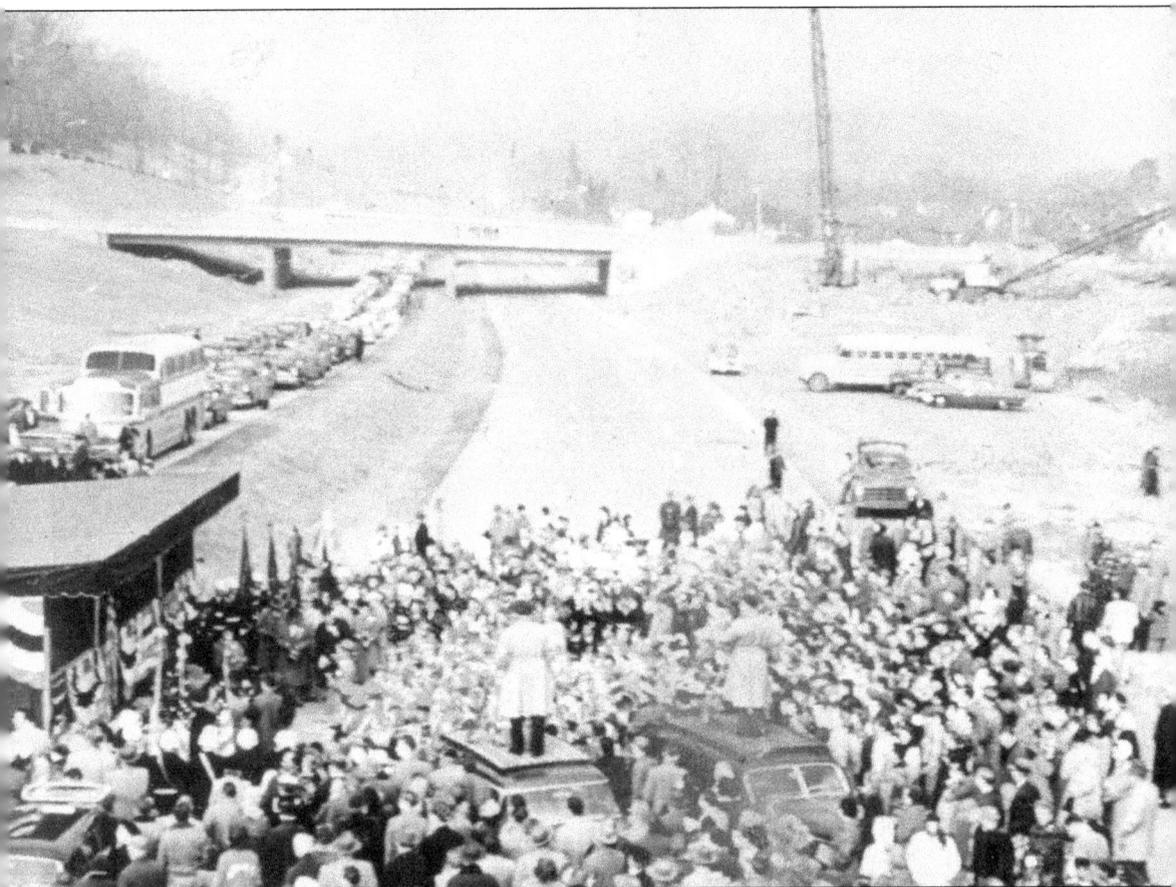

Crowds gathered on a cold day, December 15, 1955, for the official opening of the bridge. The bridge is said to be named Tappan Zee after the Tappan tribe of Native Americans who lived in the area long ago. The Zee comes for the Dutch inhabitants. *Zee* is the Dutch name for open expanse of water. Later in 1994, the Tappan Zee bridge would be renamed Governor Malcolm Wilson Tappan Zee Bridge in honor of the former governor. (Courtesy Nyack Library Local History Collection.)

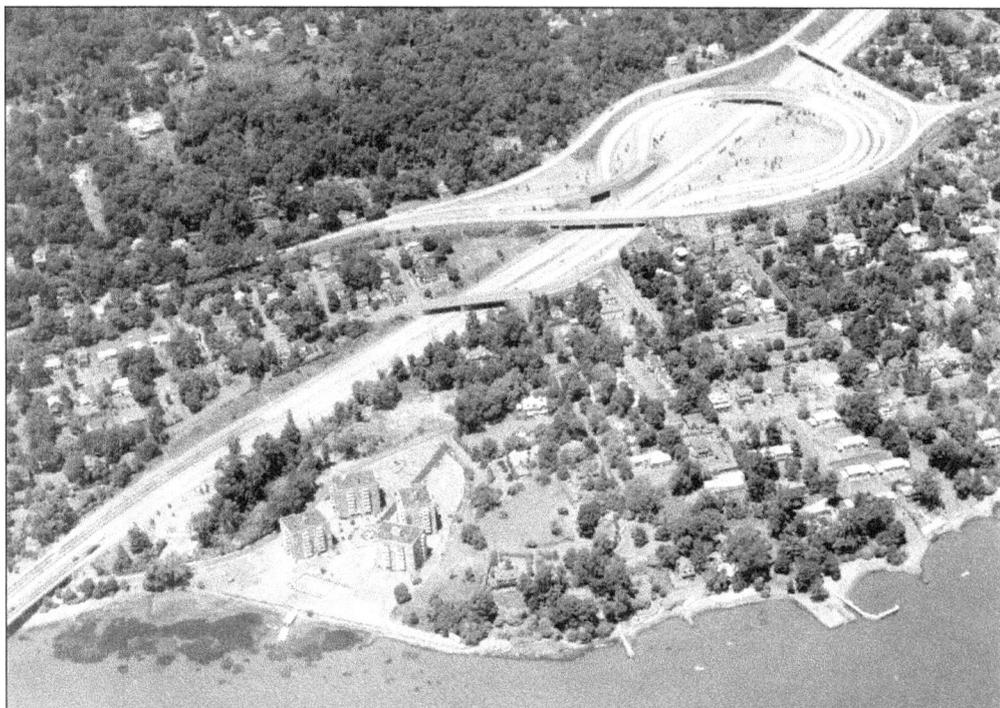

This aerial view shows the unusual circular interchange just north of the Rockland County entrance to the Tappan Zee bridge. This area is one of the most heavily traveled areas of the Northeast. The toll is collected on the Westchester side as vehicles travel west to east as seen in the photograph below. The volume of traffic has increased to more than 10 times the daily average in 1955. (Courtesy Nyack Library Local History Collection.)

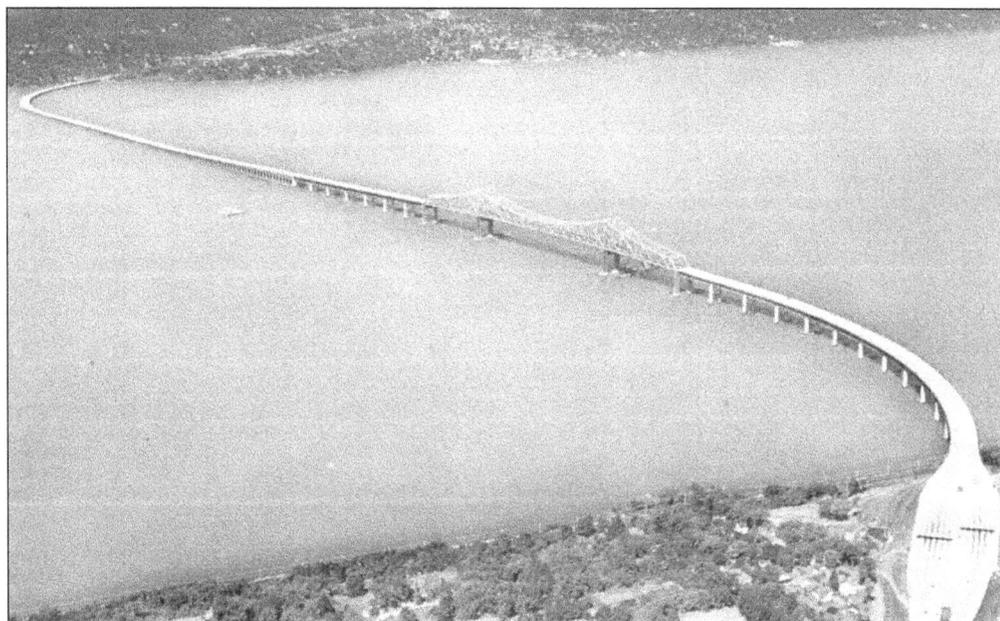

Eight

KINGSTON-RHINECLIFF BRIDGE

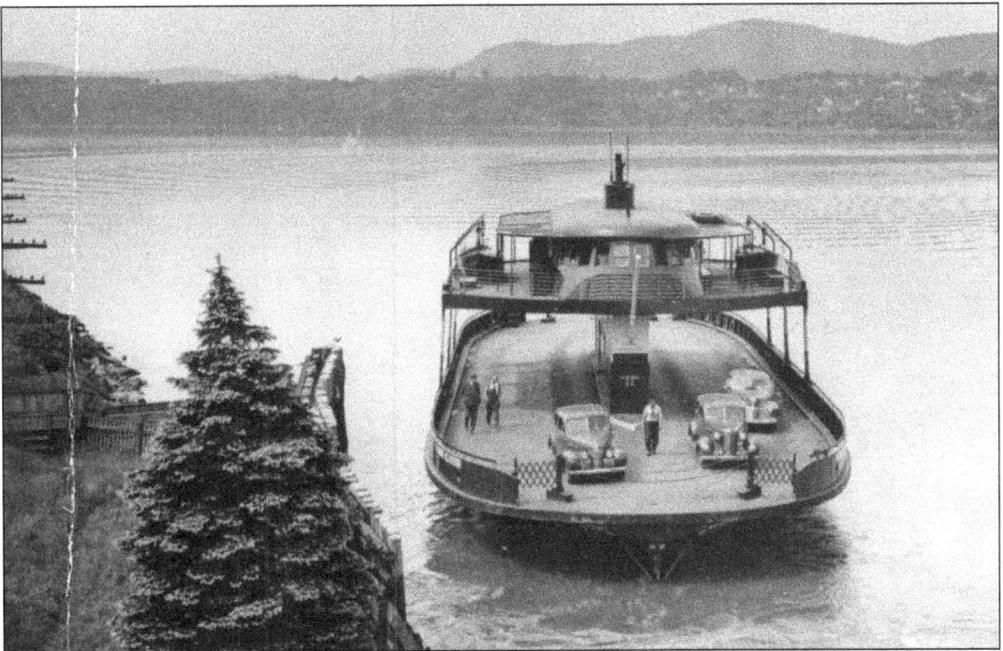

For 190 years a ferry crossed the Hudson River between Kingston, on the west shore, and Rhinecliff, on the east shore. In 1942, the ferry service was discontinued due to decreased traffic caused by the gas rations of World War II. As with other Hudson River crossings, the location of a bridge between Kingston and Rhinecliff was discussed for several years before the final location and navigational clearance were approved in 1952. To aid with the traffic in the years before the bridge opening, the NYSBA purchased and operated ferry service, beginning in May 1946, between Kingston and Rhinecliff.

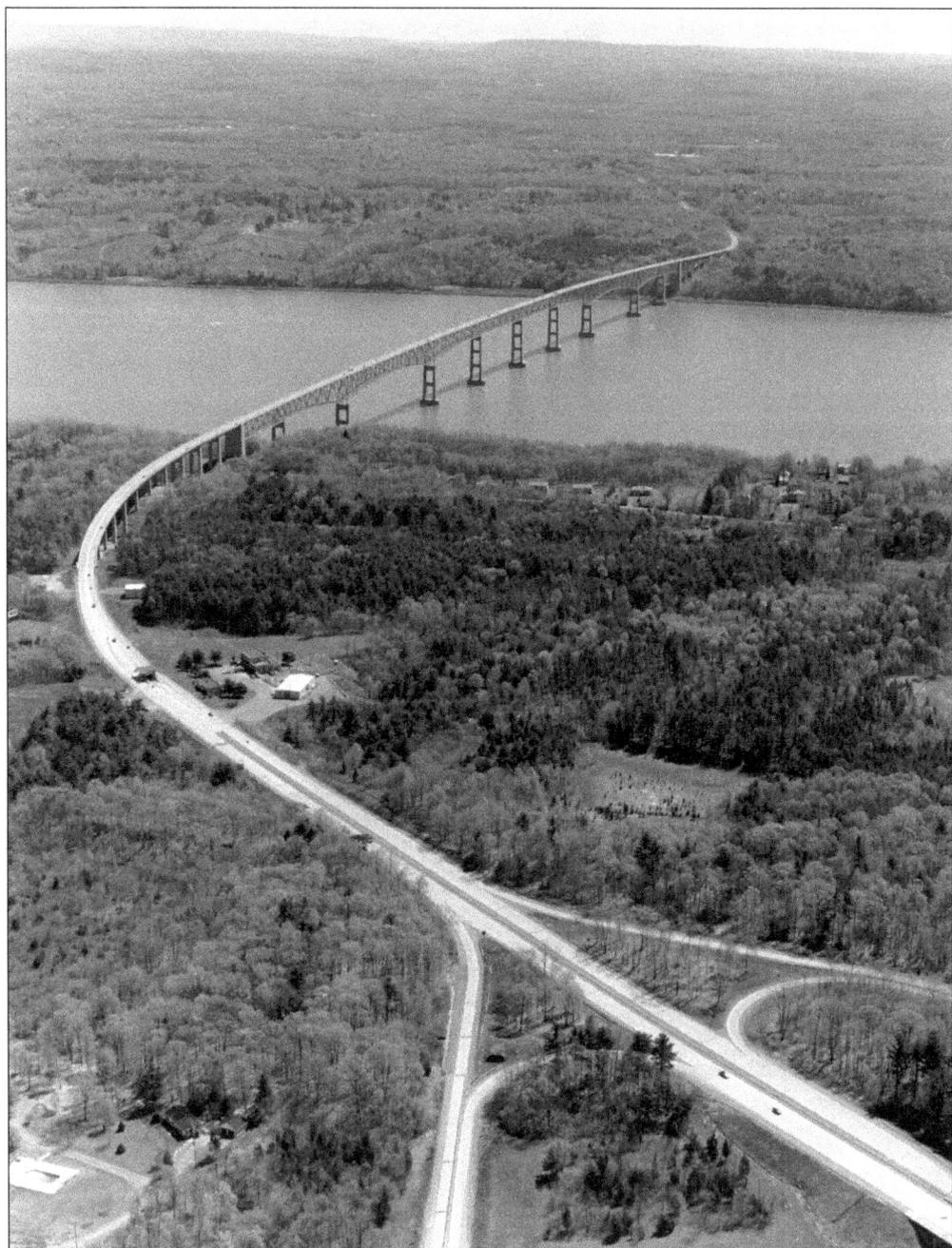

The Kingston-Rhinecliff bridge, pictured here, was originally proposed as a suspension bridge. As a result of political and economic concerns, the bridge site was moved about three miles up the river to a location not amenable for a suspension bridge. It was decided that a continuous under-deck truss bridge would be better for the new location that lacked the stable bedrock needed to anchor a suspension bridge. The designer of the bridge above was David Steinman, designer of the San Francisco–Oakland Bay Bridge and the Mackinac Bridge in Michigan.

The construction of the bridge began in 1954 with the rough grading of the approach ramps. The contract for the grading went to a Mount Vernon company. The new bridge still did not have an official name. Many suggestions were made, but the NYSBA finally decided to use the geographical location of the bridge, calling it the Kingston-Rhinecliff bridge.

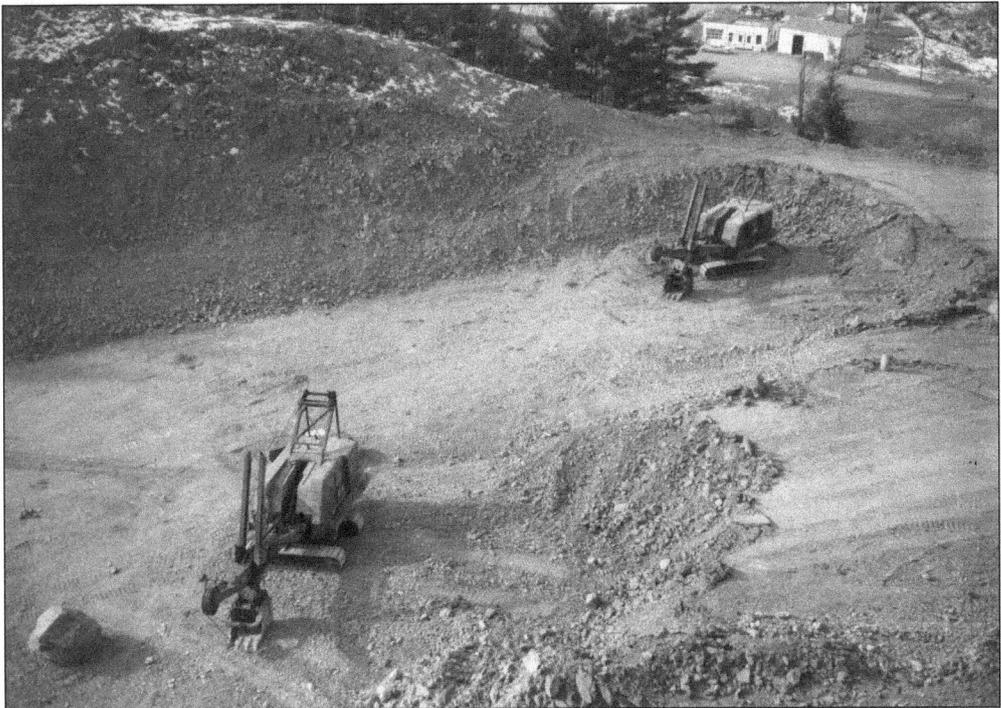

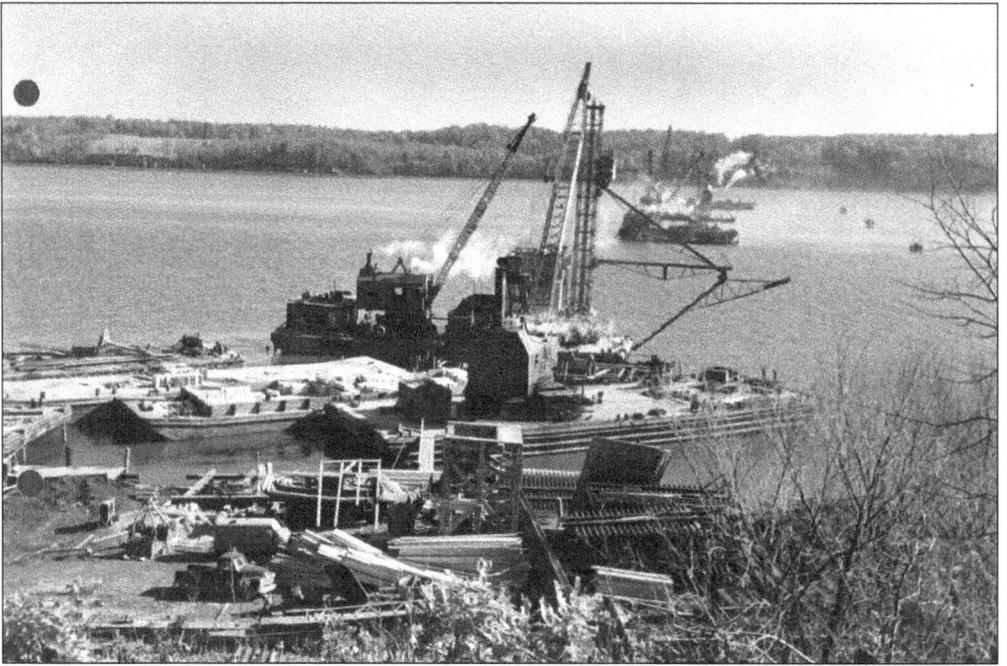

In August 1956, the first river piers were placed on the Kingston side of the river. The concrete bases for the supports were poured soon after. Within one year, half the piers for the bridge had been completed.

The pier foundations were constructed using cofferdams. As seen in this photograph, huge sheets of steel were driven into the riverbed forming a pen that extended above the water level. A hose was dropped into the pen to pour a concrete base under the river. The water was pumped out of the sealed pen enabling workers to go down below the water surface to begin constructing the pier on top of the concrete floor.

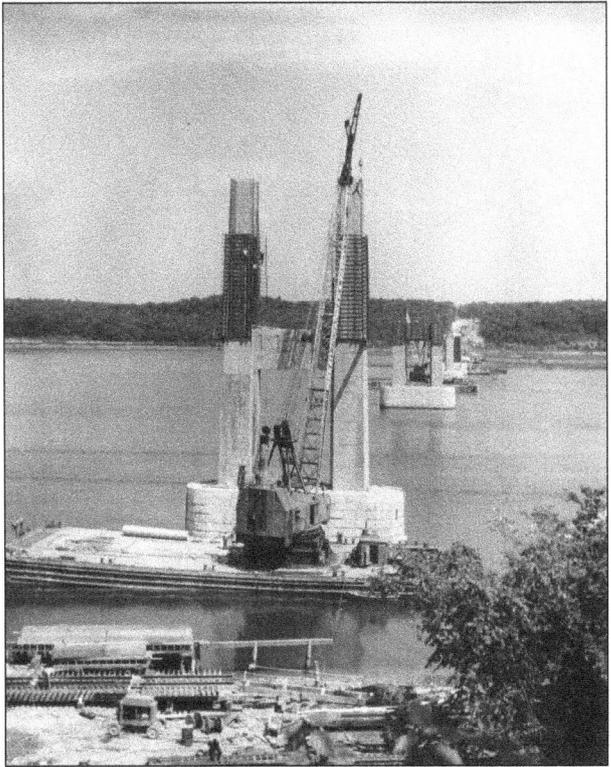

Construction continued on the shore and in the water. More advanced equipment not available to earlier bridge contractors meant less manual work for the individual worker. More powerful cranes set on barges did the heavy lifting. As seen in the photograph to the right several barges are in place for the almost simultaneous construction of the water piers. In the photograph below, a large crane is lifting the decking onto the supports on the shore.

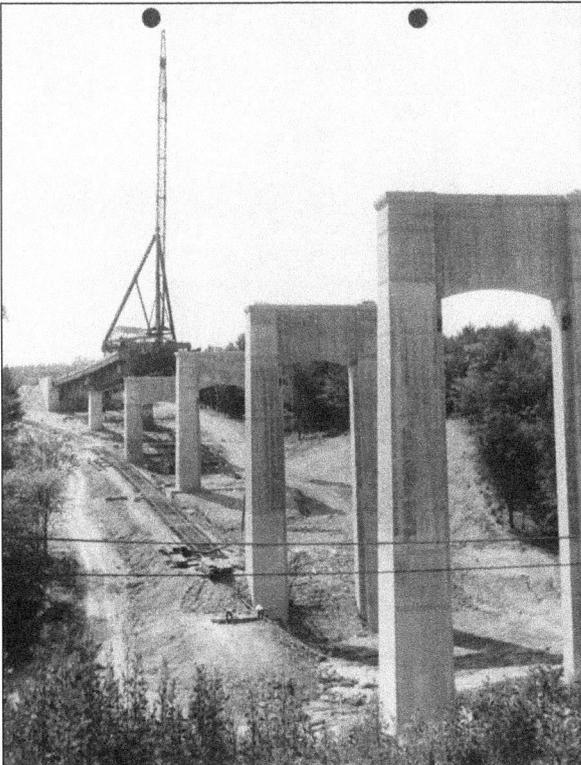

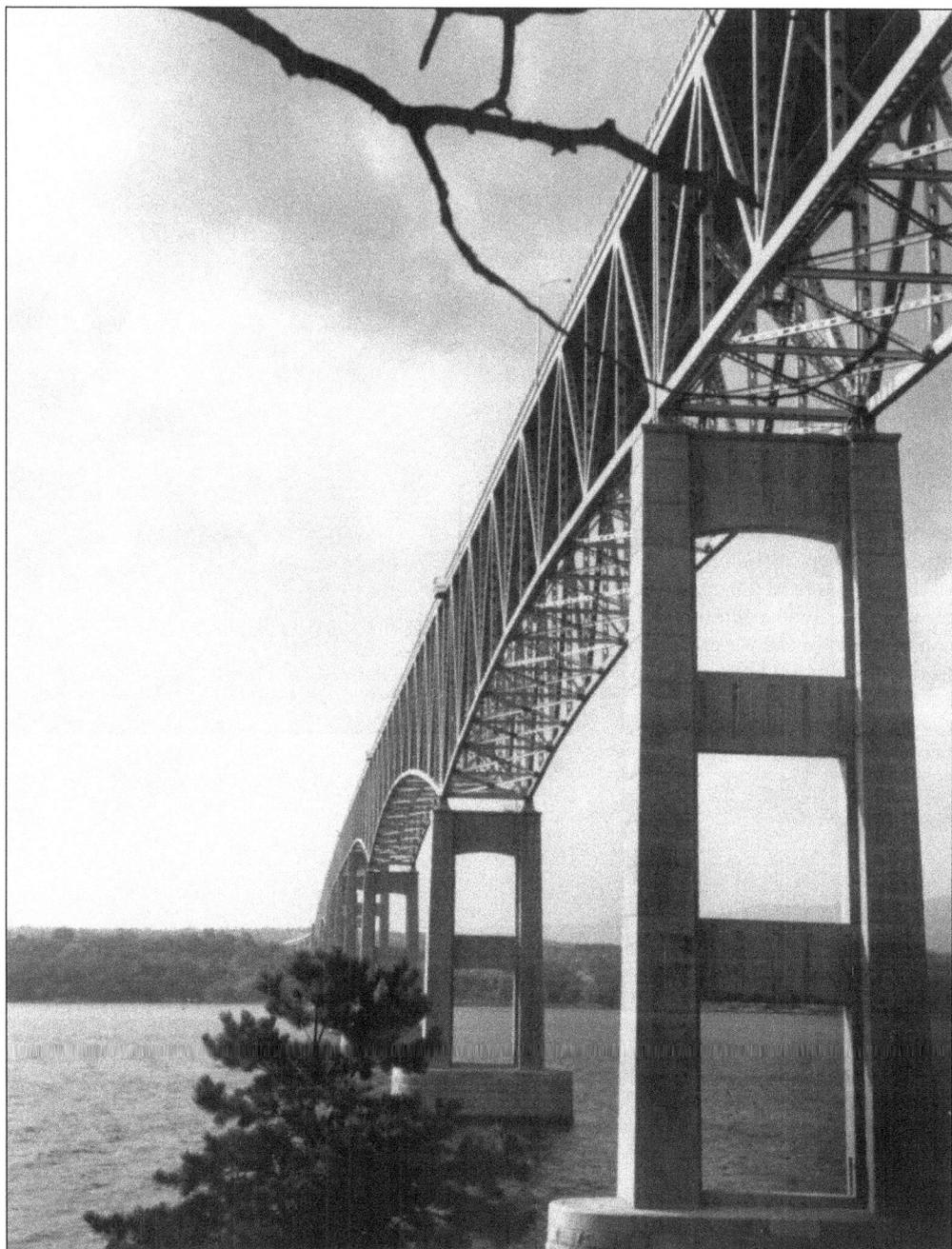

A steel shortage developed in the early 1950s, but the bridge was opened to traffic on February 2, 1957, three months before the rescheduled date. The Hudson River had frozen and industrial workers needed to use the bridge since the ferry could not run. Temporary timber curbs marked the edges of the bridge, and a temporary frame structure was built to collect tolls. As the weather warmed, more permanent structures were built, and the bridge officially opened on May 11, 1957.

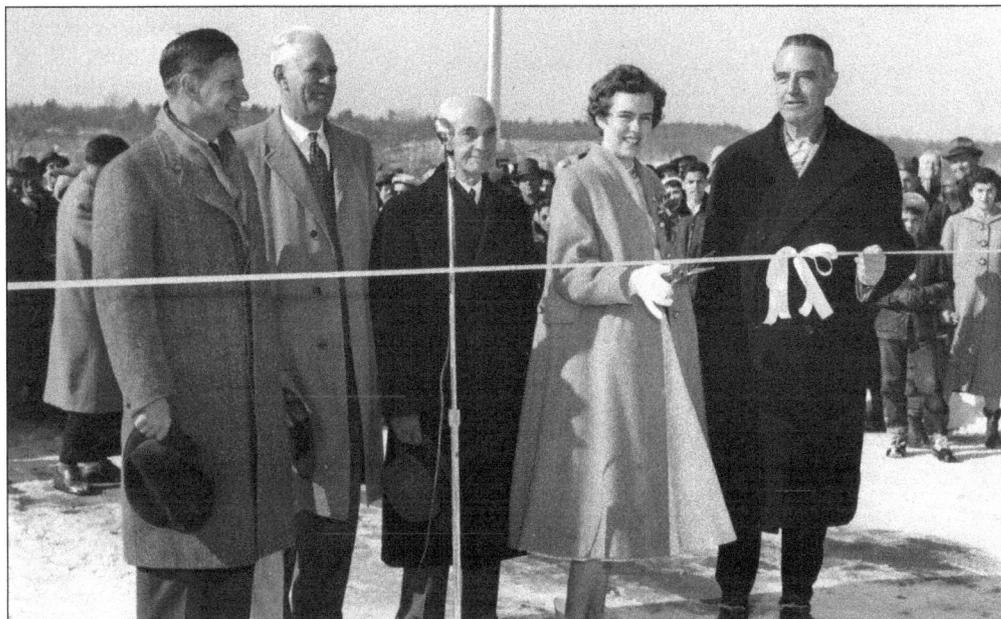

The ribbon for the informal ceremony to open the bridge in February was cut by Nancy Ruth Heppner, the daughter of NYSBA member Ernest Heppner. To Nancy's right is Gov. W. Averell Harriman. Harriman was the principal speaker at the opening. He is a member of the Harriman family responsible for the donation and creation of the Harriman State Park and the construction of the Bear Mountain bridge.

Later in the year at the official opening ceremony on May 11, 1957, Harriman was again one of the speakers. The formal dedication took place next to the bridge on the western shore followed by a motorcade across the span. Local and state officials were also in attendance.

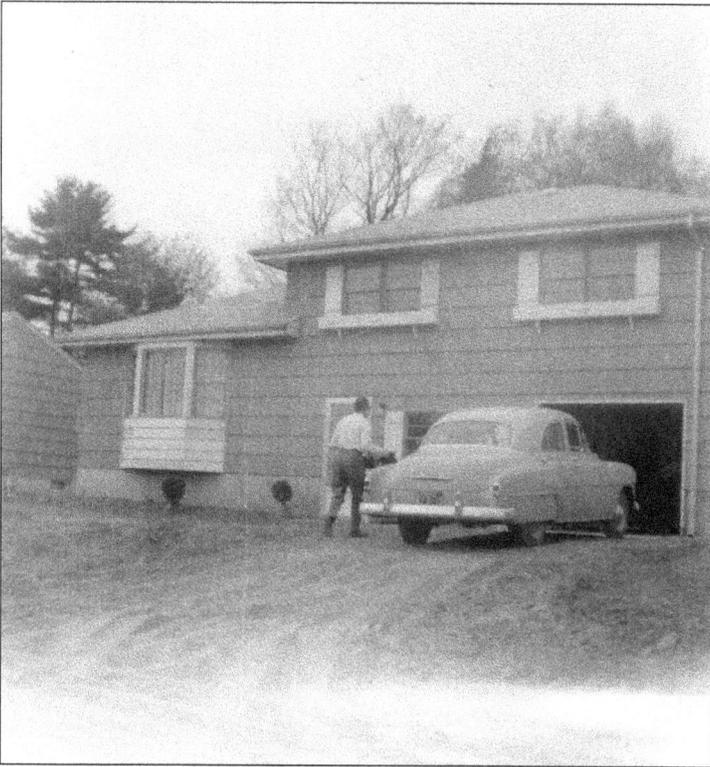

The opening of the Kingston-Rhinecliff bridge spurred the housing development on both sides of the Hudson River. More frequently people were able to live on one side of the river and work on the other. The house pictured here, owned by the Wilson family, is an example of a new tract house. The house is located in Saugerties. William Wilson, seen here in his new front yard, drives across the Kingston-Rhinecliff bridge to work each day.

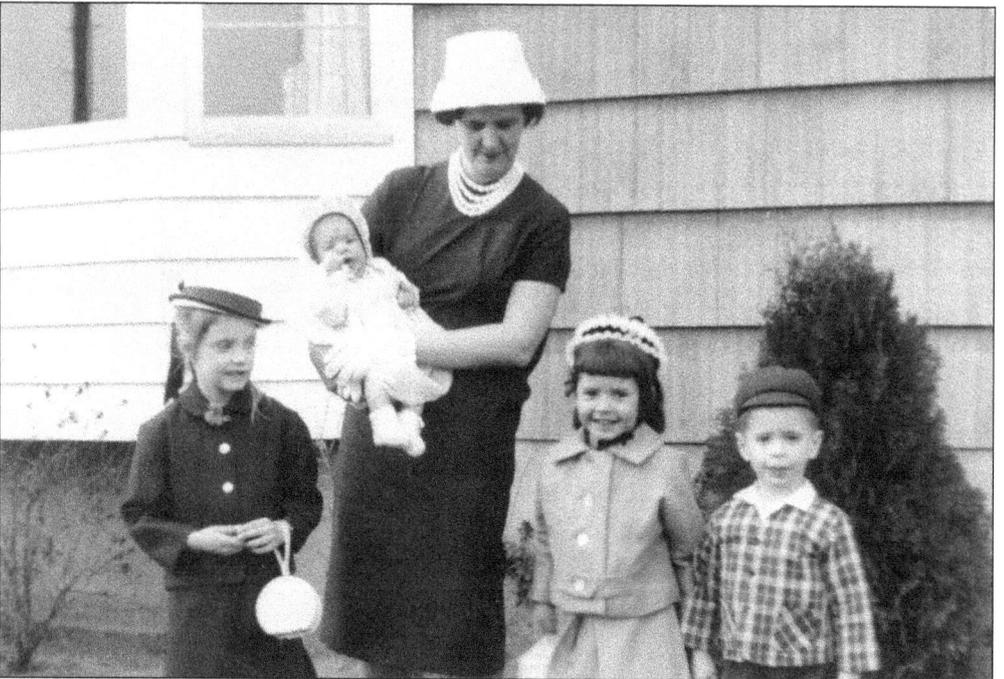

Sally Wilson, seen here with the four children, baby Meg, Mary on the left, Kathy, and Billy, was a homemaker, as was the norm in the late 1950s. While William Wilson drove the one family car to work, Sally stayed home with the children.

Nine

NEWBURGH-BEACON BRIDGE

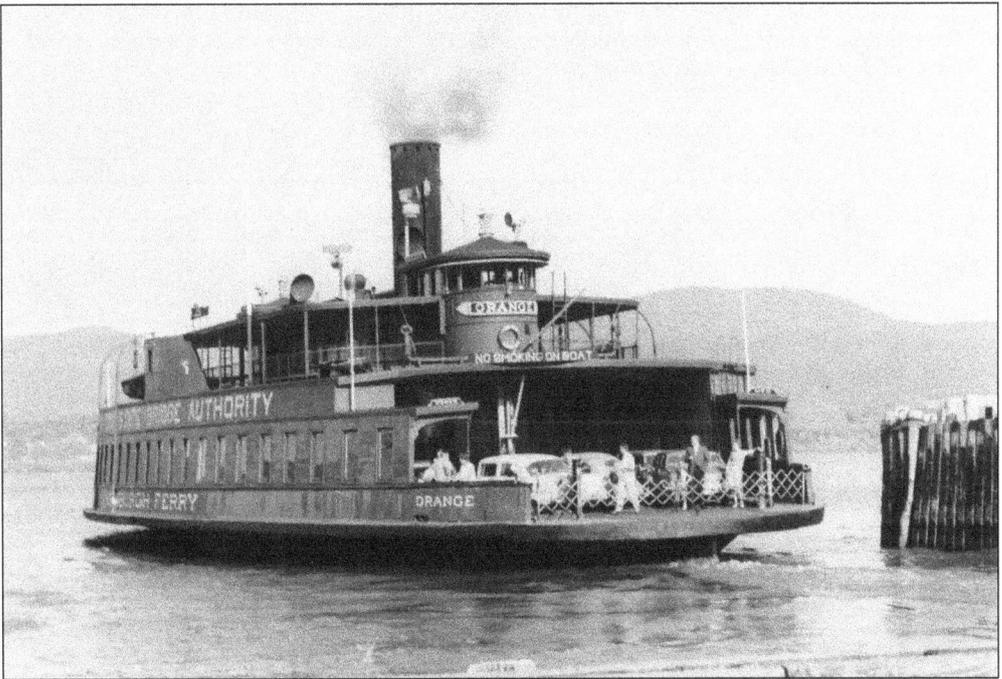

The Newburgh Ferry, shown here, ran between Newburgh and Beacon. The first official ferry was established in 1743 by royal charter from King George II to Alexander Colden, to carry passengers and goods for profit. The ferry became especially important during the American Revolution. It made communication possible between patriots in New England and the Continental Congress in Philadelphia. The ferry continued operation through Colden's heirs and the Ransdell family. Then in 1956, it was taken over by the NYSBA.

Ice and snow are evident on the deck of the Newburgh Beacon Ferry pictured here. The two oldest ferries, powered by coal-burning steam reciprocating engines had been specifically built for the purpose of plowing through heavy ice. This enabled the ferry to provide travelers with a year-round, dependable service operation.

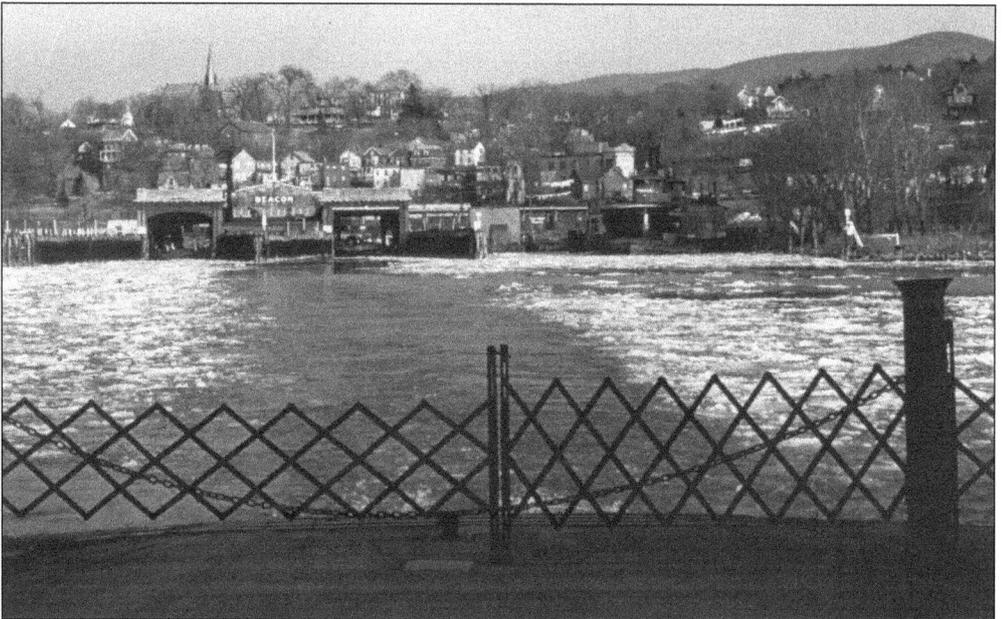

Straight ahead is the Beacon ferry terminal. Behind the terminal is the village of Beacon. Although the ferry ceased running in 1963 with the building of the bridge, as of October 2005, Gov. George Pataki reinstituted ferry service enabling commuters to park in Newburgh, then ride across the river on the ferry to Beacon to be transported to the commuter train for the ride south to New York City.

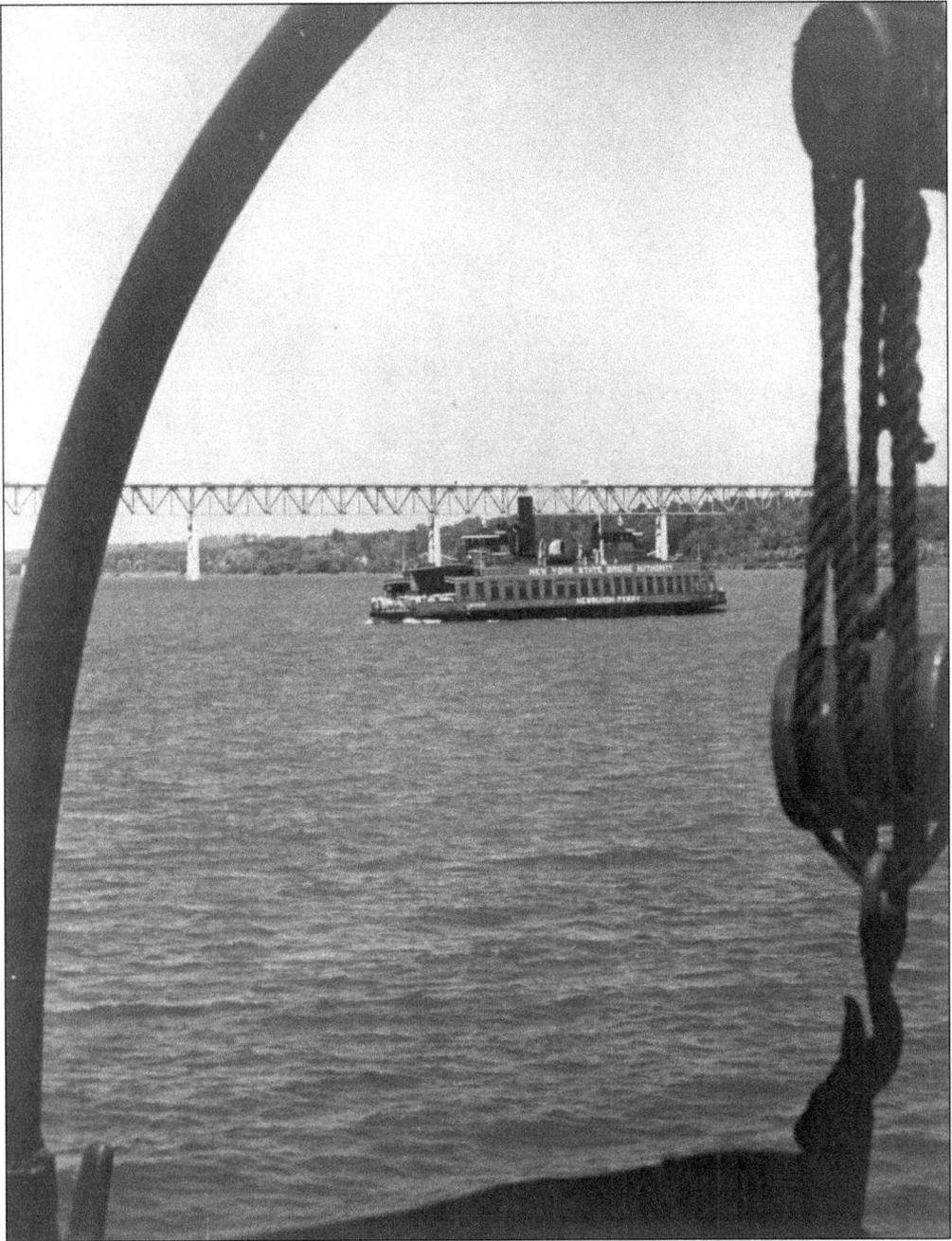

Shown here with the new bridge in the distance behind it, the old Newburgh Beacon Ferry crossed the Hudson River for the last time on Sunday, November 3, 1963, one day after the Newburgh-Beacon bridge opened. For $2 drivers boarded the ferry to Beacon one last time and returned to Newburgh via the new bridge. The ferry service ended after 220 continuous years crossing the Hudson River.

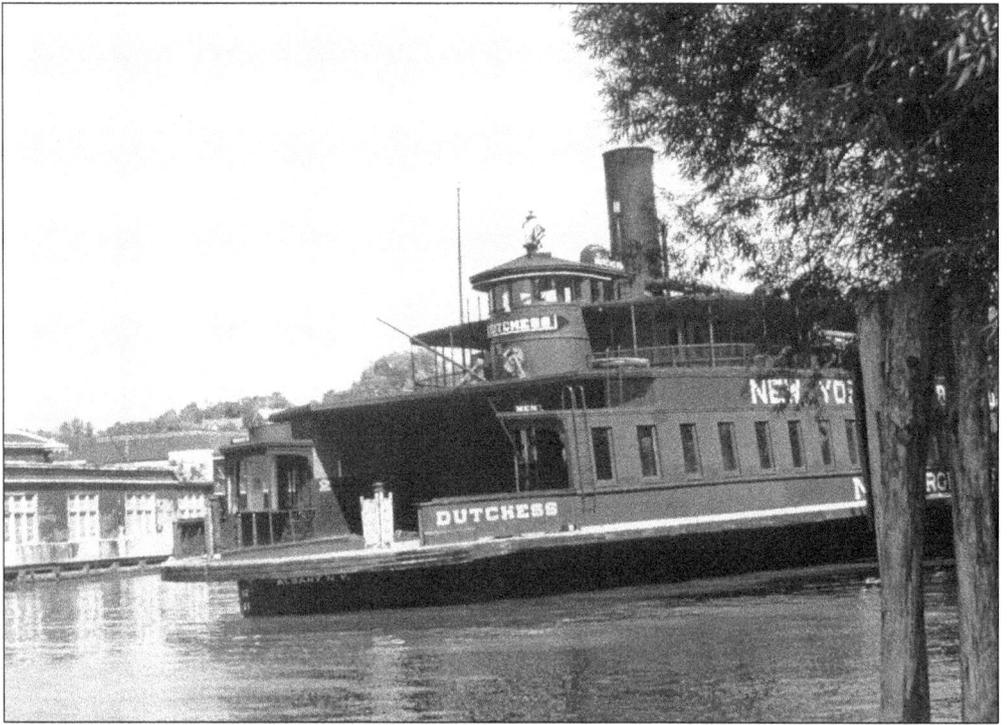

The ferries of the Newburgh Beacon run were out of work. The *Beacon* and the *Dutchess*, pictured in the photograph above, were sold for scrap. But the *Orange* would survive to work a little longer. An entrepreneur bought the boat, and with a little refurbishing, it was used to carry tourists from Manhattan to the 1964 world's fair. It ran for almost another year before it too was taken from the water.

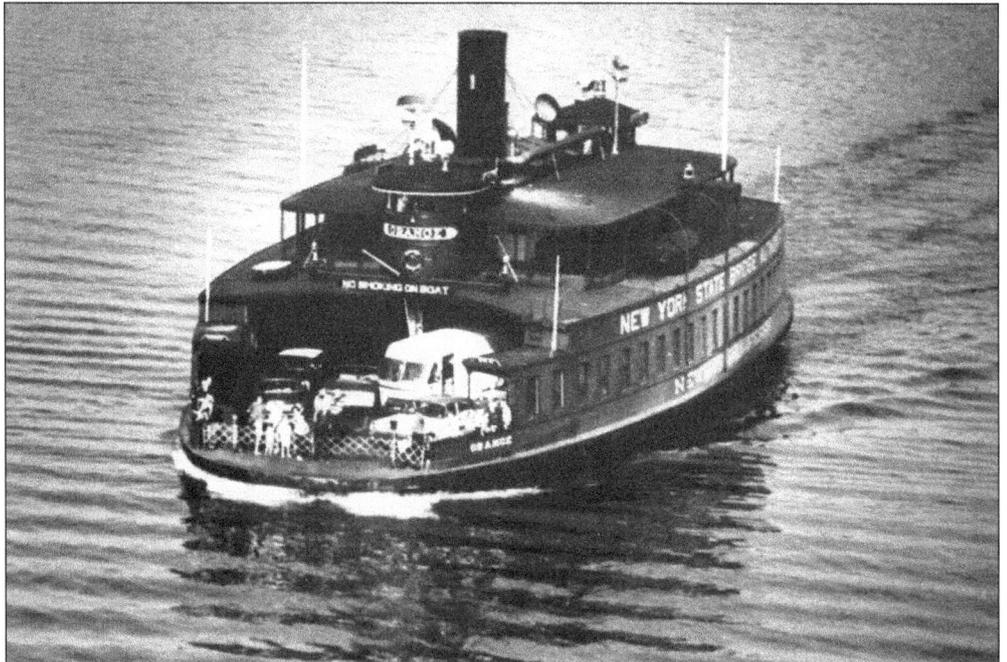

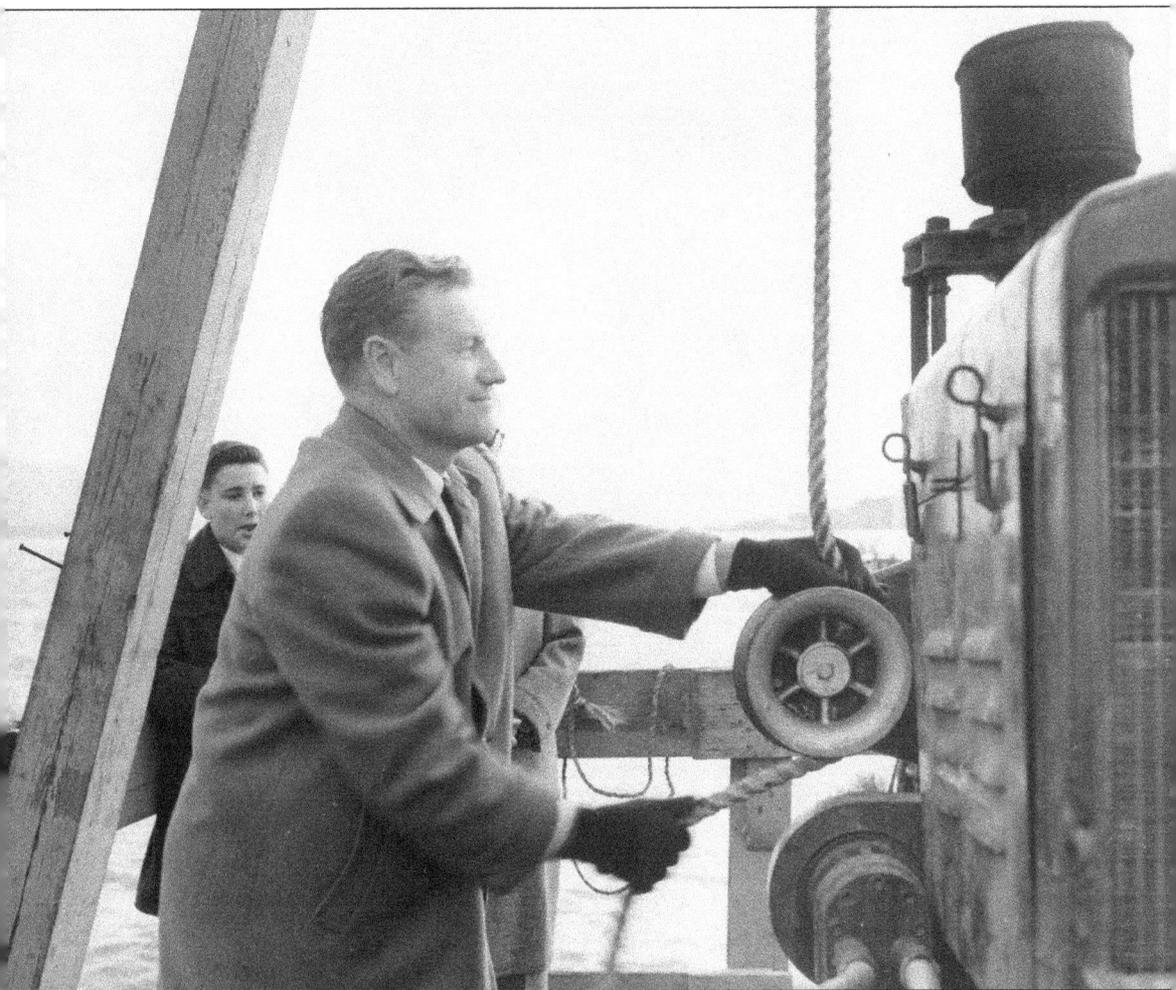

As with the other bridges across the Hudson River, it was many years of discussion before construction could begin on the Newburgh-Beacon bridge. Since 1951 when a bill was introduce into the New York State legislature, groups of people have mobilized to make the bridge a reality. Finally during Gov. W. Averell Harriman's administration, it was determined the bridge should be at least four lanes wide to carry an interstate highway; in 1960, short on federal funds, at the recommendation of Gov. Nelson A. Rockefeller the state opted to build a less expensive two-lane bridge, without federal assistance. Rockefeller is seen here starting the drilling machine signifying the beginning of construction of the Newburgh-Beacon bridge.

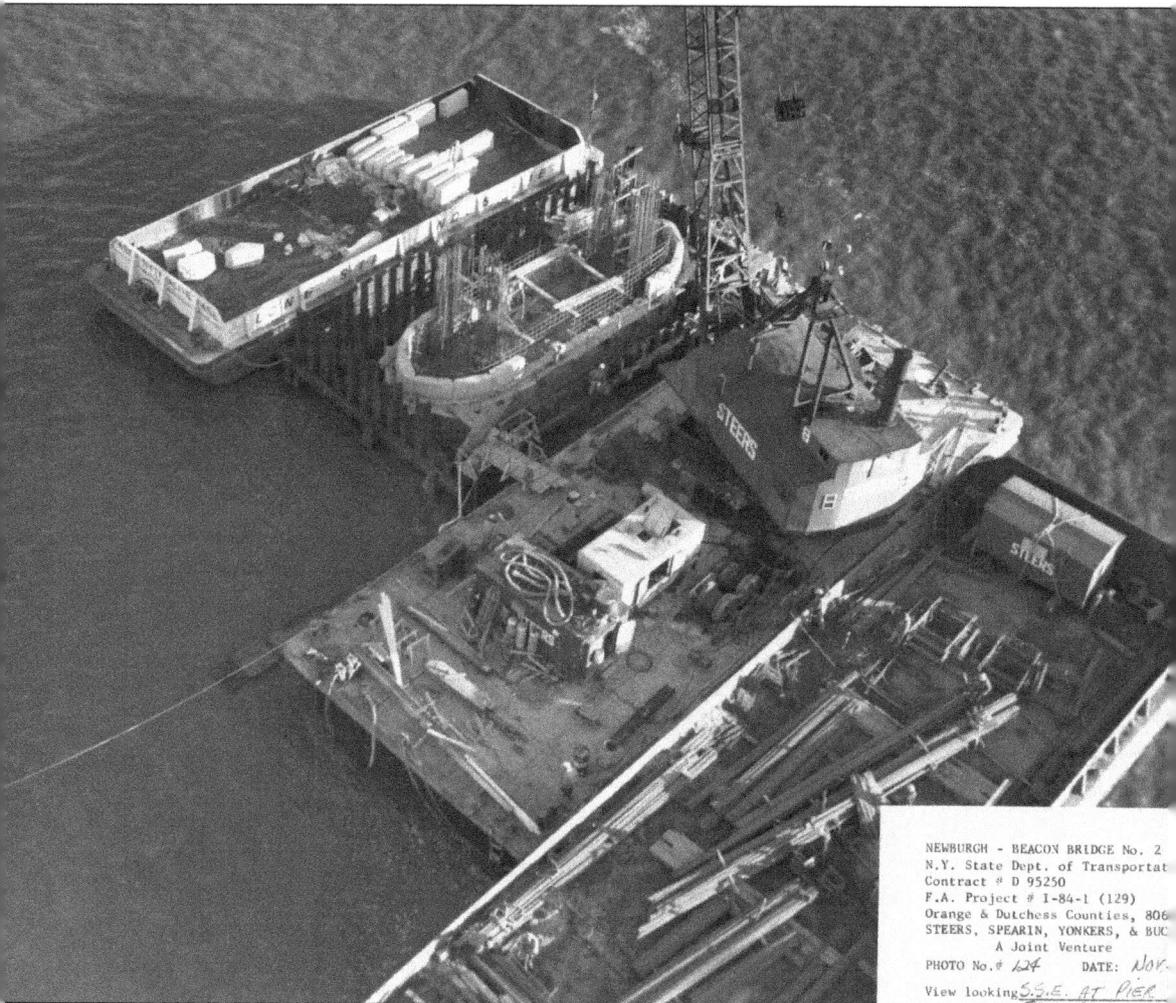

Construction began on the bridge in March 1961 with the building of the three main river piers shown here. The choice of the construction company was an intricate caisson type of foundation. Often work continued around the clock to complete the piers during the 1960 work season. Barges tied up next to the growing pier. Men can be seen next to the pier, dwarfed by the large platform.

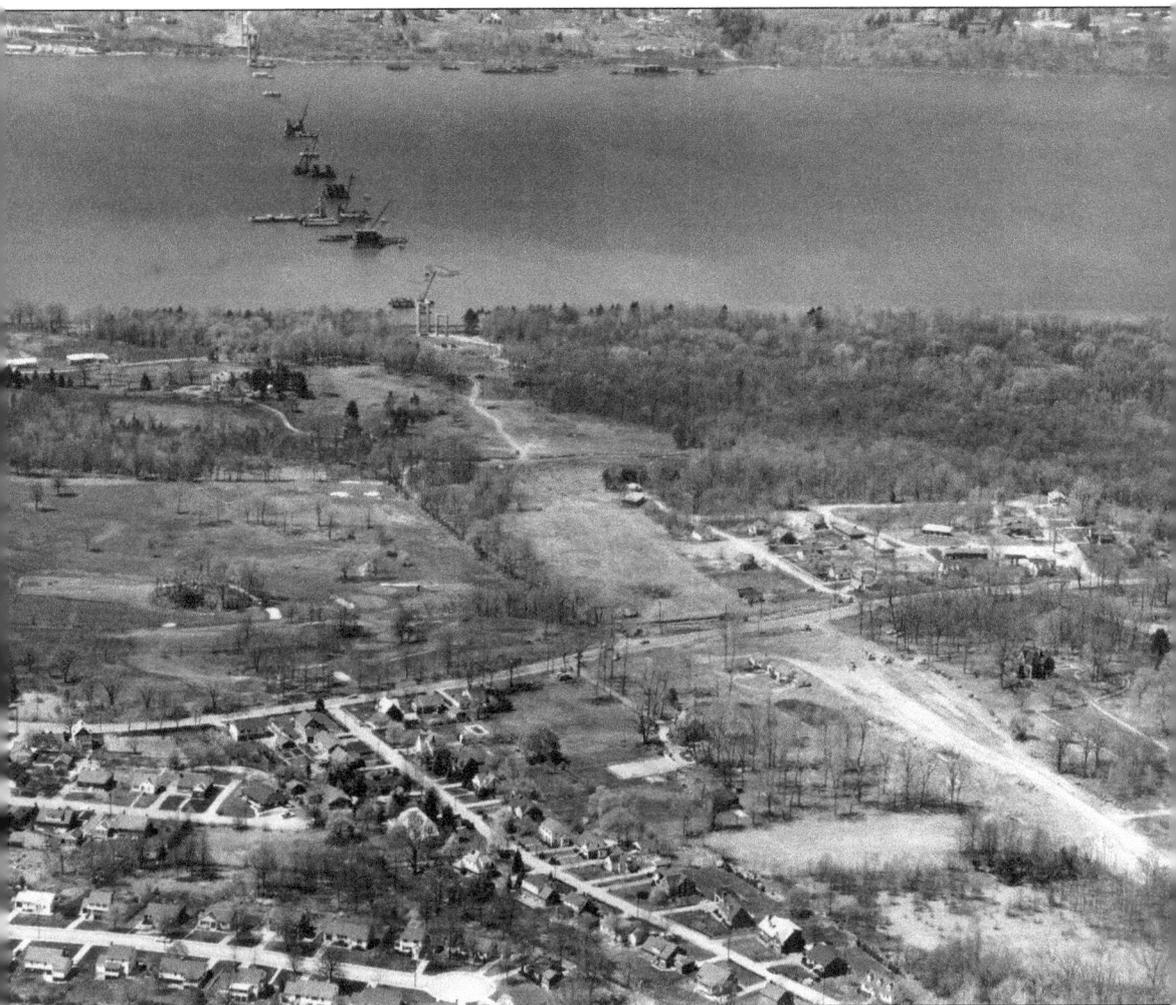

In this aerial view with the town of Newburgh in the lower half of the photograph, the approach area has been cleared. The cranes on the barges are at work on the piers in the water. Concrete supports are beginning to appear on both sides of the river.

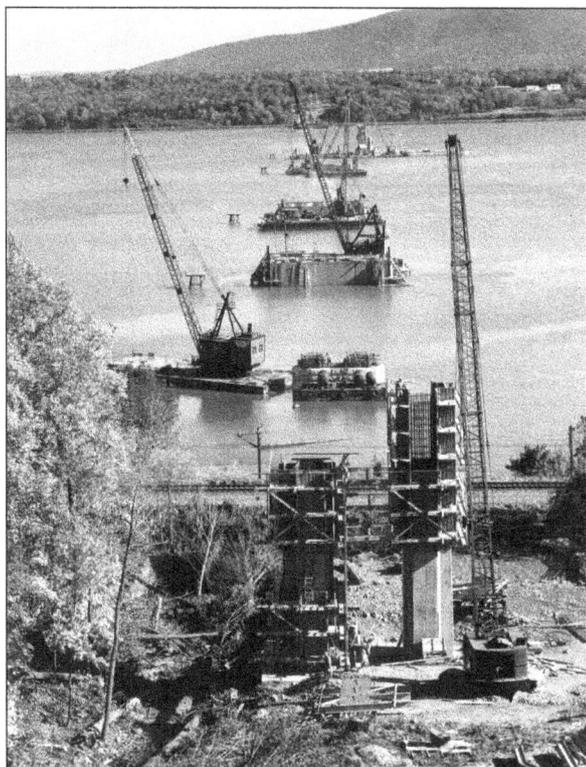

Progress is being made in this close-up photograph. Railroad tracks can be seen along both sides of the river. As was the case with the building of the other Hudson River bridges, it was necessary for construction to not interrupt regular railroad traffic.

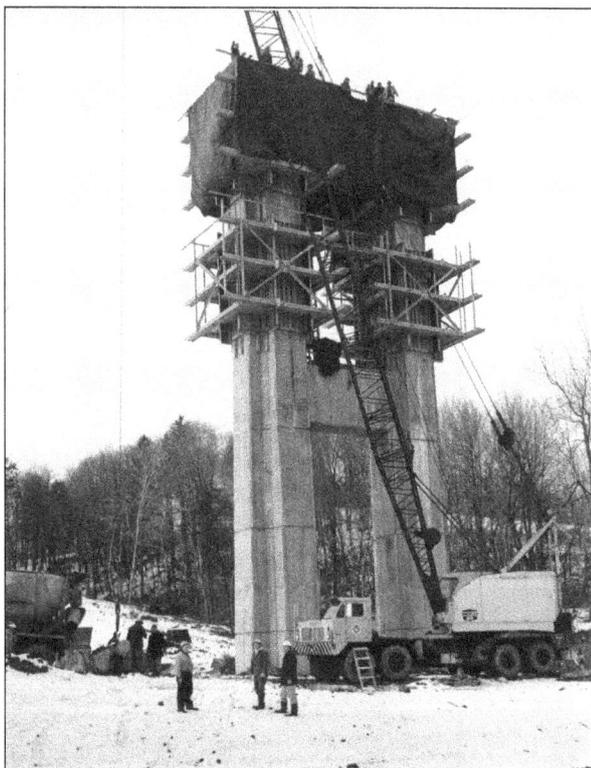

Although snow covers the ground, the work continues as the rush is on to complete the bridge.

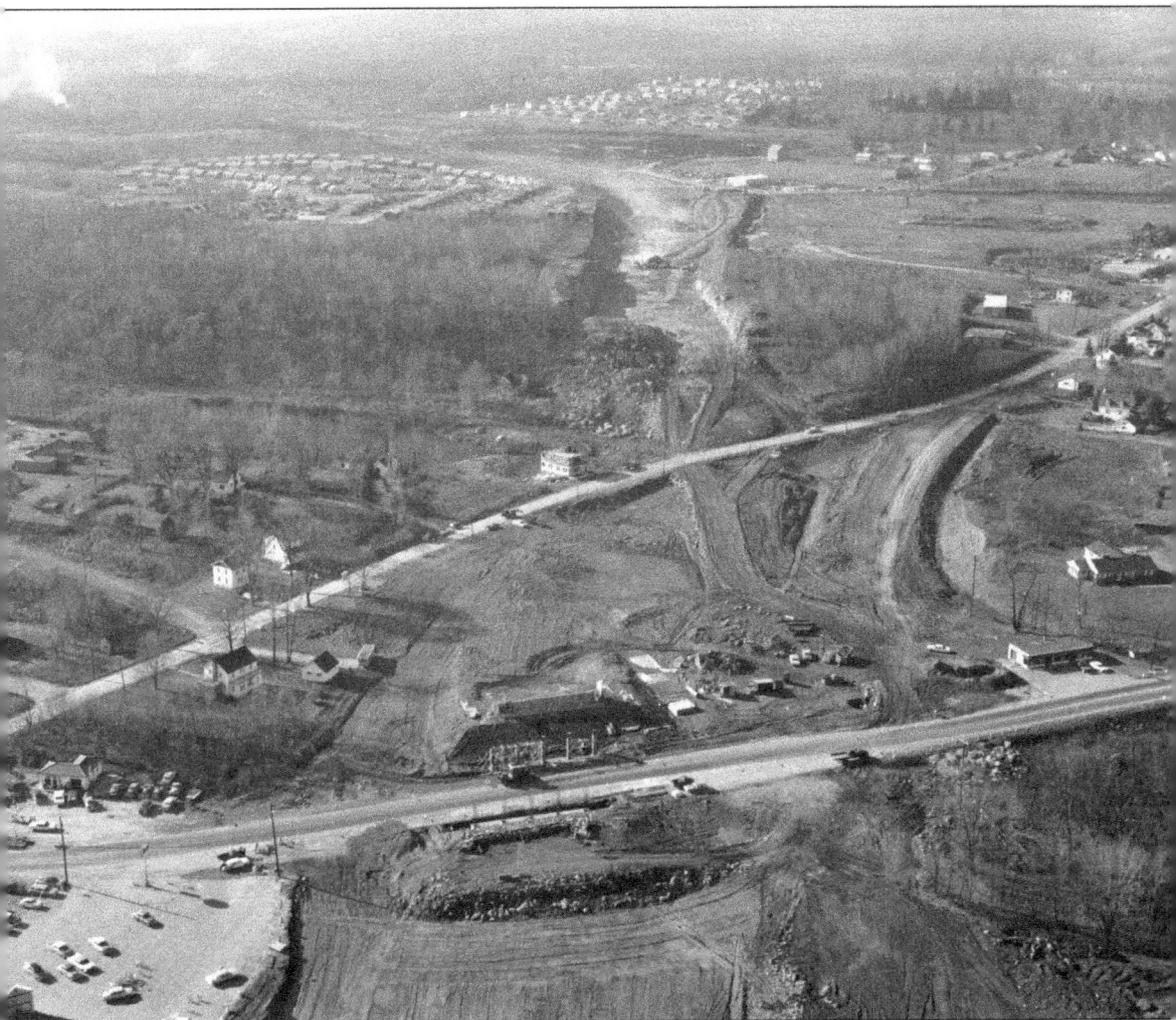

An aerial photograph on the Dutchess County side of the river shows the work on the approach to the bridge and the additional construction in the distance that will become Interstate 84 that will make the Newburgh-Beacon bridge part of one of the busiest highways in the Northeast.

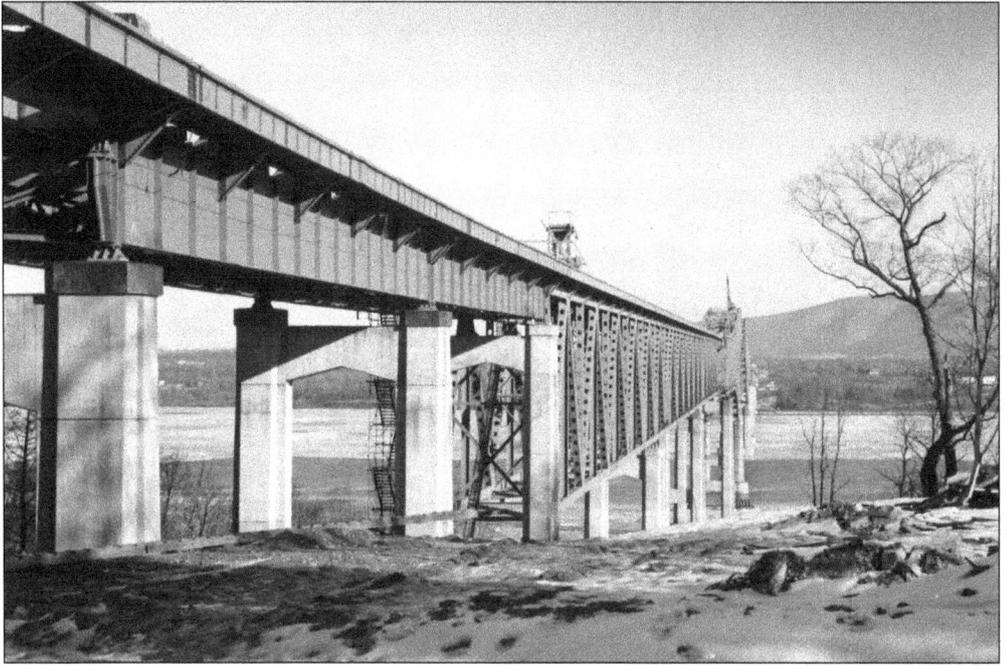

The piers of the bridge were constructed using caissons, large concrete blocks shaped like an upside-down U. The weight of the masonry on top would drive the caisson into the riverbed, the deepest of which was set 163 feet below sea level.

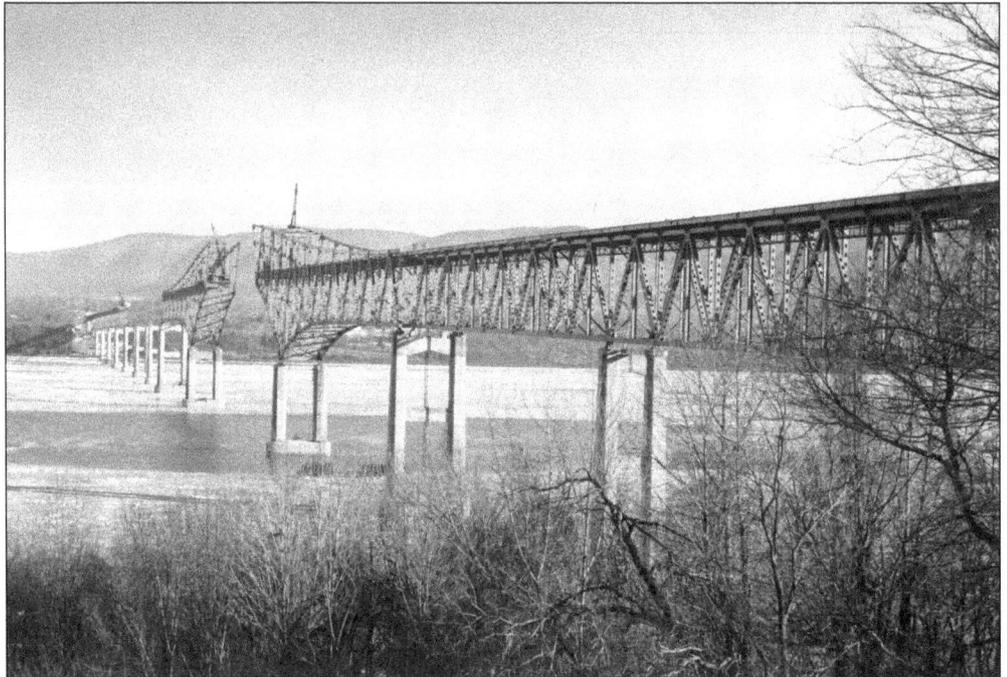

The steel for the superstructure was manufactured by Bethlehem Steel. Ice in the water delayed somewhat the erection of the steel. The spans varied in length from the main span at 1,000 feet over the main channel to 57 feet over the west side of Grand Avenue on the Newburgh shore.

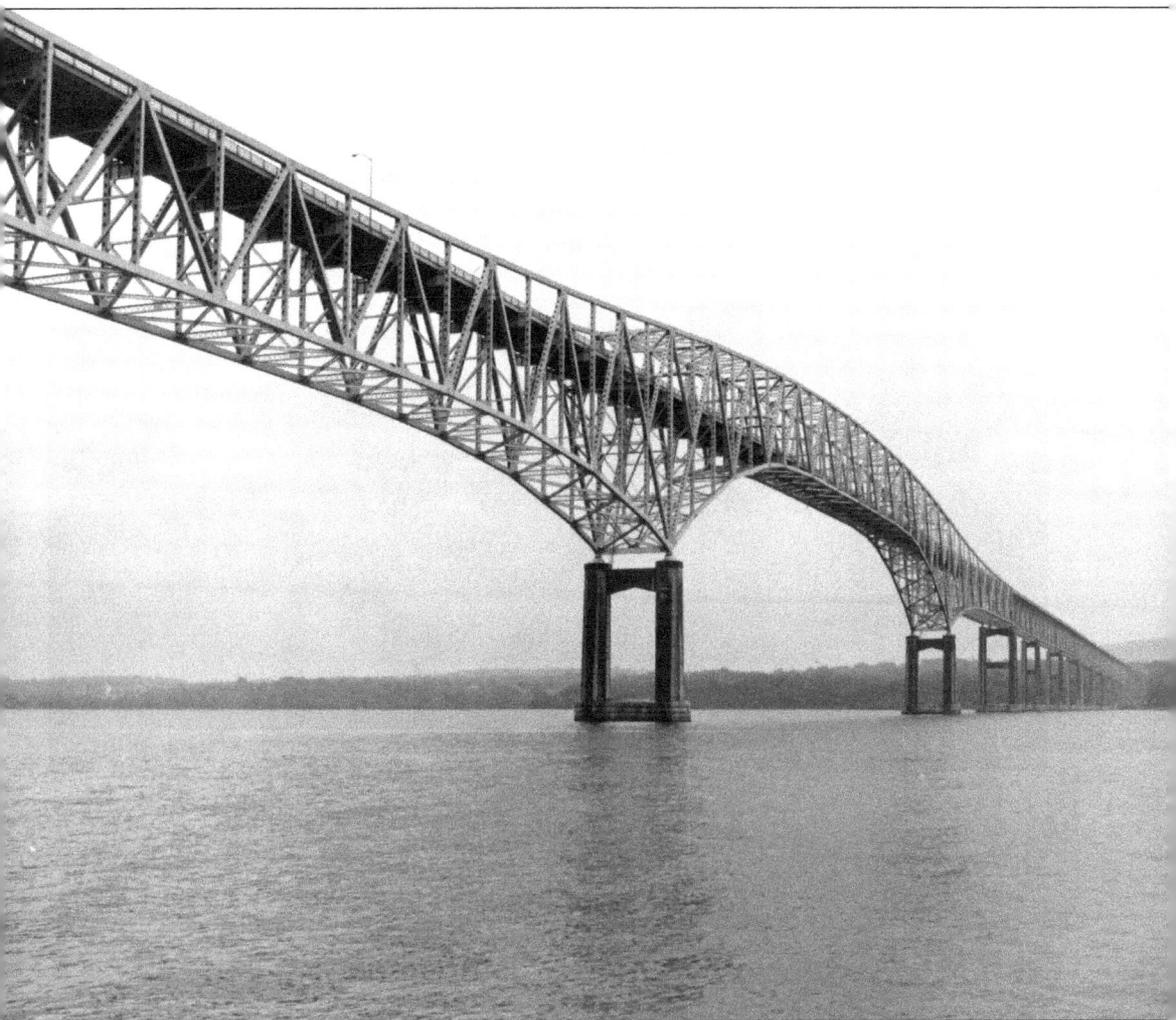

Special riveting was used to hold the massive steel beams and plates together. Workers worked in pairs as the red-hot rivets were slid through two pieces of steel by one worker. The partner on the other side, using a riveting hammer, pounded the red-hot metal into a mushroom shape while the rivet was held in place. As the rivet cooled, the two caps and the rivet contracted, bringing the steel tightly together.

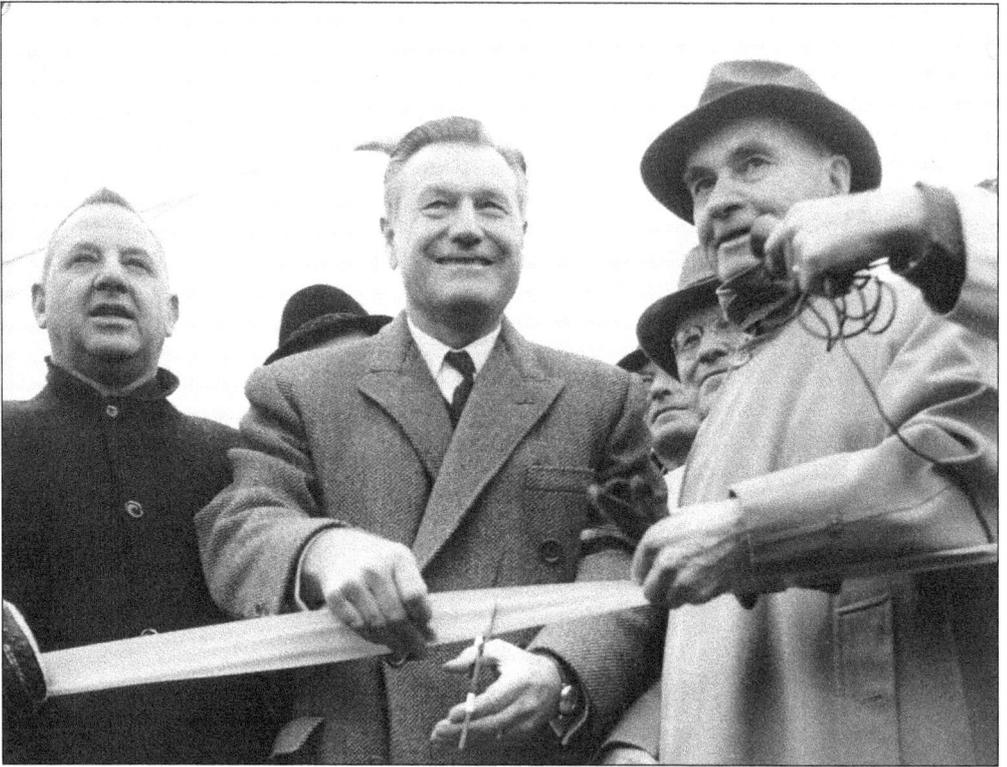

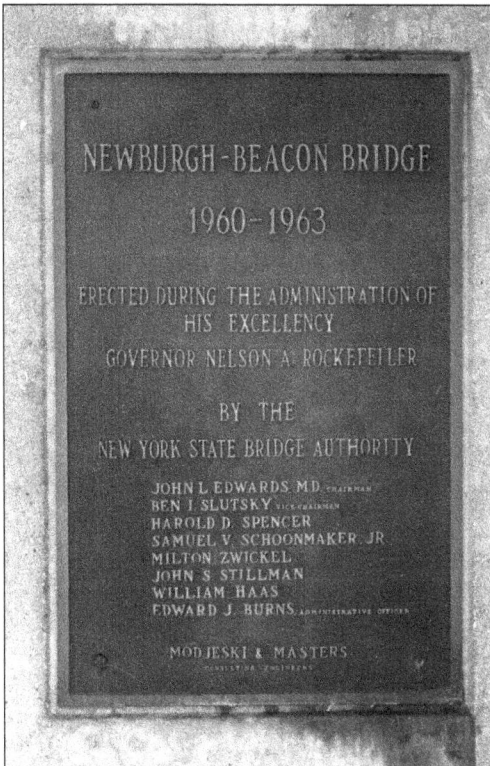

Opening ceremonies were held on November 2, 1963. Gov. Nelson A. Rockefeller officially cuts the golden ribbon while members of the NYSBA and the state superintendent look on.

PROGRAM

Newburgh-Beacon Bridge

November 2, 1963

〰〰〰〰〰〰

STAR SPANGLED BANNER

INVOCATION

REV. HERMAN L. KUSTER

Trinity Methodist Church, Beacon

REMARKS AND INTRODUCTIONS

DR. JOHN L. EDWARDS

Chairman, New York State Bridge Authority

REMARKS

J. BURCH McMORRAN

Supt. New York State Department of Public Works

INTRODUCTION OF GOVERNOR

DR. JOHN L. EDWARDS

New York State Bridge Authority

ADDRESS

HON. NELSON A. ROCKEFELLER

GOVERNOR OF THE STATE OF NEW YORK

BENEDICTION

MONSIGNOR HUBERT BELLER

St. John Catholic Church, Beacon

RIBBON CUTTING

GOV. NELSON A. ROCKEFELLER

Rockefeller spoke at the opening of the Newburgh-Beacon bridge. Within a year, 25,000 vehicles were using the bridge daily. Traffic jams were causing major problems. It became evident very quickly that more traffic lanes were needed. The second span would not open for another 17 years, in 1980.

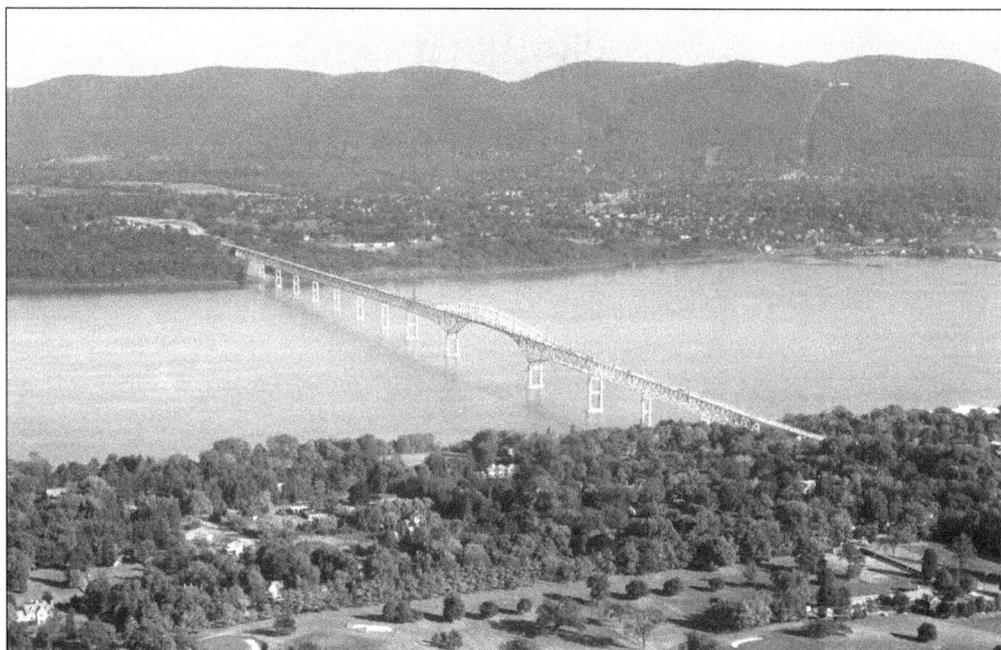

The aerial photograph of the newly opened Newburgh-Beacon bridge shows the full 7,857-foot length of the bridge. It is more than a mile straight across the river. The communities of Beacon and Newburgh showed much growth in the years following the opening of the bridge.

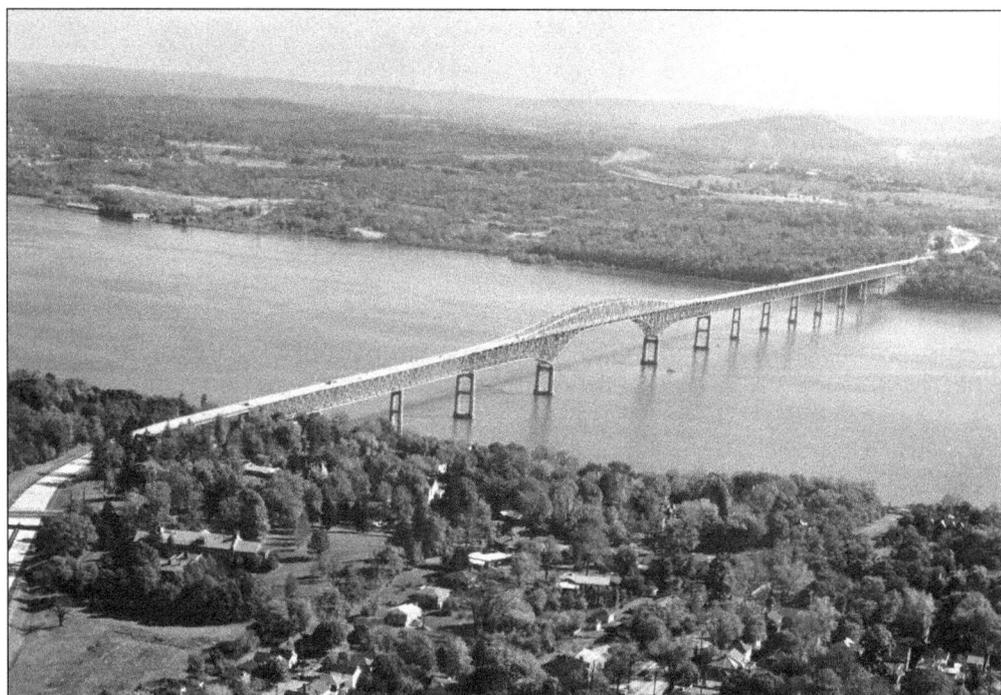

It soon became clear that although the Newburgh-Beacon bridge, as seen in this aerial photograph, appears very large, it was not anywhere near sufficient to handle traffic on the ever-congested Interstate 84 that runs from Pennsylvania, through New York, into Connecticut, and beyond.

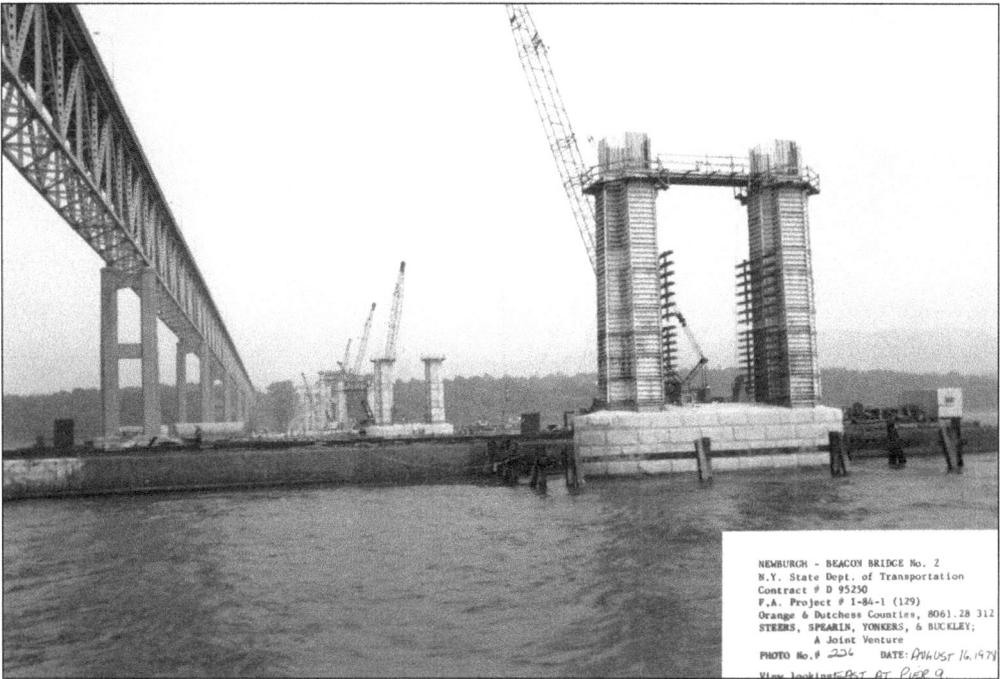

NEWBURGH - BEACON BRIDGE No. 2
N.Y. State Dept. of Transportation
Contract # D 95250
F.A. Project # I-84-1 (129)
Orange & Dutchess Counties, 8061.28 312
STEERS, SPEARIN, YONKERS, & BUCKLEY;
A Joint Venture
PHOTO No.# 206 DATE: August 16, 1978
View looking EAST AT PIER 9

It was decided in 1972 that a new bridge, built parallel to the original, would be needed to accommodate the increasing traffic that crossed the bridge daily. Construction began in 1976 on the piers, using caissons and cofferdams.

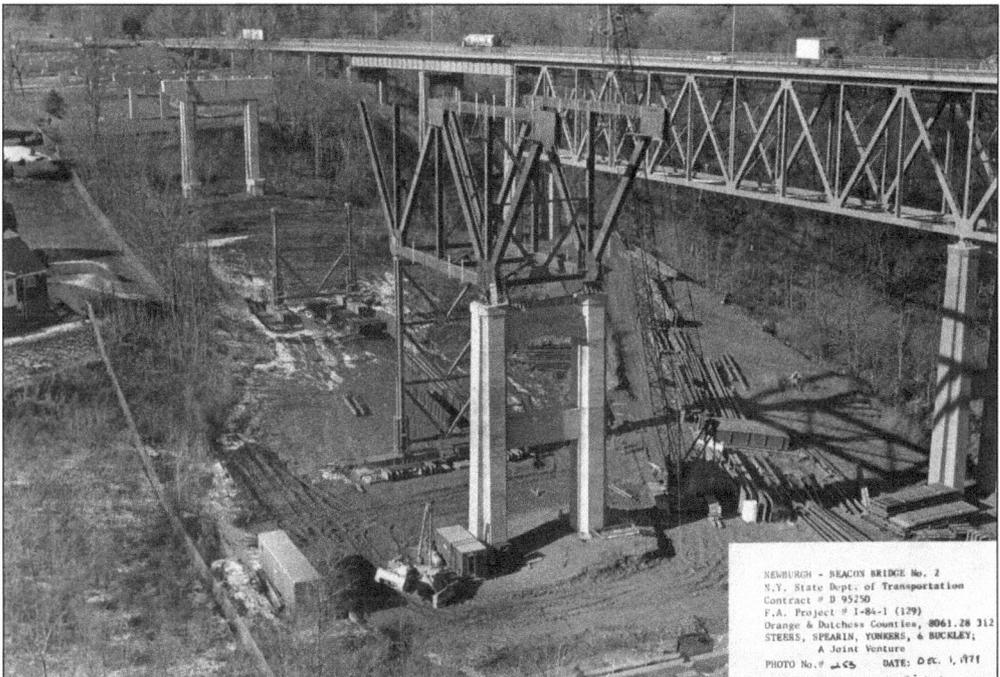

NEWBURGH - BEACON BRIDGE No. 2
N.Y. State Dept. of Transportation
Contract # D 95250
F.A. Project # I-84-1 (129)
Orange & Dutchess Counties, 8061.28 312
STEERS, SPEARIN, YONKERS, & BUCKLEY;
A Joint Venture
PHOTO No.# 268 DATE: Dec. 1, 1978

The construction on the new bridge took place as traffic crossed uninterrupted on the original span. While the old span was built much smaller than needed for lack of federal funds, the new span would be built primarily with federal funds.

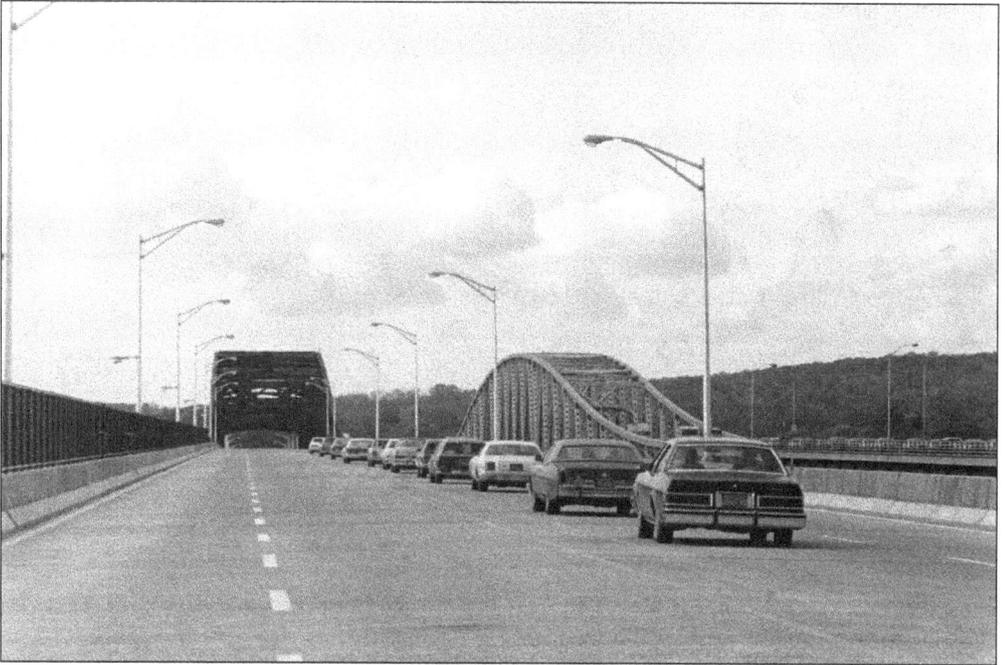

The bridge opened on November 1, 1980, one day less than 17 years after the first span opened. The older span was closed in December 1980 for strengthening and widening. The original two lanes would be widened to three lanes.

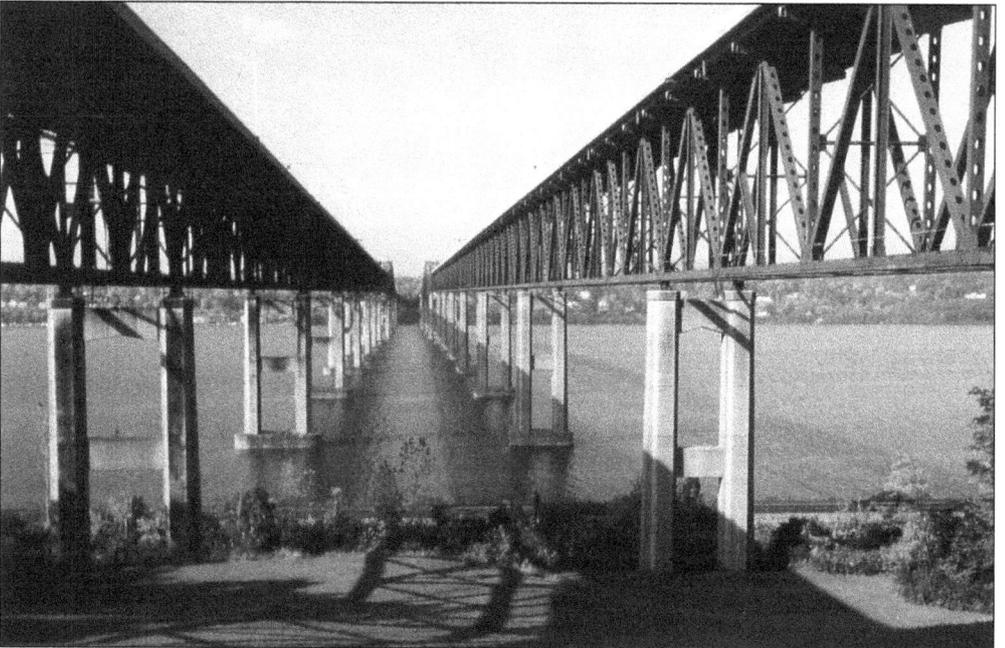

The old span would also be repainted deep brown rust to match the color of the new span's special weathering steel. The north span was reopened on June 2, 1984, after a total of more than three and a half years of work.

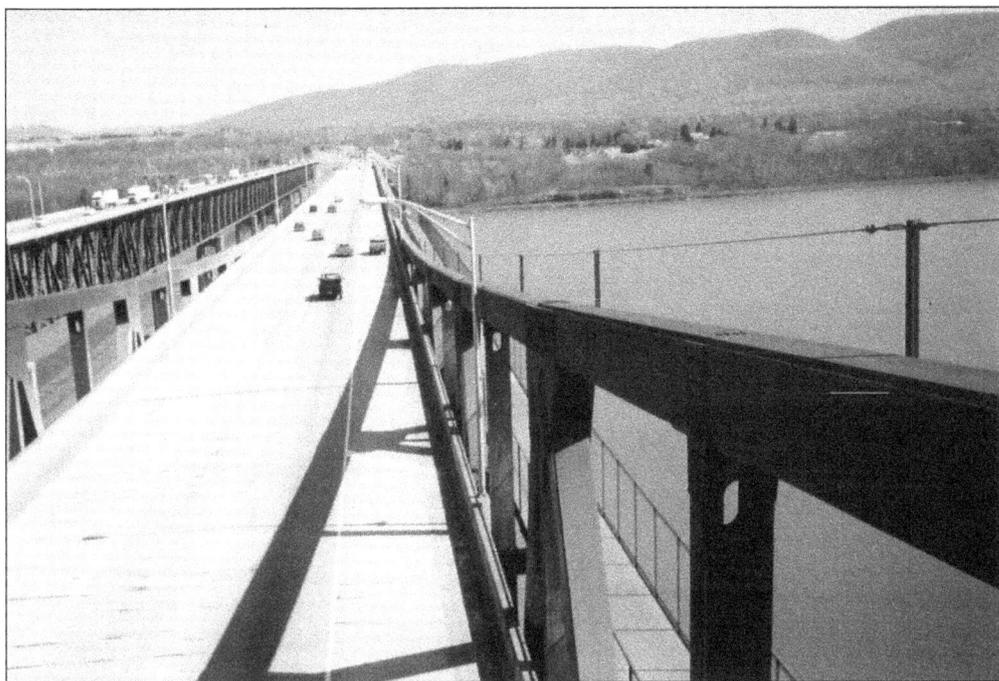

The old and new spans of the Newburgh-Beacon bridge are standing side by side. One span is going east the other going west, together connecting the opposite shores of the Hudson River.

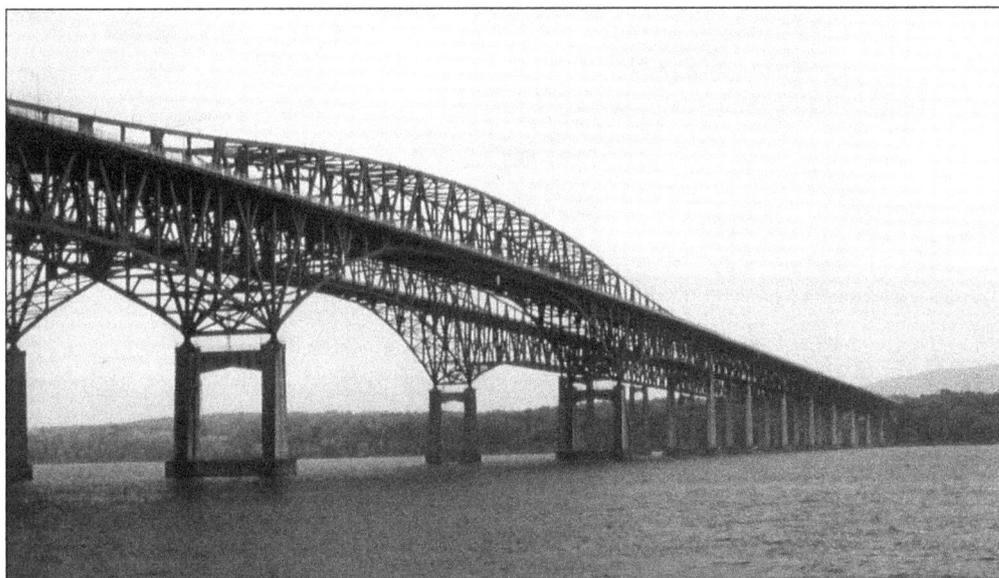

Looking up at the almost twin structures from the surface of the Hudson River they appear to be two pieces of the same structure. Up on the bridge the traffic speeds along, traveling westbound on the northern span and eastbound on the southern span. The tolls are collected on the eastern trip. In 1994, Gov. Mario Cuomo signed into law a bill officially changing the name of the Newburgh-Beacon bridge to the Hamilton Fish Newburgh-Beacon Bridge in honor of four men named Hamilton Fish who have served the Hudson Valley and the nation in public life since before the Civil War.

Visit us at
arcadiapublishing.com